Praise for
Your Brain on Art

"This book blew my mind! An authoritative yet practical guide to neuroarts—a term that, if you haven't heard it before, is even more reason to join these brilliant co-authors on a romp through the latest science on how art transforms the brain and the body."

—Angela Duckworth,
#1 *New York Times* bestselling author of *Grit*

"This book shares the science to prove that the arts and aesthetic experiences are essential not only to our health and well-being, but our ability to thrive. *Your Brain on Art* shows us how art can be a transformative tool in our lives, both individually and collectively."

—Arianna Huffington, founder & CEO, Thrive Global

"*Your Brain on Art* will change how you think about the creative world, both around you and within you."

—Charles Duhigg, author of the bestsellers
The Power of Habit and *Smarter Faster Better*

"This fascinating account . . . will inspire readers to establish their own concrete plans to incorporate as much art into their lives as possible."
 —*Kirkus Reviews*

"Deeply researched and inspiring . . . brims with persuasive data from cross-disciplinary studies into the positive effects of taking even minimal time for oneself to regularly experience art."

—*San Francisco Chronicle Datebook*

"Brimming with ideas that . . . could change the world if more people simply picked up a copy." —*Cool Hunting*

"Susan Magsamen and Ivy Ross convincingly show that making and experiencing art is a full body, full brain necessity for a health-filled, rewarding life. . . . *Your Brain on Art* carefully grounds each new topic in interviews with scientists, artists, and lay participants . . . proving the science, the joy, and the power of experiencing life enmeshed in the arts." —*New York Journal of Books*

"This wonderful book demonstrates that art is essential for health, healing, community, and bliss. *Your Brain on Art* is well researched and well written. I couldn't put it down."

—Mary Pipher, author of
Women Rowing North and *A Life in Light*

"*Your Brain on Art* explores the new science of neuroaesthetics, a way of reimagining how to live that includes art as an essential part of the human experience and an unexpected doorway to healing."

—Mark Hyman, #1 *New York Times* bestselling author of
Young Forever

"A groundbreaking book on the science behind humanity, joy, and creativity. 'Art' is the word we use for the magic that makes us better."

—Seth Godin, *New York Times* bestselling author of
This Is Marketing

"In this wonderful new book, Susan Magsamen and Ivy Ross show us how the experience of art helps to build connections and pathways for mental health."

—Thomas Insel, former director of the
National Institute of Mental Health and author of *Healing*

"Susan Magsamen and Ivy Ross, through extensive interviews and research, have created something beautiful and affirming with their book. Its pages provide proof for what so many of us have always known, that art, especially art in community, is transformative beyond measure."

—David Byrne, founding member of Talking Heads
and author of *How Music Works*

"For anyone who has been transfixed by a painting, or moved to tears by a piece of music, this book provides a fascinating tour of what goes on in the brain when we encounter art's transformative power."

—Annie Murphy Paul, author of
The Extended Mind: The Power of Thinking Outside the Brain

"Art is often dismissed as a nice-to-have, but this important book shows that it is an absolute necessity for a life well-lived. Everyone should read this book. In it, you'll learn how to reclaim your creativity, heal your body, soothe your spirit, and transform your community."

—Ingrid Fetell Lee, author of *Joyful*
and founder of The Aesthetics of Joy

"This mind-bending book can help shape richer lives and a newer world. It's the best description yet of the indivisibility of art, the natural world, and our neurological health."

—Richard Louv, author of
The Nature Principle and *Last Child in the Woods*

"An extraordinary and important book. Magsamen and Ross put us back in touch with one of the defining features of being human—art—and remind us of how and why it is important in all we do."

—Daniel Levitin, *New York Times* bestselling author of
This Is Your Brain on Music

"*Your Brain on Art* masterfully demonstrates the power of all artistic expression, from visual to musical, on brain health. This book shows us that a beautiful painting or haunting melody is not just entertainment, but bountiful nourishment for your brain, mind, and soul."

—Dr. Rudolph Tanzi, *New York Times* bestselling author of
Super Brain, professor of neurology, Harvard Medical School

Your
Brain
on Art

Your Brain on Art

How the Arts Transform Us

Susan Magsamen
and Ivy Ross

Random House
New York

Published in the United States by Random House, an imprint and division of Penguin Random House LLC, New York.

RANDOM HOUSE and the HOUSE colophon are registered trademarks of Penguin Random House LLC.

Originally published in hardcover in the United States by Random House, an imprint and division of Penguin Random House LLC, in 2023.

Image credits appear on page 265.

LIBRARY OF CONGRESS CATALOGING-IN-PUBLICATION DATA
Names: Magsamen, Susan, author. | Ross, Ivy, author.
Title: Your brain on art: how the arts transform us / by Susan Magsamen and Ivy Ross.
Description: First edition. | New York: Random House, [2023] | Includes index. |
Identifiers: LCCN 2022035702 (print) | LCCN 2022035703 (ebook) |
ISBN 9780593449240 (paperback) | ISBN 9780593449257 (ebook)
Subjects: LCSH: Aesthetics—Psychological aspects. | Arts—Psychological aspects.
Classification: LCC BH301.P45 M34 2023 (print) | LCC BH301.P45 (ebook) |
DDC 111/.85—dc23/eng/20230209
LC record available at https://lccn.loc.gov/2022035702
LC ebook record available at https://lccn.loc.gov/2022035703

Printed in the United States of America on acid-free paper

randomhousebooks.com

9 8 7 6 5 4 3 2 1

Book design by Ralph Fowler

The opinions expressed in this book are those of Susan Magsamen and Ivy Ross, and not those of John Hopkins University or Google.

Dedicated to those who
are unfolding the power
of the arts

Contents

The Language of Humanity

Art is our one true global language. . . . It speaks to our need to reveal, heal, and transform. It transcends our ordinary lives and lets us imagine what is possible.

—RICHARD KAMLER, ARTIST AND ACTIVIST

You know the transformative power of art. You've gotten lost in music, in a painting, in a movie or a play, and you felt something shift within you. You've read a book so compelling that you pressed it into the hands of a friend; you heard a song so moving, you listened to it over and over, memorizing every word. The arts bring joy. Inspiration. Well-being. Understanding. Even salvation. And while these experiences may not be easy to explain, you have always known they are real and true.

But we now have scientific proof that the arts are essential to our very survival.

We know how art, in its countless forms, heals our bodies and minds. We've got the evidence for how the arts enhance our lives and build community. We know, too, how the aesthetic experiences that make up every moment alter our basic biology.

Advances in technology allow us to study human physiology like never before, and a growing community of multidisciplinary investigators is researching how the arts and aesthetics affect us, giving rise to a field that is radically changing how we understand and translate the power of the arts. It's called *neuroaesthetics*. Or, more broadly, *neuro-arts*.

In short, the arts and aesthetics change us and, as a result, they can transform our lives.

We wrote this book for everyone—for those who have had little experience with the arts or sciences, and for those who are in these fields. Our goal is to share the building blocks of the neuroarts with you. We hope it will enrich and inspire you, your family, your colleagues and your community.

Many of us tend to think of the arts as either entertainment or as an escape. A luxury of some kind. But what this book will show you is that the arts are so much more. They can be used to fundamentally change your day-to-day life. They can help address serious physical and mental health issues, with remarkable results. And they can both help you learn and flourish.

At a home in upstate New York, a man with advanced Alzheimer's disease recognizes his son for the first time in five years after he hears a curated playlist of songs from his past. In Finland, a young mother sings to her newborn to help recover from postpartum depression faster than with antidepressants alone. In Virginia, first responders paint to release the trauma of frontline care, and mask-making helps soldiers recover from PTSD. In Israel, a cancer hospital designed with sensory experiences in mind helps patients heal faster.

Around the world, healthcare workers are prescribing museum visits. Digital designers are working with cognitive neuroscientists to find new treatments for attention deficit disorder and to enhance brain health. There's a virtual reality program that alleviates pain. And be-

cause research shows that sensory-rich environments help us learn faster and retain information better, many schools, workplaces, and public spaces are being reimagined and redesigned.

All because of advances in neuroaesthetics.

In the same way that the formal creation of the neuroscience discipline in the late twentieth century has fueled a revolution in our understanding of the brain, the formation of the field of neuroarts is building an important body of evidence about our brains on art. And there is so much more to come. Artist Norman Galinsky's work entitled *Spiral Cluster,* at the beginning of this introduction, represents the dynamic relationship between the arts and sciences. Discoveries and findings about human biology will continue to give rise to arts-based, personalized prevention and wellness programs, increasingly becoming part of mainstream healthcare and public health as clinicians and insurers are convinced by the mounting evidence that the arts really do help us heal and thrive.

Simple, quick, accessible "acts of art" can enhance your life. Already we see a rise in microdosing of aesthetics as people use specific scents to relieve nausea, calibrate light sources to adjust energy levels, and use specific tones of sound to alleviate anxiety. In the same way you might exercise to lower cholesterol and increase serotonin in the brain, just twenty minutes of doodling or humming can provide immediate support for your physical and mental state. In fact, so many studies have shown the swift physiological benefits to our health from the arts and aesthetics that we debated calling this book *Twenty Minutes on Art.*

The two of us have come to think of this book as a kaleidoscope, each story and piece of information forming colorful objects, beautiful patterns, and shapes within it. Make just one small turn of the kaleidoscope aperture and your perception of the multifaceted picture changes, revealing something you've never seen before. And the possibilities are infinite.

Not in some idealistic, intellectual way.

In a real, grounded, practical way.

This book will show you how.

An Aesthetic Mindset

The world is full of magic things, patiently
waiting for our senses to grow sharper.

—UNKNOWN

An *aesthetic mindset* is simply the ways in which you are aware of the arts and aesthetics around you, and how you bring them into your life with purpose.

Those who have an aesthetic mindset share four key attributes: (1) a high level of curiosity, (2) a love of playful, open-ended exploration, (3) keen sensory awareness, and (4) a drive to engage in creative activities as a maker and/or beholder.

The Irish poet John O'Donohue once said, "Art is the essence of awareness." Being in the aesthetic mindset is being present and attuned to the environment you are in. It fosters an ongoing connection to your sensory experiences and opens the door to creating art and appreciating aesthetic experiences—that ultimately change you.

We invite you to take the following short survey. The Aesthetic Mindset Index is based on a research instrument called the Aesthetic Responsiveness Assessment, or AReA, developed by Ed Vessel and his colleagues at the Max Planck Institute for Empirical Aesthetics in Frankfurt, Germany, where Ed is a cognitive neuroscience researcher. Collaborating with Ed, we have modified the AReA to provide additional prompts that explore your aesthetic mind and the ways in which aesthetics and the arts currently affect you. We suggest you take it now, and then take it again in a month or two after you've had time to go

out in the world and try some of the ideas in this book. See how your score changes.

Read the following statements and circle the number that corresponds to how often they apply to you, using the following scale.

1 = Never
2 = Rarely
3 = Sometimes
4 = Often
5 = Very Often

1. I attend music, dance, theatre, museums, and/or digital art activities.

 1 2 3 4 5

2. I see beauty when I look at or experience art.

 1 2 3 4 5

3. I am emotionally moved by music.

 1 2 3 4 5

4. I am impressed by symmetry in artistic works.

 1 2 3 4 5

5. I sculpt, paint, draw, craft, create films/video, or design.

 1 2 3 4 5

6. When I look at art, I feel positive energy or invigoration.

 1 2 3 4 5

7. I write poetry, lyrics, nonfiction, and/or fiction.

 1 2 3 4 5

8. When I view art, my heart beats faster, or I have other physical effects.

 1 2 3 4 5

9. I appreciate the visual design of buildings and interior spaces.

 1 2 3 4 5

10. I take (or have taken) classes in art, craft, creative writing, aesthetics, etc.

 1 2 3 4 5

11. When making or beholding art, I experience a sense of connection and community.

 1 2 3 4 5

12. When experiencing the arts, I feel a oneness, unity, or connectedness with the universe/nature/existence/deity.

 1 2 3 4 5

13. I am deeply moved when I look at art.

 1 2 3 4 5

14. I experience joy, serenity, or other positive emotions when I am making or beholding art.

 1 2 3 4 5

How to score your results

The scale is organized into three categories:

Aesthetic Appreciation is the degree to which a person is responsive to the aesthetics of experiences and of their environment.

Intense Aesthetic Experience is the degree to which a person regularly responds to aesthetic experiences in a very intense way as opposed to more commonplace forms of appreciation.

Creative Behavior represents the degree to which a person engages in creative behaviors such as art-making.

Complete the following steps to determine your individual score for each of these areas as well as a cumulative score. Your cumulative score represents an overall snapshot of aesthetic responsiveness.

Individual scale scores: Count your score for each question below and divide by the number of questions.

Aesthetic Appreciation: Questions 1, 2, 3, 4, 6, 9, 13, 14

_____ Divided by 8 =_____

Intense Aesthetic Experience: Questions 8, 12, 13

_____ Divided by 3 =_____

Creative Behavior: Questions 5, 7, 10, 11

_____ Divided by 4 =_____

Cumulative scale score: To determine your cumulative score add all fourteen of your individual question scores together and divide by 14.

_____ Divided by 14 =_____

Scoring: To see where your aesthetic responsiveness is on the three individual scales and the cumulative scale, use this ranking to determine your aesthetic responsiveness:

1 Low

2 Below Average

3 Average

4 Above Average

5 High

For example, you might have a 3 in Aesthetic Appreciation, a 2 in Intensive Aesthetic Experience, a 5 in Creative Behavior, and a cumulative score of 4.

Your
Brain
on Art

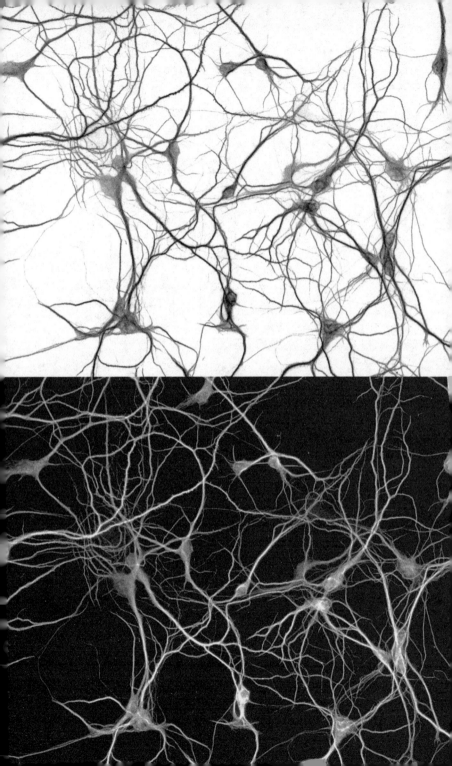

The Anatomy of the Arts

There is a vitality, a life force, an energy, a quickening that is translated through you into action, and because there is only one of you in all of time, this expression is unique.

—MARTHA GRAHAM, DANCER AND CHOREOGRAPHER

e made a bold assertion in the Introduction. We told you that arts and aesthetic experiences will improve your health and well-being and enhance your ability to learn and flourish.

So let's lay the groundwork for why that's true.

We're going to start by showing you some foundational science and offering a quick tour through your body to illuminate the ways in which you are wired for the arts. By first showing you *what* is going on inside of you, you'll better appreciate all that follows in the book, which is *how* the arts and aesthetics affect your body and mind. You can think of this chapter as your arts anatomy cheat sheet.

3

Knowing how your senses work is key to understanding the transformative nature of the arts and aesthetics in your life. If you took the aesthetic mindset survey prior to this chapter, you have a better idea of how you experience the arts and the extent to which you tune in to your aesthetic surroundings. Let's expand on that with an exercise to connect you to the sensory experiences you are having right now.

To begin, get comfortable where you are. Breathe in through your nose. What do you smell? Close your eyes and concentrate on this one sense. Maybe there's a cup of your morning coffee, a glass of red wine, or a candle nearby with a familiar scent. Keep breathing. What do you notice next, beyond those first impressions? If you were trained as a sommelier or a perfumer, you would know those initial smells are the top notes, and you would identify numerous others that exist just below them. Perhaps there's a musty odor from a dusty bookshelf, or the distinctive smell of petrichor through an open window, that incredible earthy scent that comes when a rain drenches a dry landscape.

Smell is one of the oldest senses in terms of human evolution. Your nose can detect 1 trillion odors with over 400 types of scent receptors whose cells are renewed every thirty to sixty days. In fact, your sense of smell is so good that you can identify some scents better than a dog can.

Microscopic molecules released by substances around you stimulate your scent receptors. They enter your nose and dissolve in mucus within a membrane called the olfactory epithelium, located a few inches up the nasal cavity from the nostrils. From here, neurons, or nerve cells, which are the fundamental components of your brain and nervous system, send axons, which are long nerve fibers, to the main olfactory bulb. Once there, they connect with cells that detect distinct features of the scent.

Here's where it gets interesting: the olfactory cortex is located in the temporal lobe of your brain, which broadly affects emotions and memory. This is why smell instantaneously and potently triggers physical and mental responses in you. For instance, the scent of a newborn baby releases the neuropeptide oxytocin, which activates bonding, empathy, and trust, appropriately earning oxytocin the nickname "the

love drug." A single sniff of a certain perfume or cologne can bring you back to a long-forgotten relationship. Several chemicals released when grass gets cut stimulate the amygdala and the hippocampus, helping to reduce stress by lowering cortisol. That's all because of the olfactory cortex–temporal lobe connection.

Like scent, taste is also a chemical sense: The foods you eat trigger your 10,000-plus taste buds, generating electrical signals that travel from your mouth to an area of the brain called the gustatory cortex. This part of the brain is also believed to process visceral and emotional experiences, which helps to explain how it is that taste is among the most effective sensations for encoding memory. It's why nutmeg, clove, and cinnamon taste like the fall and winter holidays for those living in America and Europe, while the herbaceous and citrusy marigold flower tastes like celebration in India, where the edible blooms are routinely part of wedding ceremonies. It explains why Susan makes her grandmother's chicken-and-dumpling recipe when she wants to feel comforted and why Ivy's go-to is moist chocolate cake inspired by the homemade rich, gooey pudding her grandmother made every Sunday growing up.

Keeping your eyes closed, refocus your attention to your ears. The hum of electrical equipment, the whirl of a fan in a laptop, the sound of chattering birds. Traffic. What's happening nearby? What can you hear in the distance? Hearing is a complex system that includes brain processes, sensory systems, and sound waves.

Maybe you're listening to music as you read this chapter. Music and sound are the most researched art form in neuroaesthetics, and we'll show you some compelling findings throughout the book. Our ability to hear is intricate and precise. Sound from the outside world moves into the ear canal, causing the eardrum to vibrate. These sound waves travel through the ossicles to the cochlea and cause the fluid in the cochlea to move like ocean waves. There are thousands of small hair cells inside of the cochlea, and when the fluid moves, these cells are activated, sending messages to the auditory nerve, which then sends messages to the brain. The auditory cortex, also located in the temporal lobe, sits behind your ears, where memory and perception also occur.

Different tempos, languages, and sound levels affect your emotions, mental activities, and physical reactions. Researchers at Stanford University in California used electroencephalography (EEG) machines to measure brain-wave activity of those listening to music at 60 beats per minute and they saw that alpha waves in the brain synchronized to the beats. The alpha brain wave is associated with relaxation. A slower beat can synchronize the delta brain wave and aid in falling asleep.

And the auditory nerve works both ways: It can signal your ear to dampen outside noise and focus on what the brain perceives as an important sound, which explains why it's so easy to accidentally startle someone who is absorbed in reading a book or looking at a piece of art. They literally didn't hear you coming.

We tend to think of sound as overt and recognizable things: a favorite song, the timbre of a lover's voice, the honk of a car horn. What you'll learn in this book is that your brain chemically reacts to frequency, vibration, and tone as well, and that these chemical triggers can dramatically alter mood, perception, and even address neurological and emotional ailments.

OK, open your eyes. You are now being flooded by light, color, and the objects in your visual field. For those who have visual impairment, it's estimated that over 80 percent can differentiate between light and dark, even if you are not able to recognize colors, faces, or shapes.

Our ability to see requires us to process light through a complex system. Your eyes work similarly to a camera. What you see is converted into electrical signals by photoreceptors. The optic nerve then sends these signals to the occipital lobe in the back of the brain and converts them into what you see. It's here that we perceive, recognize, and appreciate objects, and neuroscientists are discovering that it is one part of this lobe—the lateral occipital area—that contributes to how we process and create aesthetic appreciation of art.

Let's finish your sensory journey by touching a few things in your surroundings. The nubby fabric of your chair, the smooth surface of a table. Or if you are outside, perhaps the cool bark of a tree or the granular warmth of beach sand. Your fingers, hands, toes, feet, and skin are extraordinarily sensitive, picking up minute cues that trigger

physiological and psychological responses. In each of your feet, you have more than 700,000 nerve endings that are constantly taking in physical sensation. Touch receptors in your skin connect to neurons in the spinal cord by way of sensory nerves that reach the thalamus in the middle of the head on top of the brain stem.

Information about touch and texture is then transmitted to the somatosensory cortex, located in the parietal lobe. The somatosensory cortex is critical to processing touch. Neurons that process touch in the brain react differently to diverse features communicated by receptors. Consider how many adjectives we use to describe texture—rough, soft, furry, velvety—and what a rich sensory experience touch is.

Touch is one of the more powerful cognitive communication vehicles. It was one of our first sensory systems to evolve. We share our feelings and emotions through the simple act of holding a hand or sharing a hug. Touch rapidly changes our neurobiology and mental states of mind by releasing the neurotransmitter oxytocin, which, in addition to being the love hormone as we mentioned earlier, is also attributed to feelings of trust, generosity, compassion, and lowered anxiety. Experiments with human touch have shown how the intention of one person—to express sadness or happiness, care or excitement—can be interpreted and mirrored by another person through sense receptors. We can, quite literally, "speak" to one another through touch, because of the way it registers emotional perception in the brain.

Equally compelling is the way in which touch creates stronger, longer-lasting memories when compared to other senses. Recent studies have found that our sense of touch not only stimulates the somatosensory cortex, it engages regions of the brain that process visual signals. Even when blindfolded. One study asked its participants to touch regular household objects, like a spoon, without seeing them. When the blindfolds came off and the participants were presented with two very similar spoons, they were able, 73 percent of the time, to identify the precise spoon that they held in their hand, just by looking. And this object memory held when tested weeks later.

Your smell, taste, vision, hearing, and touch produce biological reactions at staggering speeds. Hearing is registered in about 3 millisec-

onds. Touch can register in the brain within 50 milliseconds. Your entire body, not just your brain, takes in the world, yet much of this is outside of your awareness. Cognitive neuroscientists believe we're conscious of only about 5 percent of our mental activity. The rest of your experience—physically, emotionally, sensorially—lives below what you are actually thinking. Your brain is processing stimuli constantly, like a sponge, absorbing millions of sensory signals.

So not all of the information that your brain is processing reaches your consciousness. Your attentional processes play a big role in what stimuli you actually "know" are out there in the world acting on your sensory receptors.

When you walk into a room, you likely don't appreciate all that your body is reacting to: the cast of light from a lamp, the color on the walls, the temperature, the smell, the textures. You may think of yourself as a body moving independently through the world, but you are interconnected with and part of everything around you. You and your environment are inseparable. Your senses lay the foundation for how and why the arts and aesthetics offer the perfect path to amplify your health and well-being. Your sensory inputs are constantly working, but what is actually happening in your brain as those stimuli come in?

The World Inside Your Head

Imagine your brain as a globe of the Earth containing four irregular "continent" shapes on one side with no spaces in between them. Now envision these same shapes on the other side of your globe. In other words, create a mirror image of these shapes. This is your cerebrum. It consists of two brain hemispheres that are partially connected in the middle by the corpus callosum. It passes messages between the two halves so that they can communicate with each other. The right side of the brain controls the left side of the body, and the left side controls the right.

Like different continents on a real globe, each of your brain's re-

gions have unique characteristics and functions. From front to back, the cerebrum is divided into four lobes: frontal, temporal, parietal, and occipital.

Roughly speaking, the frontal lobe is responsible for executive functions like planning, attention, and emotion. The temporal lobe, home of the hippocampus, takes care of making memories. The parietal lobe is home to the somatosensory cortex, where information about body sensations like touch and pain is received and interpreted. The occipital lobe processes visual images. Directly under the occipital lobe imagine a roundish bulb to represent the cerebellum. The cerebellum controls balance, movement, coordination, and habit formation. This means the cerebellum is responsible for a form of procedural memory that allows your body to repeat movements without having to relearn them, such as walking. No region works in isolation, of course. They all cooperate in order for you to function at your best.

Within the lobes of the brain are a number of structures that together make up the limbic system. This system is sometimes called the "ancient" brain network and it underpins emotion and behavior. This is where your instincts for flight, freeze, or fight live. The limbic system is also made up of structures that keep your body in homeostasis, which is your body's stable internal state. Your limbic system consists of your hypothalamus, which manages heart rate, body temperature, and blood pressure. The thalamus transmits all sensory information throughout the brain, with the exception of smell. And forming the shape of an almond is the amygdala; its job is to detect threatening stimuli and act instantly.

The brain is connected to the brainstem, which communicates with the spinal cord. The autonomic nervous system is made up of structures within the brain and spinal cord. It's split into two parts: your sympathetic and parasympathetic nervous systems. Imagine these as two lanes on a road. The sympathetic nervous system is the one that preps you for action, stimulating reactions like fight or flight. The parasympathetic nervous system governs your rest and reset functions, such as digestion.

In the centerfold of the book is an illustration of the brain by neuro-

scientist and artist Greg Dunn. See image D in the color insert. Greg's rendering identifies the location of many of the systems and brain regions we will discuss. You can refer back to it as needed.

Now that you have the very general lay of the land within your head, we're going to introduce you to four core concepts that underpin the science of the neuroarts and that you will be encountering throughout this book. The first is neuroplasticity, or how your brain wires and rewires itself.

Core Concept of the Neuroarts 1: Neuroplasticity

Still visualizing your brain as a globe, imagine millions of roads, highways, and bridges covering all areas, with trillions of streetlights on all of them. In some areas there are super-bright lights, in others the illumination is fainter. Some roads might look abandoned while others appear to be heavily trafficked. These are the electrical neural connections in your brain.

So, how do those well-traveled roads, or neural pathways, form and why are they so important?

We happen to have an in-house expert on that topic. Susan's husband, Rick Huganir, is the chair of neuroscience at Johns Hopkins School of Medicine and a neuroscientist who's been studying neuroplasticity for more than four decades. When Susan and Rick first started dating, he explained his research on neuroplasticity after giving her a good-night kiss on her doorstep. He later sketched how that kiss rewired his brain. She knew he was the one right then and there.

Rick has gotten pretty good at describing neuroplasticity to people, which is your brain's ability to consistently form and reorganize neuronal connections and to rewire itself. He starts by asking them to picture a human brain, just as we've done here with you. That you're able to pull an image out of your memory and call it forward is just one small example of the brain's amazing capacity to take in and store information.

This brain that you're picturing houses an interconnected network of roughly 100 billion neurons. Try to envision that gargantuan amount. Even if it's vague and imprecise, you can see that 100 billion, right? Your brain can actually conceptualize such a vast number because you were born with the capacity to make sense of numbers.

Next, Rick zooms in and describes what those 100 billion neurons look like at a microscopic level. For many people neurons resemble trees with overlapping and interconnecting branches. A comparison to something in nature, like a tree, helps you visualize the form and complexity of this infinite system in your head. Why? Your brain loves a good metaphor. Just as you can grasp a literal object with your hand, your brain can also grasp a concept.

An individual neuron has a nucleus that is the tender heartwood of the tree trunk, and it's surrounded by the cell body, which is like the rings of sapwood and bark protecting that center. Dendrites are the branches that sprout off these neuron trunks and are capable of receiving signals from other neurons. The axon, meanwhile, is like the tap root, sending signals out into the world. You can see the complexity of these synaptic connections in the images at the beginning of this chapter, which are actual photographic images Rick captured, showing microscopic neuronal networks in a petri dish.

The way that neurons communicate and connect is through a process known as synaptic transmission, and Rick has dedicated his life's work to studying how these synaptic junctions are made. It turns out, neurons are very social cells. In order to survive, they need to communicate with other cells.

Each of your 100 billion neurons is connected to about 10,000 other neurons using this synaptic process. You have quadrillions of synaptic connections, creating countless circuits across the brain. These circuits, Rick points out, underlie your body's movements, emotions, memory, everything you do. What's occurring in your brain when you are making a memory and learning is that you are making some synaptic connections stronger and some synapses weaker, Rick explains, and in that way, you actually sculpt a new circuit that wasn't there before, which encodes the memory. And *that* is plasticity.

Sometimes, a person listening to Rick's explanation will remember

hearing a phrase famously uttered by the late neuroscientist Donald O. Hebb when he first described the synapse process: "Cells that fire together, wire together." A credo for neuroplasticity and a simple statement that's easy to recall because the brain also loves a rhyme. Rick points out, though, that this isn't entirely accurate.

Synapses can *fire* together, meaning communicate, but it takes something special for them to *wire* together, meaning fuse into a connection. What stimulates our neurons to communicate with one another—to fire chemical messages—and to do so with enough energy that they wire together into a synaptic connection, is based on the intensity of the sensory stimuli. It's in the chemical soup of neurochemicals that strong synaptic connections are made, and that reflects the "saliency" of an experience.

Salience is a word that you'll read often throughout this book, and here's why: You could not possibly pay attention to all of the sensory stimuli coming into your body, or to the many emotions and thoughts that emerge as a result. Your brain is expert at filtering out the inputs that it deems irrelevant and focusing its attention on what it believes to be pertinent. Something that is salient is important to us either practically or emotionally; it's what stands out. Imagine a page with all black dots except for one red one. Where does your attention go? That's your brain making a saliency decision. Consider saliency the next time you're at a party or in a crowded room with lots of background chatter and noise. Notice what happens when a good friend arrives and you begin to catch up. The sound around you dims and you are able to focus on, and hear, what your friend is saying. This is known as the Cocktail-Party Effect.

Things that create saliency induce the release of neurotransmitters, like dopamine and norepinephrine, activating your synapses and increasing synaptic plasticity. This regulates memory formation, Rick says. The stronger the salient experience, the stronger the synaptic plasticity, because at that moment, a number of cells are activated, releasing lots of neurochemicals, changing the synaptic connections. Some of these connections are strengthened; some may be weakened. This helps to change the synaptic circuit responsible for memory formation, making them long lasting.

For instance, Rick will remember his first kiss with Susan forever because he had just found someone special, and his neurons were busy releasing neurochemicals so he would "know" and "remember" it.

There are several regions in the brain, anchored in the anterior insula and dorsal anterior cingulate cortex, that work to help you determine what is salient. This has been identified as the *saliency network*. Throughout this book, arts and aesthetic experiences emerge as major conduits for greater saliency.

So, arts and aesthetics can quite literally rewire your brain. They are a secret sauce that helps build new synaptic connections.

Neuroplasticity can work to build stronger synapses, and it can also make a synapse weaker, and even remove it. *Pruning* is the term for the removal of a synaptic connection.

You might wonder why the brain wants to prune a connection. It's the same reason a gardener wants to prune the branches of a tree or a bush: to promote stronger, healthier structures and growth. Plus, your brain does not like to waste energy. It is more energy efficient to use fewer cells, or synapses, to produce a behavior.

In the best-case scenario, pruning occurs as your brain adjusts by making enhanced connections. Lesser connections are removed. Think of it as your brain finding a new path and the old path is no longer needed. For example, you used to drive the long way home, until you discovered a better route and now you get to where you're going faster and more efficiently. You can now forget the old route. That's your brain pruning synapses that aren't engaged in salient experiences. These synaptic connections atrophy from a lack of stimulation and then permanently disconnect.

As your environment changes, so do the neural circuits within your brain. This is the basis for neuroplasticity. Your brain is designed to help you adapt to whatever environment you are in. Stimuli that are important to you in your environment become salient, which changes the synaptic connections within your brain. *Enriched environments,* which is the second core concept that underpins the neuroarts, are full of salient stimuli.

Core Concept of the Neuroarts 2:
Enriched Environments

In the early 1960s, neuroscientist Marian Diamond designed an experiment that she hoped would help prove a controversial theory about brain agility. Back then, it was commonly thought by most scientists that our brains remained static and declined as we age.

Diamond had a different perspective. She believed in neuroplasticity, even though it hadn't been proven yet. Her hypothesis was that brains changed over time and she suspected that a primary stimulus for this was the environment in which we live.

To prove this theory, she placed cohorts of rats in three different types of cages. Each cage had the basics: access to food and water, identical light levels. One group, however, resided in an "enriched environment"—a cage that included toys, textures, and objects to explore and play on. Diamond swapped these elements out regularly to promote novelty and surprise. The second group inhabited a standard cage with a basic exercise wheel, but it never changed; and the third was put inside an "impoverished" space, devoid of any exploratory objects or stimulation.

After several weeks, Diamond dissected the rat brains and found that the cerebral cortex, the outer layer of the brain, from the enriched-environment group had increased in thickness by 6 percent as compared with those from the impoverished group, which had lost brain mass. "This was the first time anyone had ever seen a structural change in an animal's brain based on different kinds of environmental experiences," Diamond later wrote.

Diamond became one of the first to observe neuroplasticity. Even more, her experiment proved that an environment had the potential to dramatically alter the brain—for better or worse. She repeated the experiment and confirmed her findings, publishing the results in a 1964 paper titled "Effect of Enriched Environments on the Histology of the Cerebral Cortex."

Her discovery was challenged, mostly by her male counterparts, with angry rebukes. She remembered how one neuroscientist furiously said to her: "Young lady, that brain cannot change!"

Diamond persevered, though, continuing to research brain plasticity till her death in 2017 at ninety years of age. Today, she is regarded as one of the founders of modern neuroscience. And because of her visionary insights and tenacity, we know that our brains have the capacity to physically rewire and create new pathways in response to environmental stimulation throughout our lives.

Researchers have since seen how our surroundings have a cumulative effect on us. The state of our human-built environment—by this we mean the places that aren't purely natural and have been designed by us—has an impact on both individuals and communities over time. This can be measured through improved outcomes in learning, health, and relationships. Neuroscience and biology continue to confirm and advance what Diamond identified: the positive outcomes of enriched spaces, and also how impoverished environments have a slow, corrosive effect on health and well-being.

The ultimate enriched environment is nature. Nature is the most aesthetic of places, because it is our original home. Nature appears throughout this book, as an aesthetic experience that neuroaesthetic researchers have been studying, and as a way to enliven the senses through uses of color, shape, smell, pattern, touch, and sight that emulate the natural world. We are increasingly seeing a trend in architecture, interiors, and object design, where elements of the natural world are incorporated.

Which is why the environment in which we are raised and the places in which we live, work, and play are vitally important. The aesthetics that surround you and the physiological sensations they elicit are core building blocks of your experience, which brings us to our third concept: the *aesthetic triad*.

Core Concept of the Neuroarts 3: The Aesthetic Triad

What's happening in your brain and body when you are having an aesthetic experience?

This is a question that has occupied Anjan Chatterjee for many years. Anjan is a professor of neurology, psychology, and architecture at the University of Pennsylvania, where he founded one of the world's first labs dedicated to neuroscience and aesthetics, the Penn Center for Neuroaesthetics.

Around 2014, Anjan and colleagues developed a theoretical model known as the aesthetic triad, and it explains how three components—our sensorimotor systems, our reward system, and our cognitive knowledge and meaning-making—combine to form an aesthetic moment.

The model is a Venn diagram depicting three interconnecting circles to illustrate the dynamic nature of your individual aesthetic-making process.

The beginning of this chapter showed you how your body and brain, through your sensorimotor systems, bring in information. This is the first circle of the aesthetic triad.

The second circle is your brain's reward system. This is a set of neural structures, or circuits, that activate when you experience happiness or pleasure. When the reward system comes online, it increases the probability that you repeat the behaviors that occurred prior to the event that sparked it. Typically behaviors that activate the reward system are ones that help the brain to keep us alive—eating, drinking, and sleeping—or ones that help the brain to keep our species alive, such as reproductive behaviors. It's here that you register love, and the pleasures of a fantastic meal, for example. As Anjan explained to us, "When we're talking about pleasure preferences we are activating our general reward system which is also used for very basic things like food and sex. The pleasure that we get out of art—when we think the art is beautiful—offers the same basic response."

It's in the third circle of meaning-making where aesthetic experiences are highly contextual. Your culture, your personal history, and the time and place in which you live all inform how you perceive and respond to something.

At the center of these three nodes lies an experience that registers as aesthetic for you. That experience consists of a combination of factors

unique to you and your biology and circumstances as well as containing some universal qualities that all humans find aesthetically compelling.

Often, beauty and aesthetic experiences are confused as the same thing, and so we asked Anjan to help define beauty for us. Which is a lot like trying to define the nature of love. But Anjan was up for the challenge. He began by breaking beauty, and our perceptions of it, into three overarching areas: people, places, and things.

When it comes to people and places, there are certain elements that we tend to weigh similarly. For instance, studies have shown that most people around the world perceive a beautiful face similarly. When presented with a variety of faces, we home in on similar attributes, such as symmetry and perceived kindness, as contributing to facial beauty. It's a swift and automatic response.

The same holds true for landscapes, where people tend to find certain elements—like sunsets on the horizon of the ocean—to be pleasing. In both cases, studies by Anjan and others have shown that our ventral medial prefrontal cortex comes online when we determine that a face or a place is beautiful.

With faces and landscapes, Anjan tells us, our responses in the brain are more consistent because we have all evolved over millennia to navigate both of these.

Our brain responses become more diverse when we start talking about objects. "Human artifacts, whether it's art or architecture, have only existed in their current form for a few thousand years," Anjan explains, "as opposed to the long swath of the Pleistocene, where our brains evolved."

There isn't nearly as much perceptual consistency when it comes to the arts. "You might love Jackson Pollock and I might love Edward Hopper," Anjan says, "and we're both having a beauty experience, but the object that is triggering that beauty experience can be very different." In other words, beauty is always, and only, in the eye of the beholder.

Take color, for instance. In India, where Anjan's family is from, the traditional color for mourning is not black, as it is in places like the United States. It's white. "You know how colorful saris are in India?

Well, white is the absence of color. That's what it means to mourn," Anjan explains.

That cultural preference is explained by the third circle of Anjan's triad: meaning-making. Where we come from, how we were raised, and our unique experiences all contribute to what we perceive as beautiful. "The meaning comes both from what I am bringing to the art—for example, my own background—but also whether the art viewing experience is profound, and how it changed how I am interpreting and making meaning in the world after having experienced it," Anjan says.

The arts and aesthetics encompass far more than just beauty. They offer emotional connection to the full range of human experience. "The arts can be more than just sugar on the tongue," Anjan says. "In art, when there's something challenging, which can also be uncomfortable, this discomfort, if we're willing to engage with it, offers the possibility of some change, some transformation. That can also be a powerful aesthetic experience."

The arts, in this way, become vehicles to contend with ideas and concepts that are difficult and uncomfortable otherwise. When Picasso painted his masterpiece *Guernica* in 1937, he captured the harrowing and brutal nature of war, and offered the world a way to consider the universal suffering caused by the Spanish Civil War. When Lorraine Hansberry wrote her play *A Raisin in the Sun*, she gave us a powerful story of people grappling with racism, discrimination, and the pursuit of the American dream while also offering a touching portrait of family life.

The arts, as you will read throughout this book, trigger the release of neurochemicals, hormones, and endorphins that offers you an emotional release. When you experience virtual reality, read poetry or fiction, see a film or listen to a piece of music, or move your body to dance, to name a few of the many arts, you are biologically changed. There is a neurochemical exchange that can lead to what Aristotle called catharsis, or a release of emotion that leaves you feeling more connected to yourself and others afterward. Throughout this book, we'll be sharing details from studies that show how specific art forms release certain hormones and neurochemicals, which in turn affect physiology and behavior.

In this way the arts elicit what Anjan explains are combinatorial properties of emotions that occur simultaneously. The arts and aesthetic experiences offer you more than just one emotional element at a time. "A good orange, if it's just sweet, feels insipid," Anjan says by way of an analogy. "You need a little bit of acidity in there to feel like it's a really good taste, and the arts do that in a more complicated way." Art that spurs multiple emotions becomes salient, which, in turn rewires your neural pathways.

Becoming aware of what you like and don't like, and better understanding how you are influenced, informed, and changed by arts encounters, creates opportunities for you to apply your own perceptual preferences to almost every area of your life. Using arts in this personalized way is so powerful because of our fourth and final core concept, your *default mode network*.

Core Concept of the Neuroarts 4: Default Mode Network

Your responses to the arts and aesthetics are as individual as the geometry of a snowflake. The sonatas of Mozart or the sounds of traditional Portuguese fado music might transport some, while others feel uplifted by the Persian calligraphy of Mir Ali Tabrizi or the smell of ink made from henna. Still others get into the flow by being immersed in a film or reading a poem. One person's cacophony is another person's symphony. And your perception is your reality.

Your experiences with the arts and aesthetics are so singular because your brain-connectivity patterns are distinctive. Through your experiences, billions of new synapses form in your brain and these conduits build a repository of stored knowledge and responses as unique as your fingerprints. No one else, not a single person on this planet, has your exact brain.

The default mode network (DMN) is now believed to be where the neurological basis for the self is housed. As neurobiologists work to map the brain, they are noting how different regions seem to work in

tandem to support specific types of activity. They are identifying how various neural networks work and what their purposes are. If you think back to our roadways analogy, these networks are like super-highways that crisscross our brain regions in order to take us to specific destinations.

The DMN is one of these networks. It is located in both the prefrontal and parietal lobes, and it can be observed in action using functional magnetic resonance imaging, or fMRI, which shows changes in blood flow in the brain. This network of interconnected brain regions is active when you are not focused on the outside world but rather focused internally. It is who you are when untouched by stimuli. This is the place where memories, a collection of events and knowledge about yourself, are housed. It's known to be the home of mind wandering, dreams, and daydreaming. It helps you optimize what you need to remember, and what you need to forget. It aids in envisioning your future. It's a catalyst for wondering, and it's also the place where you think about things that don't have an explicit goal. When you're making art, how you choose to express yourself comes in part from this network. The DMN is a filter for what you think is beautiful or not beautiful, memorable or not, meaningful or not, and it's what helps to make the arts and aesthetics a very personal experience for each of us.

Ed Vessel, who helped us develop the Aesthetic Mindset Index, has been studying the DMN for years now. Ed was curious about why different things resonate with each of us. "Why is it that some images make you go, 'Wow! That's really amazing,' and other images don't?" he told us.

What he has learned is that it comes down to how the arts and aesthetics help us to make meaning, to develop preferences, and to make judgments. The brain is a meaning-making machine in that it wants to connect the dots, find patterns and understand, and then build neural pathways accordingly.

"A big part of what happens when you interact with a piece of artwork, or when you find something aesthetically pleasing, is that there is an *aha!* moment where you feel like you've seen the world in a new way," Ed explains. "Or, as a maker of art, you've been able to look at a problem in a new way because art has enabled you to express things

that you couldn't before," he says. This meaning-making is happening in your DMN.

Your DMN, then, is the neural container that lets you process when a work of art, a piece of music or a certain landscape in nature matters to you.

In the spring of 2019, the two of us had the opportunity to coalesce this neuroaesthetics research and to illustrate, in real time, the effects of sensory perceptions on our bodies, the ways in which enriched environments work, and the unique ways we individually take in the world around us. We brought, for the first time, the science and theories of neuroarts to a global audience.

A Space for Being

Every spring, at least, prior to the pandemic, nearly 400,000 people from 170 countries gather in Milan, Italy, for the annual international design fair called Salone del Mobile. In 2019, the Google Hardware Design Group decided to create an exhibition for the public to experience the concept of neuroaesthetics. Ivy and her hardware-design group have always understood the power of color, material, shape, and sound and wanted to bring this to life for this event. Her team partnered with Advanced Technology and Projects at Google to create the software needed for this project.

Ivy invited Susan to develop the neuroaesthetic principles that would ground the exhibition. She also partnered with New York–based architect Suchi Reddy and the furniture design company Muuto to create *A Space for Being*, an immersive installation that illustrated our bodies' responses to different sensory environments. See image B in the color insert. This had never been done before. We were the first to attempt such a large-scale analysis of biomarkers—physical measurements that reflect basic biological activity—in an environment built specifically to look at space and physiological interactions.

Suchi worked with us to design three rooms using the neuroarts principles. Known as the Essential, Vital, and Transformational

Rooms, each was created with unique sensorial characteristics incorporating design elements including furniture, artwork, colors, textures, lighting, sounds, and scents. Suchi often says, "Form follows feeling," and this is what we wanted to create in *A Space for Being*.

As guests came into the exhibit, they were given a wristband that the Google hardware group had designed to measure physiological responses, including variable heart rate, respiration, and temperature. Not as vivid as a brain scan, but a lot more practical. They were invited to sit, to touch, to wander, and to really experience each room.

We quickly saw that people loved being able to explore the spaces. Free from conversation and without distraction, they were given the gift of space and time. Space to be curious and filled with the wonders of the senses. Space to just "be."

At the end of the exhibit, guests received a personalized data visualization revealing the space in which they felt most at ease based on their real-time biological feedback. This was the big finding: Many people were surprised by the disconnect between their biology and the room in which they *believed* they would feel most calm.

The reason for this discrepancy offers a pivotal insight. What we cognitively think and what we biologically feel don't always align.

Neuroscientists have been able to track the neuronal energy of thoughts using brain imaging, and to map how a stimulus—say, being asked by someone to repeat a word—causes our prefrontal cortex to marshal the brain into a cognitive process and response. Emotions, on the other hand, are processed in the limbic system deep in the brain and are not always consciously registered. Sometimes, our motor areas ignite faster than the prefrontal cortex is able to contextualize what's happening, and this is why our emotional fear of looking dumb may cause us to begin talking before our brain catches up.

In some instances, our conscious ideas are in direct conflict with our biological truth. Rab Messina, a design journalist, wrote about the surprising disconnect between her conscious thoughts as she walked through the exhibition and what was later revealed to be her body's biodata. Messina had been mesmerized by the first and the last rooms, which she saw as sophisticated high design, while the middle room—with its vibrant colors and books—made her want to flee. And yet, it

was while in that very room that her biofeedback was, inarguably, the most at ease. "Why would my body equate ease with dislike?" she wrote.

She realized that this had to do with deep-embodied emotions related to race and class. Messina was born and raised in Latin America, where "postcolonialism is alive and well," and as a mixed-race woman, she had felt the "invisible lines that keep darker-skinned individuals from shopping, lounging, eating, or just being in certain beautifully designed spaces," she wrote. She had been conditioned to not feel comfortable in elegantly considered spaces because "that's where the white elite belongs." As a design journalist, though, she sequestered those feelings and walked, with conscious confidence, into the high-design world. Yet it was in the room she perceived to be *the least* high design where her body actually calmed down. "While I could lie to myself about my own sense of belonging," she wrote, "the data didn't."

A Space for Being reminded the people who went through it that we all have agency over what we engage in and surround ourselves with, and it can aid in our overall health. For us, it reaffirmed just how much enriched environments have a physiological effect on us, and how much of our past experience can inform our present reality.

You can bring the lessons of *A Space for Being* into your life and it starts by paying attention to yourself. As you go about your day, notice how a change of scenery subtly affects how your body is feeling. Maybe you walk into one room and feel invigorated, but another makes you listless. Maybe there's a street, building, or landscape that you long to return to while there are other places you want to avoid. Bring your aesthetic mindset to the world around you, and get curious about what affects you. Maybe you can begin to narrow it down to specifics. A smell. A color. The shape of a room. If you feel a certain way in a certain place, ask yourself: Are the aesthetics of your surroundings tapping into some preconceived notion or bias, some long-held belief, as they did for Rab Messina? Imagine what you might understand about yourself as you focus on the ways in which your aesthetics inform your feelings.

In the chapters that follow, you'll learn how the arts and aesthetics are being used to support mental well-being; how they're improving

health and learning, and fostering our communities and capacities to flourish. We'll be returning to the core ideas of this chapter throughout the book. As these concepts show up you can always refer back to them here for additional clarity and understanding.

We have come a long way in building a biological foundation of how the brain operates and changes on the arts and aesthetics, and while there is much more to know, we'll introduce you to many of these groundbreaking studies in the chapters ahead.

But most important, you'll see how this new science of the arts promises to fundamentally alter how you live your life.

Cultivating Well-Being

I think that what we're seeking is an experience of being alive, so that our life experiences on the purely physical plane will have resonances with our own innermost being and reality, so that we actually feel the rapture of being alive.

—JOSEPH CAMPBELL, WRITER AND PROFESSOR

We have a friend, a successful lawyer, who keeps a couple of coloring books in her office for those times when she needs a mental break. A college counselor at a university recommends pottery workshops to overwhelmed students to help relieve their anxiety. For Susan, it's knitting, gardening, and collage, which she practices to stay both grounded and in touch with her feelings. Ivy carries tuning forks in her bag, because the resonant sound of the notes C and G combined can soothe a stressful moment.

For all of us, there are times when life is too much to handle, when

anxiety and burnout waylay us. Relieving our stress is as important as eating food, drinking water, and sleeping. And, in these moments, the arts and aesthetics make a big difference if you know how to use them. Think of the arts as an activity that changes your biology, emotional state, and enhances your mental well-being.

When the arts become a regular practice—the way you might improve nutrition, increase exercise, and prioritize sleep—you unleash an innate tool that helps you navigate the peaks and valleys of your inner life. And the best news is that you don't have to be great, or even good, at making art to experience the benefits. In a study, Girija Kaimal, assistant dean for special research initiatives and an associate professor in the creative arts therapies program at Drexel University, found that for the majority of people, making art for as little as forty-five minutes reduces the stress hormone cortisol, no matter your skill level or experience. Making art is physiologically calming. Girija explains, "The study was set up with an art therapist in the room who could provide support as needed to allow for authentic self-expression. There was no judgment or expectation, rather participants were encouraged to focus on the process and to feel safe, thus reducing stress and anxiety." She reminds us that anyone can do this at home with simple materials if they create without value judgments.

The arts offer a range of effective treatments for individual mental-health challenges, as well as our collective emotional zeitgeist. They improve our psychology by offering enhanced self-efficacy, coping, and emotional regulation. They improve our physiology by lowering stress-hormone response, enhancing immune function, and increasing cardiovascular reactivity. And that's just the beginning.

Over the last two decades, there have been thousands of studies with outcomes illuminating the reasons diverse arts practices, both as the maker and as a beholder, improve our psychological state. Take the work of Daisy Fancourt. She's a British psychobiology and epidemiology researcher at University College London who has been studying the effect of the arts on health, including a breakthrough study in 2020 involving tens of thousands of participants in the U.K. She and her two research partners used a sophisticated statistical technique that ac-

counted for multiple variables in lifestyle, and they found that people who participated in arts activities more than once a week, or who attended cultural events at least once or twice per year, had significantly higher life satisfaction than those who did not. This was the same across socioeconomic levels. People who engaged in the arts were found to have lower mental distress, better mental functioning, and improved quality of life.

Why is that?

Many of us believe ourselves to be thinking beings who feel, but as neuroanatomist Jill Taylor rightly points out, we are actually feeling beings who think. We are flooded all the time by varying emotions that are complex neurochemical responses to external or internal triggers. We know how we *want* to feel. Connected, grounded, at ease. Happy and safe. We strive to be positive, open-minded, and emotionally capable of addressing whatever comes our way. The World Health Organization (WHO) sums it up well with their definition of mental health: "A state of well-being in which the individual realizes his or her own abilities, can cope with the normal stresses of life, can work productively and fruitfully, and is able to make a contribution to his or her community."

But we are not always able to realize or sustain the quality of mental health we hope to. We are not alone. Globally, nearly 1 billion people struggle with their mental health. Depression is a leading cause of disability. Anxiety, loneliness, and toxic stress are on the rise, which can also have detrimental effects on our physical health. A generation of adolescents and young adults are experiencing epidemic levels of mental distress.

For the first time since these statistics have been collected, mental illness is increasing at a faster rate than physical disease. There's a tangible ripple effect to all of this, including an increase in absenteeism at school and at work, and higher rates of divorce. There is also an alarming sense of collective despair and an increasing lack of hope. An increase of what are called "diseases of despair," which include drug and alcohol overdose, alcoholic liver disease, and suicide.

For most of us, there are times when our mental states can bring us

to our knees. Those days when nothing makes sense. You feel in a fog. You are exhausted. You might be short-tempered and upset. You don't want to talk about how you're feeling and may find yourself disconnecting from others. Maybe you can pinpoint the moment when you began to feel unsettled by the stress of an upsetting event, a friendship in turmoil.

Other times, you don't know why your mood took a turn; it's like your body and mind have been hijacked. Your weight fluctuates up and down. You feel overwhelmed. Sometimes, these feelings really lock in and you just can't seem to get out from under them.

"I am large / I contain multitudes," the poet Walt Whitman wrote, and he wasn't joking. We evolved to carry a range of emotional responses in our bodies, which helped us survive. There's a debate as to exactly how many emotions human beings experience. Some psychologists hypothesize that we may have as many as 34,000 distinct emotions. Interestingly, the myriad emotions moving through us are modified by the needs of our physiology. American psychologist Robert Plutchik believes that there are eight foundational emotions—joy, sadness, acceptance, disgust, fear, anger, surprise, and anticipation—out of which thousands of varying degrees are possible. Anger, for instance, can register anywhere from minor annoyance to rage, with many subtle emotional distinctions in between.

We're often taught by caregivers, teachers, coworkers, and society at large to ignore our complex selves. Emotions are something we should avoid or contain or control. That's a bit like trying to tell your stomach not to digest food. Emotions are going to happen inside of you just as surely as your heart is going to beat and your lungs are going to extract oxygen from the air you breathe. You cannot stop the myriad human emotions that arise in you. That's physiologically impossible. And it shouldn't be the goal.

Besides, our emotions are not the problem in and of themselves. They are useful biological communicators that have evolved with us over millennia to help us survive. It's getting *stuck* in our emotions where the problems can arise. The goal, then, is to facilitate how emotions move through you. Mental wholeness is having the inner capac-

ity and resourcefulness to navigate the daily fluctuations of your life, even when you are feeling difficult emotions.

The desire to understand feelings and emotions has sparked numerous theories and debates, and there are many psychological views on the topic. Much of the differences in our understanding of emotional behaviors stems from the fact that it is difficult to study the underlying neural basis of emotions in humans or animals. The acceleration and sophistication of new technologies to visualize the brain has helped.

To understand why the arts are such an effective tool for emotional wellness, it first helps to discern the difference between an *emotion* and a *feeling*.

Husband and wife Antonio and Hanna Damasio, professors of neuroscience at the University of Southern California, have been studying the neurobiology of emotions and feelings for years, and, like Marian Diamond, have shown the ways in which biological changes happen automatically in our bodies in response to environmental stimuli.

Emotions are the initial expression of your response to environmental stimuli, inner needs, and drives, while feelings are the perception of what your body is experiencing: Often the emotion and associated action occur in the brain and body first, then the subjective awareness of these emotional states, reflecting feelings, occur next, if at all. What many researchers have learned over the decades is that, from a neurobiological perspective, multiple systems in the body and brain work together as we engage with the world, and our lives are a constant process of interpreting that incoming data on an instinctual, unconscious, and conscious level. Emotions precede our conscious recognition of a feeling, and often those emotional states can reside outside of our conscious awareness.

While feelings and the mechanisms giving rise to feelings are common between humans and other animals, humans have a much more complex cerebral cortex supporting increased levels of abstract representation related to our intrapersonal and interpersonal worlds, such that the conscious perceptions of our bodily responses to external and internal triggers—our feelings—are more differentiated and nuanced.

Imagine you're at the grocery store picking up dinner. A song that was popular in your childhood comes on the store's speaker system. While you're busy scanning the produce aisle, something else is going on inside you. Your brain is instantly activated, and blood flow increases to different regions. Feel-good neurochemicals including dopamine release as your reward-system response. You suddenly realize, standing there in the middle of the citrus fruits, that you're thinking about your best friend from middle school and how you two would sing this song at the top of your lungs. Your lips curl into a smile; a warm, positive feeling has overtaken you. What you're feeling is a complex emotion that relates to joy: nostalgia. A simple song has changed your whole mood.

We are constantly saturated with experiences that influence our perceptions and alter our mental states. Our senses are always crosstalking to create unique impressions and feelings about our world. And because the arts, by their very nature, are strong sensory inputs that engage multiple systems, they are uniquely capable of accessing interconnected neural pathways that allow us to process emotions, name and express our feelings, and even work on accessing the unconscious psyche.

This is invaluable as we meet the inevitable emotional twists and turns of our lives, and when we put the arts to use, they help us amplify the positive emotions, like joy and happiness, helping to usher in an overall sense of well-being. The arts also help us to relieve stress, which tends to alter our perception of our daily internal and external triggers.

Tuning into Vibration: Natural Stress Relief

In the late 1990s, Ivy was a senior vice president at the American toy company Mattel, where she was in charge of design and product development for girls. One day, she and a team of researchers and colleagues sat watching several five-year-olds playing with dolls. This team had spent months developing a new way to engage with the toy, and now was the moment of truth. The girls' responses were lukewarm at best.

In fact, they were showing less and less interest in the dolls as they played. Ivy noticed that one of her colleagues began to pace. The woman was clearly tensing up, and Ivy could feel the stress building in her.

Ivy pulled two tuning forks and a hockey puck out of her backpack. Now, working for a toy company meant that carrying a hockey puck in your bag may not have seemed completely strange, but the coworker watched in wonder as Ivy struck both tuning forks on the thick rubber of the puck, eliciting a deep, resonant sound. Ivy then held the vibrating forks up to each of her coworker's ears. Within thirty seconds, the woman let out a long sigh of relief. "Wow. Thank you," she said. "That's wild, I feel so much better. What did you do?"

Ivy had used a form of sound therapy to help reduce her colleague's stress.

Stress isn't a feeling or an emotion, rather it's a physiological response *to* our emotions. Stressors can be physical or psychological. They can be real—*a tiger!*—or imagined—*that shadow looks a lot like a tiger!* Stress is a clever biophysical strategy that evolved to help us survive times of real danger, but it can easily go awry.

Ivy's colleague had a strong emotional response to the thought that the toy would be a failure. In this case, an imaginary scenario triggered her stress—even though it felt pretty real to her! She could not yet know how this one experiment with the children would pan out, but she feared it was going to be negative. This was the stressor, and her body reacted.

The first stage of stress is alarm. Her body registered the emotion of fear as something dangerous occurring. In terms of neurobiology, this activated the autonomic nervous system, via the hypothalamus, pituitary, and adrenal glands, and invoked her body's fight-flight-freeze response. Hormones such as cortisol and adrenaline surged and her heart rate increased, along with her blood pressure. Her blood sugar likely spiked to prepare her for a physical action, like running away. She couldn't run away, though, so she stayed in that room and the discomfort mounted. All of this happened within the blink of an eye, before she consciously realized that she was even having a reaction.

If this stress response isn't quickly resolved—if she takes this expe-

rience home with her over the weekend—then she moves into the second stage, known as adaptation. Here, the body prepares for the long haul by continuing to secrete stress hormones, which can lead to insomnia, muscular pain, indigestion, and even allergies or a small cold. She might have trouble concentrating or start to feel impatient and irritable.

The third stage—recovery—can happen rapidly when the body is able to overcome stressors and return to homeostasis.

The body is so intelligent and adept at working through its stress response, to stressors both real and imagined, that it can cycle through the three stages quickly and efficiently. Stress is a natural reaction to daily pressures and it is normal. But when it's heightened and sustained, it adversely affects our health. When stuck in stress, your body saps its resources and you feel tired and depleted, and in some cases, depressed. It can also lead to other unhealthy coping distractions like smoking, drinking, and overeating, all in a futile effort to make yourself feel better by altering your brain chemistry through nicotine, alcohol, and the feel-good brain chemicals like endorphins and the neurohormones dopamine and serotonin that can be released when eating foods like chocolate. Most often this provides short-term relief, but more often, it has adverse health effects.

More and more of us are getting stuck inside of our stress response, where we simply can't cycle through. In its most recent report on stress in America, the American Psychological Association sounded an alarm over what they found to be a "mental health crisis of great proportion," affecting every age. One of the most worrying findings is what's happening to our young people. The report shows that Gen-Z teens (ages thirteen to seventeen) and Gen-Z adults (ages eighteen to twenty-three) are facing extraordinary uncertainty in their lives from unstable geopolitics, economic volatility, threats from climate change, and a global pandemic, to systemic violence, gender identity, and racism, and they have elevated stress as a direct result of consistent worry. Many are already reporting symptoms of long-term stress and anxiety.

Extreme stress can also lead to burnout. Burnout is a psychological syndrome that emerges after a prolonged response to chronic stress,

where we become exhausted, detached, and cynical. It is often associated with work, but it can happen in other aspects of our lives, including parenting, caregiving, and even community service. It's particularly acute for the millions of people in healthcare, including those who are helping sick or aging family members. A 2020 report from AARP and the National Alliance for Caregiving found that family caregivers are in far worse mental and physical health than they were just five years ago. And that was before the effects of the COVID pandemic were understood. According to the WHO, there are 349 million people who are considered to be "care dependent."

It may seem surprising at first to learn that sound is one of the more effective aesthetic experiences to reduce and alleviate stress, but once you consider how it works in the body, it makes perfect sense. Three elements comprise a sound: the object, the molecules in the air, and our eardrums. When a sound is produced by an object, air molecules vibrate against one another and create a sound wave. That wave is what we hear, while the number of vibrations per second creates the frequency. Humans are capable of registering frequencies between 20 Hz and 20,000 Hz. You can't, for instance, hear the sound of air being displaced when you wave at someone because the frequency is too slow.

The sounds you hear are caused by the motion of your eardrums, which in turn cause fluid in your inner ear to move. This is why earplugs, or just covering your ears, impairs your ability to hear sound. The moving air molecules do not have access to your eardrums.

The fluid inside the inner ear bends hairs on the cells, which then convert to nerve impulses that travel to your brain. These impulses move through the brain via neural networks that evoke strong emotions and memories—altering moods and behaviors instantly.

Sound vibration has the capacity to return the body to homeostasis and out of a fight-flight-freeze reaction. Ivy's use of the tuning forks tapped into her coworker's physiology to help disrupt that stress cycle. Her colleague could then return to a more calm and open-minded state where she could see the challenge for what it truly was: a need to tweak or rethink the toy.

Ivy learned this technique working with John Beaulieu, a pioneer in the use of sound therapy for mental health. John trained as both a psychologist and a musician, and he first observed the effectiveness of sound to improve emotional states when he worked with patients suffering severe mental illnesses in New York's Bellevue Psychiatric Hospital more than four decades ago. Today he combines traditional talk therapy with sound to help his clients.

"I've had people come and say they want to get rid of [their] anger, [their] stress, or they don't want to have sadness," John tells us. "I say to them that there's no way that you're *not* going to have the full spectrum of emotion in your life and that you'll always have stress. Everybody does, and it just means adaptation to change." Emotions are energy in motion, and each has its own frequency. In psychology, that frequency is called a *feeling tone*. The notes C and G, which Ivy struck with her forks that day at work, resonate with the Earth's core frequency and are known to be soothing vibrations. These frequencies are used together all over the world because the ratio, or interval, between the notes creates a universal feeling of harmony.

Sound becomes an excellent tool to help regulate stress, in that it can work on an unconscious level and not require concerted and concentrated effort to return to homeostasis. The frequency of sound instantly taps into what lies underneath conscious recognition, literally changing the vibrations in your body.

This may seem hard to comprehend at first, but think of it this way: The world, and everything in it, is vibration in constant motion. Nikola Tesla reportedly explained to a friend, "If you want to find the secrets of the universe, think in terms of energy, frequency, and vibration." Albert Einstein boiled this down to a fundamental fact of physics: $E = mc^2$. Everything is energy.

Einstein's equation reveals a universal reality—everything in the world is energy. You are never static; you are continually changing in response to the energy, the vibrations, moving through and around you. You respond, on a cellular level, to the resonance that is carried throughout you. Think of an electrocardiogram (EKG) readout, which measures electrical impulses in the heart, or an EEG, where you see the visible energy of your brain waves. You are measurable energy.

In his patient sessions, John uses the energy of sound from a variety of sources—tuning forks, drums, and handmade stringed instruments—but he is careful to keep it from becoming music. "Sound is vibration and frequency, and music is as well, but it is organized or composed sound, which is recognized and categorized by genres," he explains. "Music also has strong autobiographical associations." (Like that feeling of nostalgia in the grocery store.)

Sound therapy is now being used around the world. One form, known as vibroacoustic therapy, or VAT, treats both physical and mental pain. VAT imparts a low-frequency sine wave, which is the most simple form of vibration, into the body using a device embedded with speakers. VAT is effective enough that the Food and Drug Administration (FDA) has approved the therapy for increasing pain relief, circulation, and mobility.

One study in Finland looked at VAT as a stress reducer for patients experiencing chronic pain. According to the authors of this study, stress influences our perception of pain, so for those who have ongoing physical discomfort, the worry and dread of pain actually makes it more acute. Not only does the pain feel worse, it keeps them stuck in a stress response, which can lead to anxiety and depression. After VAT, these patients were able to feel more relaxed and their overall mood improved. The physical pain may still exist, but how they emotionally relate to that pain has changed. They became more emotionally resilient.

There's a scientific theory being studied now about how sound frequency increases our body's natural production of nitric oxide, and it offers some insight into the biological mechanisms for how sound alleviates stress. In 1998, the Nobel Prize in Physiology was awarded to three researchers who determined that nitric oxide is a key signaling molecule in our cardiovascular system. This molecule is made in our cells, and when it's released, vessels dilate, allowing for better blood flow. Nitric oxide enhances cell vitality and vascular flow, and may account for the relaxation effect in the body. Several small studies have shown that sound frequencies from things like tuning forks and even humming cause nitric oxide to be released in our cells.

And then there is important anecdotal and lived experience that is also being better understood. Sound has been used since the beginning of humankind to enhance and alter our moods. Australian Aboriginal tribes have played the didgeridoo for thousands of years in healing ceremonies. Buddhist monks have used Tibetan singing bowls for centuries to support focus and to alter states of mind.

When these metal bowls of varying sizes are struck with a mallet, they produce vibrating sounds, like a bell, and the scientific research now shows that singing bowls rung at different frequencies help to reduce anxiety, fatigue, and stress while improving concentration. In one small study of the effects of Tibetan singing bowl meditation on mental health, participants reported having reduced anxiety, fatigue, and even anger after a session, and they walked out with a better sense of overall well-being.

There's an emergence of sound practitioners who use instruments—gongs, percussion and wind instruments, Tibetan and quartz crystal bowls—in a variety of settings. Laura Inserra is one of the most sought-after sound practitioners in the world. She combines music and ancient wisdom practices from many cultures for a therapy she calls Meta-Music Healing.

Laura explained to us, "I use music to allow what is nonverbal to emerge and inform my clients," many of whom come to her for relief of acute stress and anxiety.

Laura believes that ancient instruments, such as the didgeridoo, flutes, and drums access inner experiences in ways that words cannot. Through deeply immersive sound journeys Laura elicits many different responses from her clients. For some there are immediate tears as emotions surface. For others they recall and release a difficult experience that got fixed in their memory and their body. Others have vivid and creative visions.

"The human body is like an orchestra," she says. "Every cell of our body vibrates to its own frequency and interplays with other cells. Sometimes we get into these beautiful places of harmony where all of our components coexist, and other times, some of them go out of 'tune.' Dissonance and disorders emerge. Mental health comes from a

wholeness, from a holistic well-being, and we can't separate our emotional body from our physical and spiritual body."

Frequently, Laura has had clients who are unable to relax and sleep. She pointed out that each of us have unique, individual needs and different energetic experiences. While sounds sometimes elicit comparable responses in people—Tibetan singing bowls can often induce relaxation—aesthetic experiences are not, as we talked about in the previous chapter, a one-size-fits-all situation. "Our biology, our personal history, our emotional traumas all determine what sounds work best," Laura contends, "and even then, like our bodies, these needs change from day to day. Being aware of these inner 'e-motions'— energies in motion—and shifts help us better self-regulate our system, when and as is needed."

She personalizes each session according to the needs of her client. "Tibetan bowls, for instance, might calm and help a person to sleep, but another person might instead have repressed emotions or energetic stagnation that needs to be released," she says. "For that person, I would probably start to drum and invite them to shake, because it's clear to me that's causing them not to sleep."

Sound plays an enormous role in how we feel. Think of: A dog bark. A car alarm. A slammed door. Think of: A baby's laugh. Ocean waves hitting a sandy shore. Wind through the trees. Your name being said by someone you love. Throughout the day, sound deeply affects your mood and your emotions, and knowing this, you can purposefully bring in sounds that help to energize you, to spark joy or to bring calm. Experiment. Now imagine making a playlist of sounds, or surrounding yourself with the kinds of instruments that resonate with you, be they tuning forks, kazoos, or drums, and creating a personalized symphony of sound for better mental health.

To illustrate the power of our unique sound vibration and frequency, at the beginning of this chapter are "DNA Voice Signatures" of our voices. Ivy's image is above and Susan's below. John Stuart Reid is an acoustic physics scientist who created an instrument called the CymaScope, which uses water as a medium to create these beautiful visible images of our sound vocalizations.

Softening Anxiety's Hard Edges

Anxiety is another core human emotion, something that we all experience. Anxiety, in essence, is an emotion—heightened fear—and it can cause our stress response to kick in. It's characterized by tension in the body, increased blood pressure, and mental worry. Anxiety can progress into a disorder, where it becomes chronic, with recurring intrusive thoughts or concerns. It manifests in so many different forms, from obsessive-compulsive disorder to panic disorder, but one of the fastest-growing mental-health challenges right now is generalized anxiety disorder, or GAD, which is when excessive worry spills over into more than one area of our lives. No matter the type of anxiety, it has a consistent undercurrent: a fear over the ambiguity and uncertainty of a human life. Chinese medicine beautifully describes the internal chaos of anxiety as "internal winds." Sometimes strong gale winds rage within us as we long for gentle breezes.

The arts practices that help to relieve anxiety are vast, and sound isn't the only vibrational aesthetic experience that can alter mood. Color is also vibration in that it is energy, and it has biological and psychological effects. Our eyes can detect more than 10 million colors. Three additional perceptual attributes—hue, saturation, and lightness—influence how colors register for us. Early studies in the neuroscience of color in sighted people found that, universally, people tend to favor some hues over others.

The visual cortex, located in the occipital lobe, controls our color perception, and colors have a biological effect on us. Red, for instance, has been shown to raise our galvanic skin response—or how much our sweat glands react—far more than colors like green or blue. In one study, when participants were separated into two different rooms, one that was colorful and one that was painted gray, those in the gray room had higher heart rates and reported more anxiety. Colors have the capacity to change our respiration, our blood pressure, even our body temperature. Blue tends to calm our physiology and help us to feel cooler.

But your reaction to a color also depends heavily on where you live, where you were raised, and the context within which you experience that color. In China, red means luck and fortune. In the United States, red represents danger; it means to be alert or to stop. If you walk into a red room as someone from China, you might feel lucky; in the United States you might feel provoked or agitated.

What we learn over the course of our lives about color also alters our expectations and affects our perception. Think of water faucets: red means hot water and blue means cool. In a fascinating study in 2014, researchers asked participants to place their hands on a red or blue surface and to notify them when that surface felt warm. The red objects felt cooler to the touch for longer and had to be dialed up to more than 0.5 degrees Celsius hotter than the blue surfaces before someone registered it as warm. The reason? We anticipate the red object to already be warm, so it takes a hotter temperature to make us register that warmth.

Color therapy is based on the ways in which the visible color spectrum improves a person's mood. Because color transmits at different frequencies and vibrations, practitioners are able to use a color's specific properties to shift the energy—and frequencies—within our bodies. Violet has the shortest frequency of all colors, while red has the longest. One study concluded that the frequency of blues and greens in mild hues help calm people in a work setting, reducing stress and fostering more creativity. The same study found that yellow promotes attention and focus. For some, red can be highly stimulating.

The act of coloring itself offers a way to reduce anxiety. In 2015, a coloring book called *Stress Relieving Patterns* became a *New York Times* bestseller. More than 12 million coloring books sold that year, many to adults looking for stress and anxiety relief. People intuitively realized what has been borne out in science, that the simple act of coloring for twenty minutes can reduce anxiety and stress and can leave you feeling more content and calmer. Coloring has been rigorously studied in recent years in an effort to understand why it is that humans can mitigate stress through such a basic activity. Some of the reasons are obvious: Coloring is a structured task that helps bring order to the

chaos of life. It's easy to do, and is portable. New Zealand psychologist Tamlin Conner, who has studied the mental attributes of creative activities including coloring, calls it an act of "little-*c* creativity"—an everyday activity that we may not think of as "art" but which reduces depressive symptoms and anxiety.

Studies have found that coloring can have a similar physiological response in the brain as the act of meditating by reducing outside noise and allowing for focus. In one study, anxiety was measured in participants before and after they drew and colored, and their heart rate, respiration, and skin conductance were measured throughout. The results found all physical indicators of anxiety reduced when coloring, and that perceptions of anxiety lowered as well. These results make sense from a neurobiological perspective, as coloring can diminish activity in the amygdala.

Neuroscientists have long been working to better understand what happens in the brain when we see colors in proximity as we do an activity such as coloring. In recent research, some scientists have turned to magnetoencephalography devices, or MEG, which use magnetic sensors to detect electrical activity of neurons as they fire. Using MEG, some have been able to map where in the brain certain colors register. For instance, when participants in one study were shown varying hues of blue, brown, and yellow, the brain activity was the same for the cool colors—the light and dark blues—while the warm colors, yellow and brown, produced similar brain activity. It begins to suggest the ways in which different colors trigger specific brain wave activity.

We next look at mandalas and their role in using colors and drawing to relieve the stress caused by anxiety. There's a whole body of work around mandalas and visual imagery and symbols that began with Carl Jung. In 1938, the Swiss psychoanalyst visited a Tibetan Buddhist monastery outside of Darjeeling, India, where he consulted with one of the lamas about a subject that had become a source of fascination for him: the mandala, or *dmigs-pa,* as the Tibetans referred to it. A mandala (Sanskrit for "circle") is a circular pattern, considered a sacred geometry, that's been used in spiritual practice since ancient times as an active visual meditation.

In many cultures, the mandala is a symbol of wholeness—the totality of the universe and the self contained within its bounds. According to Jung, the lama explained that a mandala was a mental image built up through an individual's subconscious. It could be used to uncover insights hidden within the layers of the mind and to achieve a state of emotional equilibrium.

Back in Europe, Jung's studies in Eastern spiritual practices led him to experiment with mandalas as a tool for accessing unconscious thought patterns and emotions, both in himself and his patients. He would invite his patients to spontaneously fill in circular drawings, adding patterns and symbols as they came to mind. This simple activity seemed to help guide people back to their emotional center "through the construction of a central point to which everything is related," he explained.

A study published in the journal *Art Therapy* confirmed what Jung was seeing in his practice. Just twenty minutes of coloring mandalas resulted in significantly lower anxiety levels, more than free-form drawing on a blank piece of paper. The researchers hypothesized that mandalas offered a soothing structure and direction while being complex enough to require the kind of heightened focus that redirects one's attention away from anxious, roaming thoughts.

By taking this art one step further and creating your own mandala, you can, as Jung discovered, gain access to your unconscious. Jung saw that drawing in this way, bringing spontaneous images and symbols and pictures to the page, offered a potent insight into the psyche, and mandalas were particularly adept at bringing buried emotions into meta-awareness and then awareness, even with those experiencing severe stress and anxiety.

What Jung did is an example of mindfulness-based art therapy (MBAT), which can include spontaneous drawing to help with adaptive responses to stress and anxiety. The images that emerge when we spontaneously draw are the language of the unconscious, offering insights into our emotional states. These drawings are capable of "speaking" when our voice cannot, Jung found, and when it comes to anxiety and stress, working with imagery stored in our brain and connected to our somatic experience has profound results.

Seeing and Believing

Therapist Jacqueline Sussman uses aesthetic imaging as the center of her practice called Eidetic Imagery Therapy. Based in New York, Jackie works with a diverse group of people in high-performing careers all over the world—some of whom often have debilitating and recurring stress and anxiety.

One client, Adriana, is an architect in her mid-forties who wanted to deal with long-standing issues in intimate relationships. Adriana seemed only to attract verbally abusive men. She told Jackie about her anxiety, which she traced back to her upbringing: Adriana had grown up in a small village in Greece where traditional beliefs limited what women could do. Her parents were very strict with her. Her brother was encouraged to have girlfriends, but Adriana was told it was forbidden for her to have sex before marriage. She ended up marrying a man just like her father. "He would pick at my looks, my body, my intelligence," she told Jackie. "I want to own my authentic voice and my femininity and sensuality."

In their sessions, Jackie asked Adriana a series of questions that helped her to envision specific mental images. "Every day through our lives we experience an endless stream of sights, sounds, feelings, and emotions," Jackie explains. "The mind absorbs these events, processes them, and stores them away in the form of rich, vivid images that contain personal meaning. Eidetic images are the detailed visual, physical, and emotional snapshots that form spontaneously in response to significant real-life experiences. They differ from memories, dreams, guided visualizations, or symbolic images in that they are concrete imprints in our minds of real and factual historical events."

Researchers believe eidetic images are not memories in that the image isn't tethered to a specific series of events and outcomes, and it's not an invention of your imagination in that it isn't made up. This image may be from your childhood, or it could be from a few hours ago. If, for example, we ask you to picture the house you grew up in, an image would pop into your mind. If we say, "Picture a starry night,"

you may remember a camping trip in your youth, or the time you saw van Gogh's famous painting. An eidetic image is different from a memory in that you are not recalling a specific situation and series of events; rather, you are envisioning a picture in your mind that reflects an emotional state.

Using images to access the psyche dates back to the early twentieth century and the burgeoning field of psychotherapy, but eidetic therapy saw a leap in use in the 1970s, primarily through the work of psychologist Akhter Ahsen. Ahsen developed a process by which the practitioner taps into eidetic imagery as a therapeutic tool by posing a series of questions that call to mind specific images. The therapist then helps the patient understand the physical and/or emotional responses to these images, and to discern their meaning. An eidetic image contains three primary components. The image that emerges is a picture seen in the mind's eye. The somatic response is the physical or emotional sensation accompanying the image, including sensory details, such as sights, sounds, smells, or any other form of information. The meaning, or the message, the image conveys provides the reason it has been stored this way within the mind.

Ahsen was effectively using the concept of the aesthetic triad before we had a definition for it: how we take in images, assign meaning to them based on our experiences, and how they affect our perceptions of the world. These images are highly sensorial. They were taken in through your sensory system and they have stored memory not just in your brain but also in your body. When we're asked to recall an image, then, we can tap into an accurate somatic experience that allows us to visualize the feeling and recall the physiological inputs that we took in with that image.

In one of their sessions, Jackie asked if there was a woman in Adriana's life, past or present, who exhibited a sensuality that she admired, and she pictured a Spanish friend named Lola who danced flamenco at a recital.

"Picture an image in your mind of her dancing at the recital. What do you see?"

"She is fully immersed in the dance," Adriana said, her eyes closed,

and a small smile coming to her lips. "It is as if there were a life force running through her. I see she is loving dancing because she is expressing her femininity and expressing her womanhood."

"As you see her, how do you feel?"

"I feel joy. I want to be like her."

With several more questions based on images, Adriana was able to discern that she felt joy in the pure expression of Lola's femininity. There was no dark shadow of shame. By the end of the session, Adriana was finally able to name how she wanted to access her own sensuality.

Jackie's process of asking clients to conjure these eidetic images helps them to also feel the somatic experiences they've kept locked in their bodies. To visualize these images and understand them helps reduce anxiety, revise old emotional patterns, and create a new and more empowering sense of identity. "These images trigger complex neurochemical reactions, eliciting emotions that can then be interpreted and unpacked to reveal underlying patterns and triggers," she says. "By engaging with our own storehouse of mental imagery, we can rewire our neural circuitry and break down the habitual, knee-jerk reactions of the mind."

Nature, Nurture, and the Built Environment

Aesthetics happen through the arts, yes, but as we've discussed, aesthetic experiences are also happening to you all the time. The light in the room, the sounds around you, the smells—these are aesthetics, as potent as a Picasso or a Rothko. Color, texture, and temperature are more of the raw ingredients that contribute to our aesthetic input. Then there is nature, which, as we've shared, is the ultimate aesthetic experience.

Nature has a strong effect on our parasympathetic nervous system, which is the part of our autonomic nervous system concerned with conserving our physical energy. It is also known as the "rest and di-

gest" system. When we come into contact with plants and vegetation, with water and other natural elements, it immediately reduces adrenaline, blood pressure, and heart rate. There is growing research on the role of the natural environment, in particular woods and forests and spaces near water, for mental health.

A 2019 study published in *Frontiers of Psychology* confirmed that spending just twenty minutes in nature—or in a place where you feel connected to the Earth—significantly lowers the levels of the stress hormone cortisol. Healthcare practitioners are now prescribing "nature pills" based on studies that show that time outdoors has a measurable effect in regulating our physiological system.

Even just shifting your visual perspective in nature changes your physiology. As Andrew Huberman, a neuroscientist at Stanford, explains, the act of looking at a horizon or a broad vista releases a mechanism in the brain stem that can reduce anxiety and the stress response by changing how you view, and perceive, your environment.

One of the most prevalent elements in design is nature-inspired spaces. The adage among many architects and interior designers is "bring the outdoors in." From simple elements like houseplants or botanical designs on wallpaper to the structural choices that frame views of nature via windows, we've long attempted to infuse natural elements into our interiors. The late biologist Edward O. Wilson, before he died in 2021, spoke to us about our innate and evolutionary need to seek connections with nature and other forms of life, compelling us to both go out into nature, and to bring it inside. The famed architect Frank Lloyd Wright once said, "I go to nature every day for inspiration in the day's work. I follow in building the principles which nature has used in its domain." You cannot help but be soothed and awed standing in his masterpiece of nature-meets-home called Fallingwater.

Today, a new kind of design is rising: spaces that specifically aim to address societal ills and nurture us using neuroaesthetics research. In Denver, several public housing projects have been designed as trauma-informed spaces. The Arroyo Village is one of those: a homeless shelter that also includes low-income and affordable housing for individuals

and families. When the firm Shopworks Architecture designed the interiors, they considered the future residents' mental needs and made interior and landscape choices to enable them to feel safe and comforted. Lots of natural light, larger corridors that offer ample space to move between units, and soundproofing in the apartments have taken into account the sensory needs of those who have experienced homelessness, abuse, and racial trauma.

Around the world, meanwhile—in stores, museums, libraries, and private homes—architects are creating sheltering spaces using curves. The National Museum of Qatar has a vaulted, amorphous interior shape fabricated from 40,000 slabs of wood that seem to form a cocoon; MAD Architects in Beijing, China, designed a library out of snowy-colored concrete and skylights, and it feels like you're ensconced inside a whitewashed beach shell. Many neuroaesthetic studies on curves over the years have shown how our universal affinity for these rounded shapes is more than just cultural or personal preference, it's biologically driven by our sensorimotor system.

Ed Connor is a neuroscientist and the director of the Zanvyl Krieger Mind/Brain Institute at Johns Hopkins. His research on visual object processing in the brain has shown how individual neurons create a representation of the 3D-shape fragments we see, and most of these neurons associated with fragment perception respond to broad surface curvatures as opposed to sharp ridges and points. Ed theorizes that the brain evolved to process important objects in our environment, especially plants and animals, whose shapes are usually characterized by smooth curves. This emphasis on curves is increasingly being expressed in art and design.

You can also see this play out in new outdoor spaces meant to counterbalance the anxiety and uncertainty that so many of our public spaces have, unfortunately, devolved into. There are landscape architects at the forefront in bringing neuroarts principles into their field, leading a rising trend in building nature-inspired experiences in public places to support mental well-being—from an explosion in tree groves to the revival of sculptures, park benches, and nature trails in everyday and unexpected places. Little Island, which was designed by London-

based Heatherwick Studio and opened in 2021 on the site of an old pier in New York City, is a stunning example. See image C in the color insert. The new park seems to rise out of the Hudson River with 132 tulip-shaped concrete structures forming the space. Each "tulip" takes a different shape and has been engineered to hold the soil, lawn, overlooks of the river, and the more than 66,000 bulbs and 114 trees that have been planted. An amphitheater is nestled into more than 350 species of flowers, trees, and shrubs.

Too many of us, though, especially children, are being cut off from much-needed time in nature, as Richard Louv so powerfully pointed out in his 2005 book *Last Child in the Woods*. "The shift in our relationship to the natural world is startling," Richard wrote. "For a new generation, nature is more abstraction than reality."

Children are rarely allowed out into nature during school hours. And as the world urbanizes, access to outdoor spaces with the vibrancy of a natural setting is diminishing. Richard has deemed this "nature-deficit disorder," which he defines as a growing alienation from nature. "Yet, at the very moment that the bond is breaking between the young and the natural world, a growing body of research links our mental, physical, and spiritual health directly to our association with nature—in positive ways," he wrote.

When we caught up with Richard about his latest work and research, the three of us aligned over how the arts have been treated the same way that nature has when it comes to education. "Around the time they were kicking arts out of the schools, they were also canceling recess and designing schools without windows," Richard said. "Why aren't we moving kids outside more, to gain all the benefits, the neurological benefits, of learning in nature?"

Fortunately, a positive movement is happening all over the world: a surge in new public parks and spaces, where nature meets art. In Japan, immersion in nature for mental well-being is called shinrin-yoku, or forest bathing. Early studies, beginning in 2015, show that delving into nature helps mitigate anxiety and raise positive outlooks. "When one ponders humans existing less than 0.01% of the species' history in modern surroundings and the other 99.99% of the time living in na-

ture, it is no wonder some humans yearn and are drawn back to where human physiological/psychological functions began and were naturally supported," one research team concluded.

South Korea is "hitting mung." Mung is a Korean word for being zoned out, and citizens actively worked to space out during the pandemic using nature experiences designed to relax and escape. People paid to ride through and above the clouds in a film called *Flight* in movie theaters. They also entered the Space Out Competition, where participants attempt to reach the lowest heart rate in a healing forest.

There are times when simply escaping to the outdoors isn't possible. But with the right thinking, it is possible to bring the outdoors inside in a very real way. Someone who excels in creating nature-infused spaces is the architect Tye Farrow. Based in Toronto, Canada, Tye is one of the world's most prominent practitioners of, and advocates for, human-built environments that enrich our lives through neuroarts choices. Tye is also part of a group of architects and researchers who in 2002 formed the Academy of Neuroscience for Architecture with the goal of applying the latest in neuro and cognitive sciences to the betterment of our built environment.

Tye has identified seven architectural elements, what he calls the "super vitamins" of enriched environments, that help us to be healthier and more in sync with our surroundings, and several of these are pulled directly from nature: natural light, natural materials, and structures reminiscent of natural shapes. He uses evidence-based design, which draws upon scientific research, for his projects. And science shows that environments with these nature-inspired elements can reduce blood pressure, heart rate, and muscle tension, among other things. Environments that effectively use natural elements like this are shown to reduce anxiety and increase emotional resilience and a sense of well-being, and it means that we are biologically primed to function better inside of them.

What does it look like to design an architecture of hope in a hospital setting? This is what Maggie Keswick Jencks wondered as she learned,

in 1993, that her breast cancer had returned. Maggie and her husband, Charles Jencks, sat in the windowless hallway of a hospital in Edinburgh, Scotland, taking in the bad news. Maggie, who was a writer, gardener, and designer, realized that there needed to be somewhere better for families like hers to go and process a cancer diagnosis. A place that was private and quiet where you could compose yourself after hearing difficult news; a space filled with natural light, plants, and art to help soothe. Somewhere a family could gather over a cup of tea in a comfortable chair and talk through options if they wanted. A place where architecture and greenery could become a salve. Maggie liked to say: "Above all, what matters is not to lose the joy of living in the fear of dying."

The first Maggie's Centre opened in 1996, and today more than twenty centers exist around the U.K. Heatherwick Studio, which also designed the Little Island park described above, was hired to design the building on the campus of the St. James University Hospital in Leeds. One of their challenges was the setting: a cluster of medical buildings with very little green space. So they brought the garden to the building, creating a structure out of large-scale planters that house tens of thousands of flower bulbs and plants. The planters create private enclaves for individuals and families to find reprieve. Heatherwick Studio also endeavored to bring nature indoors. The building, which is made from prefabricated and sustainably sourced spruce timber, includes soaring interiors with wood ceilings that feel as if you've stepped inside a grove of arching trees. Plants overflow from wicker-covered pots, and windows overlook the gardens.

Lisa Finlay, partner and group leader at Heatherwick Studio, told us how their vision for the Maggie Centre in Leeds "combines our instinct to design for emotion, with a clarity that understands the power of architecture." Lisa and the team felt like the creative brief for the building was incredible. "It asks you to imagine what it might be like to walk into a building after you have just received a cancer diagnosis. What might you need when you come in? How would you take it step by step—how would you feel? This is truly the architecture of hope."

Thomas Heatherwick, founder of Heatherwick Studio, said upon

the building's completion that "Maggie's Leeds has been a very special project for me and my team because we are convinced that there are kinder, more empathic ways to design places that can have powerful impacts on the way that we feel. This is particularly important in the design of healthcare environments, but is so frequently overlooked."

Another major anxiety-inducing setting is a hospital, where hours are long and stress is high, not to mention the stakes. Creating intentional spaces rooted in fundamental nature aesthetics can help relieve stress symptoms. There was a dire need to test this on a massive scale when COVID-19 inundated hospitals in 2020 with hundreds of thousands of severely ill and dying patients. At Mount Sinai in New York, the staff took over labs that were not in use and transformed them into virtual reality recharge rooms for healthcare workers. Studio Elsewhere, a data-driven design and technology firm interested in the brain-body connection, designs rooms using evidence-based research on the connection between natural environments and stress reduction. Healthcare workers entered an immersive multisensory experience designed to change their physiology just by being there. Artificial plants, required to maintain the sterility of the hospital, filled a cocoonlike space, giving it a forested feel. Battery-operated candles filled tabletops and counters. High-definition images of different natural scenes, like campfires and waterfalls, were projected on the wall.

Compositions were created to enhance the auditory experience with specific tempos and timbres known to reduce stress. Aromatherapy replicated the scent of a forest floor, the smell of the ocean, and other natural smells. The designers did not ask the healthcare workers to wear biofeedback devices during their quick trip into the room, but in an exit survey, people said that they felt a huge sense of relief and gratitude after only fifteen minutes in the room, similar to the data from the study cited above, suggesting that their dip into a nature-inspired experience reduced stress hormones and heart rate. They also later reported feeling more renewed and reflective throughout their day. Nature is so potent, in fact, that even just the suggestion of it through a simulated experience changes our physiology.

Words Matter

In 1929, the poet T. S. Eliot was analyzing poems like Dante's *Divine Comedy* to understand why they had such sway over a reader, even if the reader, like himself, wasn't proficient in the given language (in this case, Italian). Eliot was trying to understand what he called "poetic emotion," and he concluded that "genuine poetry can communicate before it is understood."

Eliot was onto something. Poetry is the oldest form of written literature, dating back at least 4,300 years, but likely even farther than our surviving written accounts reflect. Before that, poetry was an oral tradition that emerged in diverse cultures around the world and was passed down for generations. It has been used as medicine, dating back to the Greeks, who "prescribed" poetry in conjunction with other medical interventions. Poetry is frequently featured at our most pivotal ceremonial moments, from personal celebrations like a wedding to political and civic ones, such as the inauguration of a new president in the United States. Poetry has, as an art form, been with us from the beginning of humanity. Today, there are even more ways we use language, through vibrant performance art forms including slam poetry and spoken word.

Recent studies are beginning to shed some new light on the biological and psychological effects of this ancient art. Starting around 2015, groups of researchers across the globe began using fMRI machines and other noninvasive measurement instruments to discern the effects poetic language has on our brains.

Arthur M. Jacobs, an experimental psychologist and professor of experimental and neurocognitive psychology in Germany, examined a number of methods and models that were being used at the time for investigating the neural bases of poetry. The new research was suggesting that poetry, more than any other literary form, demonstrates "the complexities with which our brain constructs the world in and around us, because it unifies thought and language, music and imagery in a clear, manageable way, most often with play, pleasure, and emotion."

In 2017, a group of psychologists, biologists, and linguistic experts from the Max Planck Institute in Germany aimed to understand this by studying the physiological effects of poetry. First, they measured skin variability to look for peak emotional responses, like chills or goosebumps, which are physical phenomena indicating states of high emotional and physiological arousal. They gave participants new poems that they had never read and allowed them to self-select a few, and the results were unequivocal. All participants experienced chills, while 40 percent showed goosebumps on video monitoring that took place during the study.

Next, they put participants into an fMRI machine to understand what was happening in the brain as these peak emotional experiences were taking place. This time, the team selected all of the poems in order to test the effects of reading the poetry for the first time. The subcortical areas of the basic reward system lit up. Reading poetry, in fact, lights up some of the same parts of the brain as listening to music. It provides a familiar rhythm that taps into something more ancient in us. So even though poetry is words, it reaches beyond language. By providing quantitative data from psychophysiology, neuroimaging, and behavior, "our studies converge in showing that poetry is a powerful emotional stimulus capable of engaging brain areas of primary reward," they wrote.

Our brains are hardwired for the rhythms and rhymes of poetry, lighting up the right side of the brain, while a poem that truly resonates with us does so at a neurological level by stimulating the areas of the brain that are associated with meaning-making and the interpretation of reality. Poetry, at a cognitive level, can help us make sense of the world and consider our place in it.

Poetry also offers a safe way to engage with difficult emotions. Why is it, for instance, that we are able to read W. H. Auden when he writes "stop all the clocks" in his sorrowful elegy to a beloved friend, and why might we even turn to it when we are in mourning ourselves? We are able to sit with sorrowful emotions in this way because poems are "particularly effective in inducing intense involvement, sustaining focused attention and granting high memorability," the Max Planck re-

searchers wrote in their study, and "importantly, all these effects occur against a background of the personal safety of the perceiver. That is, the perceiver is always aware of the distinction between his or her own reality and the fictional reality as well as of the possibility to withdraw from the aesthetic stimulus at any time."

We can close the book, or turn off the recording of the poet, or walk away from a poetry reading. We can use it when and how we need it. Rhyme and rhythm have been shown to intensify emotions at a neuro-chemical level as poetry activates brain areas such as the posterior cin-gulate cortex and medial temporal lobes, which have been linked to the default mode network and introspection. Reading poetry can also help us to relax and gain perspective on ourselves. In an Exeter study on poetry, the researchers saw on imaging studies from an fMRI that reading poems ignited the region in the brain associated with being in a restful state. Our brains process poetry differently from prose. When we read through the verses, it can create a state that neuroscientists refer to as "pre-chill," where we ride a gentle crescendo of calm emo-tion. Which is to say, reading a few poems when restless or unable to sleep can help relax you and give you more perspective and insight.

Writing, or reading, poetry also helps the brain to create new narra-tives and to stop replaying the same worrying thought patterns over and again, activating neuroplasticity processes in the brain. Poetry and other forms of narrative have been shown to make us more self-reflective. In his book *The Spider's Thread,* cognitive psychologist Keith Holyoak examines how it is that poetry taps into two psycho-logical mechanisms—analogy and conceptual combination—to create metaphors.

In 2015, Pulitzer Prize–winning poet Mary Oliver sat down with Krista Tippett, host of the popular podcast *On Being.* Oliver, who died in 2019, rarely gave interviews, but here she talked about her difficult childhood in Ohio and how she escaped to nature as often as she could, with a small notebook and a pencil. "I got saved by po-etry," Oliver said. "And I got saved by the beauty of the world." Poetry, she once said, gets at that "wild, silky part of ourselves" that can be hard to otherwise access. Oliver was a master of using sym-

bols of the natural world and metaphors to capture the luminous wonders of life. Oliver went on to read from her well-known poem "Wild Geese."

Tippett often invites poets as guests onto her show precisely because the right words make a profound difference in our relationship to the world. "When we're dealing with emotional upheaval, things that have to be moved through us in order for our lives to move forward, we see the importance of poetry in taking us towards healing," Krista told us. "It is about sensory experience and how we calm ourselves and tether ourselves. How do we stay resilient? How do we ground ourselves again and again? Poetry plants us in our bodies. It plants us as much in what has been experienced as in our thoughts. That's how we become whole."

Everyday Arts Prescriptions

In Boston, pediatrician Michael Yogman writes a new kind of prescription for his young patients: the arts and play. Yogman, who is also assistant clinical professor of pediatrics at Harvard Medical School, prescribes his patients a daily playful activity to be done with a caregiver or friends, such as dancing, drawing, or playing pretend. He tailors his "prescriptions" to match the needs and preferences of each child, emphasizing the idea of joyful engagement. Michael says, "Children need different things. They have specific likes and dislikes depending on their developmental stage and their emotional engagement. We work to find the best fit that maximizes joyful discovery." Michael's goal is to head off stress, loneliness, and anxiety by helping his patients understand and process their emotions and build skills for the future. He also works to enhance safe, stable relationships with parents and peers, which promotes resilience. The activities he prescribes help them to regulate emotions, and soon his kids are able to incorporate these practices into their lives. Over time, they gain knowledge and confidence and learn to buffer stress.

This is what's known as social prescribing, and it's happening in the U.K., Canada, and the United States. Physicians, psychologists, social workers, and others are prescribing singing classes for stress, museum visits and concert tickets for anxiety, and nature walks for burnout—offering prevention and intervention. Social prescribing engages the arts as an immersive form of precision medicine, aligning cultural activities with individual needs. And these activities don't have to be time-consuming or expensive to integrate into your daily life.

What if, instead of scrolling on your phone with your morning coffee, you spent twenty minutes drawing in a doodle diary, or creating your own mandala? You could black out words in the newspaper and create a found poem, or pick up your kid's (or your!) LEGO bricks for free-form design, or Play-Doh to create something new. Take old clothes and make a memory blanket. Throughout the day you can pause and add a little bit of art and aesthetics into your life and see how it changes your mood. The list is endless and the results are immediate.

New technologies are making it even easier to access a range of arts and aesthetics experiences for mental health uses. John Legend and other world-renowned musicians have partnered with the mindfulness app Headspace to bring music to mindfulness practices. The website Wavepaths combines personalized music with and without psychedelic therapy using state-of-the-field science. And through NEA Research Labs, neuropsychologist Robert Bilder at the University of California, Los Angeles, has developed a groundbreaking, simple-to-use well-being assessment app using psychometrics to measure in real time the benefits of the arts. Currently in the pilot stage, the Arts Impact Measurement Systems, or AIMS, can be used by researchers around the world to collect standardized data on the benefits of the arts. Large data sets will emerge that can be analyzed to better understand and target mental health and well-being approaches.

There is infinite energy and vibration in the universe, there are also unending ways the arts aid in cultivating well-being. They help us navigate the uncertainty and unpredictability of life and ride the wave of

complex emotions and feelings. As neuroaesthetic researchers continue to learn more about the mechanisms for why that is, the future promises to bring us even more compelling insights. Grab a pencil, a pen, a paintbrush, a tuning fork, a harmonica, a drum, a ball of yarn, or a bag of potting soil and some plants and bring the benefits of art and aesthetics into your day.

Restoring
Mental Health

Learn to get in touch with the silence within yourself and
know that everything in this life has a purpose.

—**ELISABETH KÜBLER-ROSS, PSYCHIATRIST**

Aaron Miller still remembers the day he got an emergency call at the fire station in Fairfax County, Virginia, where he'd worked for more than a decade. A townhouse was in flames. He and his crew jumped into action, racing across town with sirens blaring. Aaron is the kind of person you hope arrives when you're in trouble. He's good at his job, but he's also compassionate and kind, offering a stable presence when you are at one of your very worst moments.

As the truck pulled in front of the blazing building, Aaron had an eerie feeling that he'd been there before. Something about the scene resembled an emergency call that he'd taken very early in his career. That previous fire had been massive. The homeowner was on oxygen,

which fueled the flames into a raging inferno, making it extremely difficult to extinguish. The man, who was wheelchair-bound, had been trapped on the second floor. He'd died long before rescue crews arrived. "I saw things that I took in," he tells us. "It wasn't obvious to me at that moment that I was holding on to what I saw."

Years later, he was reliving that first incident. His pulse went berserk, his breathing was rapid and shallow, his hands turned cold and clammy, and he lost control of his fine motor skills. His mind was playing tricks on him. "I believed there was a man trapped on the second floor of the townhouse," he says. "It was completely irrational to what I knew to be true, but I was projecting that old image onto this new scene." His brain had taken him back in time as his body viscerally experienced that initial tragic fire. He was confused and petrified.

Not long after, Aaron met Kathy Sullivan, a registered expressive arts consultant and educator with a no-bullshit personality and a heart as big as they come. She's a doggedly persuasive woman who can convince hundreds of firefighters to make time for art classes, and she's who you want in your corner when you're not feeling your best.

In 2017, Kathy co-founded with Captain Buck Best a nonprofit called Ashes2Art, one of the first and only creative-arts wellness programs in the country designed for first responders and their families. She provides a range of artful experiences, bringing in everything from doodling and mandala-making to sculpture, forging, and fused-glass work. Ashes2Art is not intended to be trauma therapy; rather, it fosters an open and experiential creative arts space that emphasizes self-discovery and well-being. When one woman EMT fell in love with doodling, Kathy gave her a set of markers and suggested that she use them during her downtime at work.

This first responder now sends Kathy photos of her art-making, which she does to process difficult calls. It helps her to relax and focus. Using functional near-infrared spectroscopy (fNIRS), researchers found that doodling, coloring, and free drawing all activate the prefrontal cortex, the area of the brain that helps us focus and to find meaning in sensory information. Their findings also showed that the simple act of doodling increases blood flow and triggers feelings of

pleasure and reward. It turns out doodlers are more analytical, retain information better, and are better focused than their non-doodling colleagues.

Aaron instantly loved Kathy's classes. In college he'd studied graphic design, but he stopped making art when he became a firefighter, thinking that it wasn't important now that he was not going to make a career of it. "My brain is so switched on, and I am constantly engaged in thinking about firefighting and firefighting things," he told us one morning from his home in Virginia, his Australian shepherd, Dexter, dozing on the floor next to him. Behind him was a gallery wall of some of the art that Aaron now makes of highly detailed vintage trucks. Aaron finds that the process of drawing these vehicles requires enough focus and concentration to take him away from the stress of his work life.

He opened up about how hard it is to "fail" in his job. He often thinks of his role as either saving a life or losing a life, fixing a problem or failing to do so. It's black and white, with no middle ground. "I am a person who deals in the currency of winning," Aaron says.

Making art with Kathy, he says, dramatically changes his perspective. "When I am doing art, I'm in what I call a droning state. A different part of my mind is working. That switched-on part of me is turned off. And while I'm off, I can have better conversations about my emotions, or anything, really. I'm just an easier person to talk to." He says that he is a better father to his two young children, and a better husband, simply because of the practice of drawing. At a neurochemical level, the act of drawing has been shown to release serotonin and endorphins that foster a more generous, open frame of mind. Specific studies into the neural effects of visual art production and mood have shown that drawing, by changing brain-wave activity and increasing blood flow to the frontal regions of the brain, has a positive effect on our psychological resilience.

Aaron is now able to access and express experiences that he had locked away. Simply drawing unlocked them. He doesn't use terms like "toxic stress" or "trauma" to describe what he encounters at work, but he knows that making art is helping him to be a whole and happy man. To feel well.

The Trouble with Trauma

Trauma, post-traumatic stress disorder (PTSD), toxic stress—these are terms that are often used interchangeably, but they are not the same thing. The main difference between PTSD and the experience of trauma is important. A traumatic event is time-based. Let's say you are involved in a car accident, where you go through the normal physiological cycle of fight-flight-freeze. Over time, your body regulates itself back to homeostasis and you move on with your life.

With PTSD, however, you develop a longer-term condition where you continue to have flashbacks and re-experience the traumatic event as if it were still happening. Every time you get in a car, you hear the sound of screeching wheels and, like Aaron at that townhouse fire, you physically relive the crash. Toxic stress and chronic trauma can sometimes look and feel very similar, yet they are physiologically different. Toxic stress is caused by an overactive or hyperstimulated response of the autonomic nervous system; trauma is related to the memory of the event that is stored in your brain and that causes you to relive it. When you are constantly subjected to situations that engage your stress response and don't allow your body to recover, toxic stress occurs. Chronic neglect, economic hardship, unemployment, and food insecurity are examples of situations that create toxic stress.

Resmaa Menakem is a somatic therapist who has spent much of his adult life exploring what trauma is and isn't and how it plays out in our bodies. Somatic therapy is a body-centered psychology that uses physical techniques to help move emotions and experiences that have become stuck inside us. Instead of just talk therapy and cognitive therapy, the somatic approach recognizes that the body holds on to trauma and can be instrumental in helping us to recover. "Bad things happen to us but they don't necessarily create trauma. When trauma occurs, something shuts down," Resmaa shared with us.

He went on to say, "Trauma is embodied and has two components. The first is being stuck, and the second is having a sense of urgency at the same time. Trauma is anything that happens that is too much, too fast, too soon, or too long that occurred without repair."

Trauma isn't a difficult event; rather, it's the imprint of an event on our brain and body. It's what happens when we have a strong emotional response that we can't regulate. And this can come in many forms. We tend to think trauma happens only after harrowing experiences like war or abuse, but trauma affects every single one of us in ways small and large. There are moments that may seem benign—say, an argument with a friend—but the body may hold on. "Contrary to what many people believe, trauma is not primarily an emotional response," Resmaa explains. It is, he adds, "a spontaneous protective mechanism used by the body to stop or thwart further or future potential damage. Trauma is not a flaw or a weakness. It is a highly effective tool of safety and survival." Trauma gets stuck in the body, he adds, and it stays stuck until we deal with it.

It was only in the 1980s that researchers began to study the pervasive and overlapping symptoms of veterans returning from war. This work focused on why some people develop PTSD and others don't. Brain scans of soldiers reliving a traumatic experience show that they are physiologically reacting exactly as if the original event were still occurring. This type of post-trauma locks you into a specific past moment, hijacks your present, and keeps you stuck in the past. The actual event may have had a beginning, middle, and end, but your memories of it and your physical responses to it, don't. There is no conclusion.

"The trauma that started 'out there' is now played out on the battlefield of their own bodies," psychiatrist Bessel van der Kolk explains in his seminal book *The Body Keeps the Score,* "usually without a conscious connection between what happened back then and what is going on right now inside." We can no longer move through our natural stress response in order to get back into homeostasis or physical balance.

Self-regulation of your physiology in these moments is difficult. Imagine a building in the high heat of a summer day suddenly having all of its windows and doors thrown open. The air-conditioning system would go into overdrive, futilely trying to regulate the internal temperature against the onslaught of hot, humid air.

Your body is like this when in trauma.

Within your limbic system, which we described in Chapter 1, you have an internal alarm, not unlike the one in Aaron's firehouse. Intense

sensory inputs and emotions activate this system—in particular the amygdala, which instantly hops into action when you perceive something as a threat. Maybe you've crossed a street and a car suddenly barreled down on you. Your amygdala sounded the alarm and triggered your stress-hormone system and your autonomic nervous system to kick into high gear. You were flooded with cortisol and adrenaline; your heart rate and breathing rates increased. You had a full body stress response that resulted in fight, flight, or freeze. You might have jumped out of the way of that speeding car, which is flight. Or stood immobilized, a deer in the headlights, which is the freeze response.

"There is a tremendous amount of energy created and contained in traumatic experiences," Resmaa shares. "This energy needs to be metabolized because it is the fuel needed to free us up. To survive."

Aaron and his fellow first responders rely on their normal stress response to move them into action in an emergency. "I need my adrenaline to pump and I want my attention to focus and my energy to rise when I'm responding to a call," he says. But if that stimulus becomes too much, if it tips over an emotional edge, that's when it becomes a traumatic event. "We've seen people absolutely lose their minds in training scenarios where there's no real fire, there's no real danger, but the recall perception is there and it drives people to not be able to function," Aaron says. "That potential recall is always right there on the precipice of kicking in." In trauma, our survival mechanisms wind up working against our well-being.

Resmaa has coined the acronym HIPP to explain trauma. "It can be *historical, intergenerational, persistent and institutional,* and *personal,*" he says. Trauma can occur anywhere, anytime, and in a number of ways. There are many different types of trauma. Collective trauma is when you experience something as a group. Intergenerational trauma may be ongoing in a family, or it may be inherited through epigenetics. Acute trauma happens when there is a single occurrence. Chronic trauma is defined as repeated and prolonged.

Regardless of the type of trauma or where and how it began, Resmaa says that "the arts are a huge piece in healing. Trauma stops our primary emotions and needs for joy, awe, and wonder. It cuts us off from one another. The arts engage these human resources to help us begin to

heal." Just like Kathy, Resmaa incorporates the arts and aesthetic techniques in his somatic therapy work, which we'll learn more about later in this chapter, because the arts "slow us down enough so things can be played with and inquired into," he says. "The arts can be a softened way of leaning into the hardened boundaries of trauma; they unarm you and are a way that gets underneath the defensive mechanisms."

One reason the arts are such effective medicine for chronic and traumatic stress is that they help you self-regulate your physiology by inducing a meditative-like state. For a lot of us, we envision meditation as a quiet practice, often done by sitting on a mat to achieve a calm and relaxed disposition. But Sharon Salzberg, an author and teacher of Buddhist meditation practices, says that actively making art and beholding it are some of the most meditative practices.

Sharon co-founded the Insight Meditation Society in Barre, Massachusetts, with Jack Kornfield and Joseph Goldstein in the 1970s and has spent decades teaching people around the world how to connect with their mind, body, and spirit. "We say mindfulness is that place where you're really connected but there's some spaciousness in your awareness of what's happening, and it's in that space where many possibilities arise," Sharon told us.

Being in the aesthetic mindset, as we described in the introduction to this book, is about being present in your life. You're feeling and sensing all of the things that make you feel alive, grounded, and connected. When you tap into the arts to foster a meditative state, the places in your brain responsible for judgment and personal criticism are quieted in your prefrontal cortex, and you can assess a more generous, perspective-taking point of view.

Opening the Box

You might not think that an artist like Judy Tuwaletstiwa has much in common with a firefighter like Aaron, but she does. In her early eighties, Judy's short gray-white hair gently frames her dark eyes as she greets you from behind thin, metal-rimmed glasses. Her sympathetic

and focused attention makes you want to sit across from her, a cup of tea in hand, and talk for hours, as we have many times in her light-filled studio in New Mexico. Surrounded by paint, canvases, clay, and other art materials, you instantly feel comfortable and energized.

Though Judy doesn't spend her days running into burning buildings, traumatic experiences have marked her life. She was born into chaos: Her parents were, she told us, "fanatical Communists" who lived in constant crisis, a chaos created by dogma, anger, and unacknowledged fear. The intergenerational trauma carried by Judy's immigrant Jewish grandparents expressed itself in her father's violent temper and serious mental disorders. Words became knives that created stinging superficial cuts or deep wounds to the heart. She never knew when the "knives" would fly. Boundaries did not exist. Researchers are beginning to understand the tragic reality of intergenerational trauma, the link between highly traumatized people and their children, who have an increased risk for PTSD.

Judy survived by doing what many of us do: She boxed away the difficult experiences and emotions, keeping on with her life. Finding safety at school and in her economically poor but multiculturally rich community, she became an outstanding student and leader. She eventually studied English literature at Berkeley and Harvard, where she received her MA in teaching. Later, she taught herself art.

But by 1984, her life was disintegrating. Emotionally drained, she felt broken. She'd weathered a long, difficult marriage while raising four children, doing art, and teaching. Her husband struggled with bipolar disorder, as had her father. The energy of keeping her childhood trauma locked away depleted her. With her kids largely grown and her mental health failing, a dear friend offered her heartfelt advice: "You've always wanted to spend time alone in the desert. You need to go there. Now."

Judy borrowed a tent. Planning on a month of camping in the canyons of the American Southwest, she packed minimal supplies into her VW Rabbit. "I'd lost myself in the chaos. I needed to find out who I was again," she told us. "I didn't know that I was beginning a journey to confront the traumas from my childhood."

"Chaos" is a word that many trauma survivors use to describe their past. And no wonder. The brain, undergoing trauma, struggles to create cohesive narratives. Tucked in the limbic system, the thalamus is like the air-traffic control of your sensory inputs, integrating what you see and hear and touch into your autobiographical memory. But it breaks down under extreme stress.

You're often left with sensory snapshots as sensations, sounds, and images. These reside in your unconscious, connected to very strong emotions but without a clear narrative.

For Judy, the sensory snapshots included feelings of helplessness, anger, and terror, her parents' emotional struggles played out again in her turbulent marriage. Accessing the healing unconscious images connected to these feelings overwhelmed her, so she kept them locked in her own Pandora's box: they lay there, always under the surface, ready to emerge and, at times, explode.

In the middle of her desert journey, as Judy hiked in New Mexico's Chaco Canyon, the "light simply washed over my soul," she says. She experienced the land as "a reservoir of the unconscious" where time and space expanded into dream, myth, and possibility. Walking through Ancestral Puebloan sites, Judy learned about Kiva murals. Kivas are large, circular underground ceremonial rooms. In some kivas, the Ancestral Puebloans painted rich and evocative murals on the walls. When ceremonial cycles were completed, they would whitewash a wall and then paint another ritual-based mural. "One hundred paintings lay under one wall's textured surface. I imagined participants surrounded by the wisdom of invisible but present images formed by ancestral hands," Judy recalls. Something inside her began to surface.

Home from her trip, Phillip, a member of the Hopi Tribe who Judy met at Chaco Canyon, called her. Knowing she had spent years teaching the creative process to children and adults, he said he wanted to learn to paint. She responded, "You should do what your ancestors did."

Judy suggested he buy a small canvas; red, blue, yellow, black, and white tubes of acrylic paints that he could mix; and a couple of brushes that felt right in his hand. She said, "Make a painting. When it feels

complete, photograph it. Then whitewash the canvas. Do another. By photographing and letting go of each painting, you can let go of self-criticism. When you develop the film, study the photos to learn what to explore next.

"When I got off the phone, I thought, 'Wow, that is one great idea.'" Using a six-by-four-foot canvas, Judy started a series she calls the Continuing Paintings. But instead of whitewashing between layers, she lets one painting flow into the next. She began the *White Continuing Painting* in 1985, knowing the paintings would exist only as photographs and the final painting would be a coat of white paint. "Exquisite images emerged then dissolved into disturbing ones, only to reemerge in other forms," Judy says. "Some days, dark images and difficult feelings emerged. I felt like I was swimming in the deepest part of the ocean."

A year later, she painted the *Black Continuing Painting*. Two years later, in 1987, as she painted what became the *Red Continuing Painting* she felt as if she had fallen into a dark, ashy place. "The Holocaust entered and, with it, rage—a rage I embodied since my childhood. The painting was leading me into the nightmare of what humans can do to each other," she says. Other feelings and images emerged in cathartic twists and turns over the intense two weeks she painted almost a hundred layers that live in the photographs and under the final coat of red paint.

Compelled, over hours and days, she entered a flow state where images arose spontaneously, one evolving into the next, "like life really is," she says. "I painted as though a dream were happening on the canvas." She grew to trust the process of letting one image disappear as another formed. "The images I loved, those that bestowed healing and light, I sat with, usually for three days, until I absorbed their beauty and honesty. Then I could let them go to continue the process. If a painting felt ugly or chaotic, spoke of wound and shadow, I would make myself sit with it, studying these reflections of my own hurt and confusion until I grew to perceive their unique beauty, their dark intelligence. It took three days also. Then I would continue."

What Judy found in this process of creating and letting go was a pathway into the unconscious. "I follow the brush as it illuminates,

teaching my eyes to listen. The story has always been here. The language forms. The meaning will come," Judy wrote.

She worked six months on the first painting, two months on the second and two weeks on the last. Between eighty to ninety photographs comprise each series. You can see a black-and-white piece from one of these Continuing Paintings at the beginning of this chapter and image F in the color insert.

"When you make art and you don't know what's going to happen, you're involved in the mystery that life really is. I'm thankful I was not classically trained as an artist because all my work has erupted from the unconscious. I've had to find ways to express that stirring, boiling within, to try to map the ever-moving ocean. That's where I think art is most healing. Our hands can lead us to healing. They have a special intelligence that helps us go inside ourselves—where only we can journey."

Later, Judy integrated talk therapy into her journey to wholeness. When Judy shared the photographs of the Continuing Paintings with her therapist, she responded, "What you depicted is the healing process, the spiraling therapeutic process, where you return again and again to something to see it with new eyes. Healing doesn't happen in a straight line. It unfolds." Judy intuitively had created a container that held the charge of her past traumatic experiences and her need to process and let go. Judy was able to paint meaning for herself.

Judy and Aaron are not alone. Trauma affects everyone, as we noted. We tend to think that it happens to people working in highly stressful jobs. Or it's something that happens to soldiers and people living in war zones, or to those who have been physically, sexually, or mentally abused. But we can all hold on to things. A bad conversation from decades ago, the way we fought with our siblings, the disconnection of being left out of social situations, the fear of starting a new school. Illness, divorce, the death of a pet, the loss of a job—things that happen to all of us and are part of a human life but that may leave a biological imprint.

After hearing Judy's story, Susan recalled a difficult emotional time that she had locked away, the evidence of which was still sitting in a

box in her basement. Over twenty years ago, Susan made the decision to end her first marriage. At the time, her two sons were young and it was heartbreaking for everyone. Her boys were devastated at the loss of the family life they had always known, and she wanted to be strong for them. As they grieved, she reassured them that everything would be OK. But inside she felt the trauma of her own marriage, the divorce, and the fear of the uncertainty it brought all of them.

One day, she found a block of terra-cotta clay left over from one of the boys' school projects and spontaneously began to sculpt. What emerged was the statue of a woman on her knees, her arms raised with hands reaching for the sky and her head leaning back, sobbing in utter speechless despair. As her fingers had molded the soft, cool clay from the earth into a likeness of herself, tears streamed down her face. Susan never trained as a sculptor, but she had the feeling that her hands miraculously knew what they were doing and it amazed her.

What she didn't appreciate at the time was how rhythmic, repetitive movements with the hands have been shown to release serotonin, dopamine, and oxytocin in the brain, making her feel a little bit better. Sculpting with clay has also been found to alter our brain-wave activity in such a way as to induce a calmer and more reflective state.

Remembering this sculpture, Susan searched for the box where it was stored. As she unwrapped the clay figure, carefully held in the linen she had placed around it to protect it, Susan was instantly taken back in time to the moment she made it. It was as if a golem had come alive. The sculpture still radiated the hurt and loss from that time, but also the unfolding of her life. What a gift to be able to create an object that releases so much pain. Clay is one of the few mediums that enables both hands to work with equal dexterity, tapping into the wholeness of the conscious and unconscious mind.

Psychiatrist James Gordon has also used drawing as a tool when working with individuals and groups all over the world living with trauma. He has been called into some of the most horrific situations like the Bosnian War, post-earthquake Haiti, and most recently the war in Ukraine. Jim reminds us that there are two common and dangerous misconceptions about psychological trauma: The first is that it

happens only to *some* people. The second is that trauma is impossible to recover from.

"In fact," Jim told us, "trauma comes to all of us sooner or later. Trauma is a part of life. We have to understand that and not be ashamed. And when it comes—*when* and not *if*—we can learn from it, heal from it, and move through it."

Jim was a research psychiatrist at the National Institute of Mental Health for many years and was a former presidential advisor, and in 1991 he founded a nonprofit in Washington, D.C., called the Center for Mind-Body Medicine (CMBM), which includes art-based healing as part of its comprehensive program to successfully address individual and population-wide psychological trauma and chronic stress.

Jim has found drawing to be one of the simplest, most reliable ways to access traumatic images and to move through and beyond fear to process what has happened. One reason for this may well be the ways in which the act of drawing ignites activity in the brain. Several studies have looked at brain waves before, during, and after people draw, and it's notable that as we draw, there is activity in multiple parts of the brain. There is also an increased level of brain activity in the left hemisphere. This region is associated with verbal processing, and so this reinforces the idea that when language around trauma is hard to find, drawing helps to stimulate the verbal processing regions of the brain, supporting cognitive processing and, eventually, helping us to find the words. Drawing activates multiple regions in the brain that force our brain to process information in new ways while inspiring us to imagine and create new images in the brain.

Jim has used a three-drawing technique for years that has been extremely helpful. He starts by reminding you that these drawings are just for you. Even if you feel self-conscious about your art skills, we can all draw something, and stick figures work just fine. He instructs you to begin by gathering three blank pieces of paper and some crayons or Magic Markers, or whatever is handy. You should do the drawings quickly, without overthinking them. They'll be more authentic and surprising if you just go for it, the way Judy allowed images to emerge onto her canvas without judgment. "These drawings are call-

ing your shy imagination, your intuition, off the bench, to play a creative guiding role in your life," Jim explains.

The first drawing is of yourself. The second is "you with your biggest problem." The third is "you with your problem solved." Now, you may find that last one impossible to imagine before you draw. But don't worry, this is not a logical list of possibilities. You're not asking your rational, cognitive brain to be in charge. Quite the opposite. You're marshaling other parts of your brain to be of service. It's a reminder that the arts are passively active. No need to think; just do it.

Drawing "is tapping into a very old part of ourselves and moving us into the emotional and intuitive parts of the brain," Jim told us. "I think that there's an authority to the imagination that at least complements anything we can do rationally, and in my experience, art like this goes beyond words in helping us to understand what's going on with ourselves and to understand what we should do with it. All these drawings are different ways of accessing the imagination and what's possible."

This technique has engendered hope, awareness, and discussion among people from refugee camps and the war-torn Gaza Strip to Jim's clients struggling through divorce and grief. In the spring of 2022, Jim flew to Poland to work with civilians traumatized by war in Ukraine as well as those who had fled to Poland as refugees. Using drawing as early intervention to help release "the fear that has frozen in their bodies," he explains, will help to keep people's PTSD from taking hold. Jim and his team are also training others in this work so that it can be ongoing. According to peer-reviewed studies of this work, the techniques used by CMBM have "reduced the numbers of those qualifying for the diagnosis of PTSD by 80% or more."

Let us repeat that: Programs that incorporate drawings as an early intervention reduced PTSD by more than 80 percent.

For some of us, our difficult experiences do reside in the conscious mind. We constantly remember the painful details, but we don't know how to let them out in a way that feels safe or productive. We keep these stories hidden from others even when we want to share more, because we fear judgment, shame, stigma, or that people won't believe us. It becomes a secret we live with.

Keeping traumatic experiences under wraps like this can trigger mental and physical health problems. In the 1980s, social psychologist James Pennebaker began looking at questions of trauma and health while at the University of Texas at Austin. He'd done a series of studies examining how people express their symptoms—and their perceptions of their symptoms—to healthcare professionals. He sent out a survey to 800 college students, and among the 80 questions he posed, one asked if the students had experienced any sexual trauma prior to the age of seventeen. "The responses to that question changed my career," he says.

About 15 percent of the students answered yes. Those students also reported far higher rates of physical and emotional symptoms and doctor's visits than those who answered no. In follow-up interviews and studies, Pennebaker learned that the issue was not so much around the traumatic experience itself, but rather that these people felt that they had to hide what happened to them. They kept the experience from others, and, to a large extent, buried it within themselves. They were reluctant to discuss it, hesitating to open the box and peer inside at what they were feeling. What is it about secrets and trauma that is so toxic? James wondered.

He developed a working theory: Keeping a secret is a form of active inhibition. "Concealing or holding back strong emotions, thoughts, and behaviors . . . was itself stressful," he explained in a journal article in 2017. "Further, long-term, low-level stress could influence immune function and physical health."

If keeping a secret about trauma contributes to our being unhealthy, Pennebaker thought that having an outlet for safely revealing these stories might help. Talking about our trauma to someone else is complicated, however, because of fear, stigma, or social pressures that inhibit the freedom to reveal our full story.

He designed a study in which he asked groups of undergraduates to write about a traumatic experience over the course of several days, while others in a control group wrote about superficial topics. He instructed those in the expressive writing groups to write about their thoughts and feelings surrounding the most traumatic experience of their life. He encouraged them to really dive in and explore their deep-

est emotions. He assured them that all of their writing was completely confidential, that spelling, sentence structure, and grammar didn't matter. Pennebaker saw that those using expressive writing around trauma had far fewer visits to the campus health center than those who wrote trivial stories.

Numerous studies using this same writing paradigm confirm that when you intentionally tap into personal and emotional stories through writing, it helps reduce both mental and physical ailments. In one study on the effects of expressive writing on the brain, researchers saw that the act of writing about a past traumatic event changed neural activity by activating the mid-cingulate cortex, an area that is critical in processing negative emotion. The act of putting words to our emotions and feelings can help us contextualize, and better understand, difficult events in our lives at a neurobiological level.

Pennebaker has now spent more than thirty years studying how committing our thoughts and feelings to paper can improve mental and physical health. His work has shown how writing can help those who feel alone to give a name to their feelings, connect to their needs, and process traumatic events. Dozens of studies by Pennebaker have also found that expressive writing can reduce blood pressure, lower stress-hormone levels, lessen pain, improve immune function, and alleviate depression while also heightening self-awareness, improving relationships, and increasing our ability to cope with challenges.

Creative nonfiction—an umbrella term for genres like memoir and personal essay—is another form of expressive writing. Through the act of writing, the author sets out to learn about themselves. Often the best essays and memoirs start off by asking a question, and the author writes their way to an answer. The very word "essay" comes from the French verb *essayer*, meaning "to try." Through the act of writing, we can learn to map our own minds and come out the other end more informed about how we feel and think. As the writer Mary Karr wrote in her book *The Art of Memoir*, "A memoirist starts with events, then derives meaning from them."

But for some of us, it's impossible to put secrets or traumatic experiences into words at all because of the ways they have altered our brain. The words, quite literally, cannot be found.

Hidden Wounds

"It's a war within yourself that never goes away."

That's how one combat veteran describes surviving modern warfare. When art therapist Melissa Walker began working at the National Intrepid Center of Excellence (NICoE) Healing Arts Program at the Walter Reed National Military Medical Center in Maryland, she had a sense of the internal war that veterans continue to fight at home. She'd seen it firsthand. Melissa's grandfather was a Marine serving in the Korean War when he suffered a bad injury to his neck. His physical wounds eventually healed, but at home he rarely spoke of his experience.

Melissa remembers hearing him at night shouting obscenities from his room down the hall. "During the day I would announce myself as I entered the room, careful not to startle or agitate him," Melissa recounted in a TED Talk. "He lived out the remainder of his days isolated and tight-lipped, never finding a way to express himself, and I didn't yet have the tools to guide him." These experiences with her grandfather inspired her to pursue the work she does today.

For generations, the silence of the soldier was misunderstood as a stoic reticence to talk about horrifying experiences. But of course we now know it can sometimes be the result of PTSD or a major depressive disorder.

Sometimes soldiers returning from war can't share their stories because there's an actual shutdown in the Broca's area of the brain. This is one of the regions responsible for speech and language in the frontal lobe. It's the same place that can be affected in stroke patients, rendering them speechless. When the Broca's area isn't functioning effectively, you struggle to put your thoughts and feelings into words.

In his lab, Bessel van der Kolk saw on fMRI scans the significant decrease in the Broca's area when a person was actively reliving a trauma through flashback. In this case, the individuals being monitored had survived a major car accident, and they were asked to recall as much as they could of that harrowing event. "Our scans showed that the Broca's area went offline whenever a flashback was triggered.

In other words, we had visual proof that the effects of trauma are not necessarily different from—and can overlap with—the effects of physical lesions like strokes." The brain was reacting as if the trauma were actually occurring. It helps to explain why it can be so difficult for us to put the experience into a narrative. The words quite literally do not exist, earning this physiological state the name of "the speechless horror."

In 2010, NICoE launched a program that had creative arts therapy at its core. Part of a national program called Creative Forces, it was codeveloped by the National Endowment for the Arts, the Department of Defense, the Department of Veterans' Affairs, and state art agencies, with twelve clinical sites across the country. Service members and their families attend art-therapy sessions with Melissa and her colleagues as part of an intensive, holistic four-week program of comprehensive care for TBI (traumatic brain injury) and PTSD.

When Melissa works with these patients, who are mainly active-duty military service members, she often channels these memories into mask-making, which is one of the most effective art-therapy directives. Mask-making is an ancient art form, dating back at least nine thousand years, and has been used around the world in rituals, celebrations, theatre, and performances. Mask-making has also been used as a therapeutic tool, helping us share experiences and feelings through symbol, metaphor, and visual imagery.

In a dedicated studio space, service members are given a blank mask and a range of supplies like paint, clay, collage materials, and markers. They are encouraged to create a mask representing any aspect of their experiences that they want to explore. They are also invited to bring in materials that may help them in creating personal representations. Some have incorporated images of their deceased friends, or even the medals they'd earned in battle. The primary goal in the beginning is to provide a way for service members to externalize their thoughts and feelings in a nonjudgmental environment. The sessions, Melissa tells us, encourage self-expression and self-efficacy. Once they have created a physical representation of their experiences, service members are often able to bring words and greater meaning to their creations. When

shared in group settings with family members or other service members, the stories told through these masks become a bridge to greater empathy, cohesion, and acceptance.

After completing the program, one patient shared, "I'm often asked what it feels like to have PTSD or TBI. In the past, I've been at a loss for how to describe these feelings—until I made my mask." Most significantly, many service members have reported that the act of mask-making diminished the occurrence of flashbacks and other symptoms that had been plaguing them for years.

What has emerged at Creative Forces over the years are thousands of dynamic, symbolic artworks depicting the inner universe of war. One mask shows a face fractured into pieces and stitched back together with barbed wire. Another depicts a bifurcated face, where one half is a smiling woman, the other a ragged and snarling monster. Still another looks like a skeleton. One veteran who came through the studio later told *National Geographic* that he wished, some days, that he'd lost a body part in war, because at least that way people would know that he had suffered. By making the mask, he said that he was finally able to make visible what was happening inside himself.

There has been significant study into what happens in a brain damaged by stroke, lesion, and injury, and this has offered insights into why it is that mask-making is so effective, even when trauma impacts cognition. When the Broca's area of the brain shuts down and language is detrimentally affected, individuals are still capable of making visual art. Some neuroscientists have theorized that this is because the brain's creative visual capacities evolved before language, and are therefore not localized in such a way as to be compromised. The insights gleaned through the act of making art in turn help the brain to begin to process trauma through language. The mental processes that derive from art therapy are believed to be caused by brain activity, and researchers are now working to map where and how this happens.

Over ten years and thousands of masks, Melissa and her team began to see patterns in the work. In 2018, she and other researchers observed 370 active-duty military service members to look for associations between visual imagery and depression, anxiety, and post-traumatic

stress. They also analyzed a large database of masks created in the program and discovered several themes. For instance, the physical and psychological injuries were often shown through graphic representations. There were bruises and scars, and symbols such as demons. Other themes, such as grief for their lost abilities and their lost friends, often appeared, as did their struggles with transitioning back into civilian life and a sense of disillusionment over their role in war. The visual language of art helped these individuals find their voices again and, most important, helped them begin to recover a sense of self.

Collective Racial Trauma

Resmaa Menakem, whom you met earlier in this chapter, remembers coming into his grandmother's kitchen in the 1960s, her hands thick and gnarled from picking rough cotton on a farm, and she would be humming. Not the soft, quiet hum of a person occupied in a task, but the loud, boisterous sound of a person who used to sing across an open field. "Using the body as a musical instrument is art," Resmaa told us. "I don't think my people would have survived 250 years of legal rape—rape done for pleasure, rape done for profit, rape done to sell my ancestors and their children—if it wasn't for the humming and the rocking and the swaying and the vibratory glances across the land. That's an art form." In fact, he sees the body as an emergent instrument of healing.

As a somatic therapist, Resmaa uses bodily sensation to release trauma. The work is not focused solely on cognitive thinking but largely on physical experiences or what is called bottom-up processing. By experiencing sensations in the body, people are able to get out of their heads and process traumatic experiences more effectively.

Historically, people of color have not sought out psychotherapy as frequently as white people, either because they have not had access or because of the potential stigma associated with mental health, but this is changing. Resmaa is among a growing number of trained Black so-

matic therapists. Currently, only about 5 percent of licensed psychological therapists, of any type, in the United States are people of color. In recognition of his work, community elders gave him the name Resmaa, which means "to rise in the alignment of truth" and Menakem, "using the foundation of his people" in the Kemetic language.

"Black and Indigenous people don't experience post-traumatic stress disorder. We experience persistent and pervasive traumatic stress. It's ongoing," Resmaa says. "White body supremacy weathers and erodes the brain architecture. It weathers the endocrine system. It weathers the musculoskeletal system. It weathers the reproductive system. It is the cause of sustained physical and mental decline."

This reality, he says, requires full-bodied therapeutic approaches to begin the healing journey because "the particular ways in which trauma occupies the body, entering through the rational and the cognitive first don't often work."

The arts and aesthetic experiences that Resmaa uses in his therapeutic practice, including having clients hum, rock, shake, sway, dance, and make art create direct routes to the body's stored energy.

He begins by creating a kind of embodied psychological container to hold space for traumatic experiences, emotions, and energy. In general, all of us are conditioned to avoid what is emotionally difficult. "In my practice we do a lot of primal movements. I watch people's basic movements and gestures. For example, when I hear a client grunt, I'll begin to grunt with them. Now, that may sound like nothing. But grunting and moaning are ancient vibratory languages we all have. There is an embodied alignment that gets established when you hear somebody mirroring you, and you don't even realize it. That's what I call container setting. What I'm trying to do is hold the charge with them."

Once a client-therapist container is secure, Resmaa invites his client to explore the charges created by trauma, to begin to play with what emerges through physical sensations. He talks about using toys, not tools—and encourages clients to think about what is in their own toy box to work with this energy. He evokes curiosity and creativity, encouraging exploration, inquiry, and discernment. "Sometimes we be-

come so constrained and don't use our imagination to help us heal. Think about something as simple as cloud watching," he says. "It reminds us that things can be joyful and all right."

In this more playful flow state, the body is able to pause. "I love the idea that healing is in the rest notes, in the in-between places. Silence can say a lot when things are marinating, and you need to allow for this," Resmaa says. "There is a quaking that happens, and stuff starts knitting together."

Recovering from racial trauma is an ongoing personal and collective process that needs to be tended to. It's not fast or slow. "It is something that unfolds and it takes time. You first must metabolize your trauma charges so you can transform and change, so you can emerge as your full self," Resmaa says.

Resmaa challenges us all to build a container to hold the charge of race. Not just people with Black and Brown bodies, but those who are white as well. He offers the hope of being honest about racial injustice. "It's an art form to reclaim those pieces. These things need to be inquired into, and something will emerge by your participation and attending to it."

Theatre for Healing Hearts and Minds

When an actor walks out from behind the curtains and inhabits a role onstage, something exceptional happens: Their body moves in new ways, the timbre of their usual speaking voice changes, their very essence evolves in order to portray a life that is different from their own. Nisha Sajnani has long appreciated the capacity of theatre to address the ways in which a difficult life might cut us off from our physical experience, and in turn, compromise our mental well-being.

Nisha has worked for many years with immigrant women of color, refugees, children, and those who are disenfranchised, because the many burdens that these women shoulder—from working double and triple shifts while also attending to caregiving and sending money back home,

to grappling with language disparities, bias, and racism—lead to mental distress and a sense of *disembodiment,* or the disruption to bodily self-awareness. As the director of the Drama Therapy Program and the Theatre and Health Lab at New York University, Nisha is a theatre practitioner and drama therapist who has developed a process where people can contextualize the struggles in their lives and reconnect with their bodies once more. Being embodied, being able to sense what's happening for you internally, emotionally, is key to moving through difficulty, according to those, like Bessel van der Kolk, who study the physiological importance of embodiment for trauma recovery.

Nisha learned early how the language of the body is primary to how we experience and understand the world. Our body movements are planned by an area in the forebrain known as the basal ganglia, while our cerebellum helps to regulate posture, coordination, and balance. A group of sensory nerves known as interoceptors help to create our sense of what's happening in our bodies. This sense can be disrupted, or amplified, when we are emotionally overwhelmed.

Before coming to NYU, Nisha worked for many years in the Post-Traumatic Stress Center in New Haven, Connecticut, where she supported people experiencing acute anxiety-related conditions. She researched how creative-arts therapies might help facilitate stress reduction, and learned that through the act of movement and play we are able to remember difficult experiences and move them in physical expressions that are not jarring or overstimulating. "What we know, at this point, is that when we are frightened and go through life-threatening experiences, our immediate priority is not to talk about it. We experience it and we move into action around it in order to preserve ourselves," Nisha says. Theatre, and trauma-informed drama therapy involving movement and play, can help a person reconnect, physically, to their lived experiences and shape them in new ways.

Using improvisational movement, storytelling, role-play, and performance, Nisha helps people to use their body as the basis to explore their lived experience and their relationships with others.

"Their experience is best understood when it is embodied and made visible through an art like theatre," Nisha has said.

Nisha has learned that we need to move from a place where the experience is an isolated, occupied territory in our psychology. "It's about organizing traumatic experiences through the arts so you can rejoin the world, rather than hold that experience internally and remain alone in it," Nisha explains. "Theatre is particularly good at embodying an experience, paying attention to how you viscerally experience it, moving that into concrete, visible forms—a sound, a gesture, a drawing, a movement—and using symbolic metaphors to try to help you communicate the complexity of an experience without immediately having to reduce it."

For psychotherapist and dance therapist Ilene Serlin, dance and movement are the ways that she supports individuals and communities as they reconnect to their bodies and stories after trauma. Ilene has traveled the world teaching women to dance in order to connect and express emotion. Coordinated movements of dancing engage the basal ganglia and the cerebellum, as in theatre work, but also activation of the motor cortex. Your sense of how your body relates to the rest of the world comes in via a sense known as *proprioception,* or your awareness of your body's action, movement, and location in space, and the movement of dance ignites this sensory self-awareness. Dancing has been shown to improve mood and to help stave off depression by releasing serotonin; while dance increases neural activity between brain hemispheres and helps to develop new neural connections.

In Jordan, the Syrian women Ilene has worked with speak only Arabic, and talk about trauma is not culturally accepted. By belly dancing in a room together, they were able not only to express themselves openly but to gain the neurochemical benefits of movement. One woman Ilene has worked with explained how dance therapy helped her in expressing the locked feelings inside by making them "flow to the surface, in a form of movements, rhythms in accordance with music." It's healing for women to share themselves through dance.

The same can be said for men. Dance is a conduit for emotional wellness for everyone. In a Finnish study of men who participated in dance as children, researchers found that dancing as a child increased men's compassion, self-awareness, and healthy identity and that these

attributes carried with them into adulthood even after they no longer participated in dance. As they noted in their findings, dancing "teaches us to become aware of our bodies and to read another person's body language. It helps us understand the concept of being different and guides us to engage in cooperation with various kinds of people. Dancing also boosts our body esteem."

Through the Eyes of a Child

We've been talking about how to meet traumatic events after the fact with arts-based practices. But what about building skills early in life, so that future generations might better cope with the inevitable challenges of life?

Marina was a bright, outgoing six-year-old living in Mexico City. The city she grew up in is plagued with chronic challenges, including high crime, oppressive pollution, little access to nature, and few jobs at low wages. But Marina lived in a house filled with extended family, a robust and vibrant place that included her grandfather, Pa. Each morning Marina and Pa shared breakfast and played before she went to preschool, and every afternoon she burst through the front door, calling out his name, excited to share what she did that day. They were inseparable. He made her feel safe with his unconditional love and support.

One day, Marina came home and called out, but her grandfather didn't answer. Pa had died suddenly and unexpectedly while she was at school. The shock of his death and her inconsolable grief radically affected her. At home she often cried and refused to talk about her feelings, despite her mother's best efforts. At school, she became introverted and afraid. This once-vibrant child was now sullen, reserved, and skittish. Her mother watched as the spark in her daughter's eyes was extinguished by her anguish and tears.

Sudden loss of a loved one and childhood grief can be processed positively or negatively, and fortunately her teacher had an idea she

thought would help Marina. In one corner of Marina's classroom her teacher had created El Rincón de la Calma, or "The Calm Corner." The walls were painted a soothing blue with rolling green hills and a tree. Shelves were stocked with art supplies, and a beanbag chair rested on the floor. Throughout the day, when kids felt overwhelmed, they were invited to spend time in the Calm Corner. Soon, the kids didn't need to be asked to visit; they went on their own and used the space to get in touch with their feelings.

Marina's teacher, Miss Elizabeth, had been trained in a program known as Healing and Education through the Arts, or HEART, an initiative of the Save the Children Foundation.

"The primary goal of HEART is to improve psychosocial well-being," Sara Hommel told us. Sara is the director of mental health and psychosocial support for international programs at Save the Children. "We know that a child who is stressed, and who does not have the support needed to process and recover from that stress, is likely to be distracted, unable to concentrate, unable to regulate their emotions, and can become withdrawn or be hyperstimulated." When children are confronted with extremely difficult situations, like the death of a loved one, conflict, war, or natural disasters, and they have no context for how to process the event, it can lead to trauma, to PTSD, to freezing or staying stuck. Like Marina grieving for her Pa, we can withdraw from our lives.

HEART has found that by regularly having the children and the adults engaged in expressive arts activities for many months, even years, they gain the skills necessary to process stress and anxiety—and avoid the downstream trauma that might have resulted if left unattended.

The program incorporates three primary activities: First are techniques such as breathing and muscle relaxation. Then there are structured activities, where making art is done as a group with guidance from an adult facilitator. The third is free arts, where individuals get to play with various creative expressions, making art in any way they like by drawing, dancing, or playing with clay and fabrics. In every case, after art is made, they have a sharing circle, where kids are able to explain the meaning of what they've made.

A pivotal element of the initial training is in reminding the adults

that this is not about "good" or "bad" art. Sara shared that HEART trainers often start their training by drawing two cats. One is a decent rendering of a tabby that looks like a six-year-old may have drawn it. The other is a jumble of scribbles. "And they'll say to the group, 'These are both drawings of a cat. Which one's better?' The answer is neither. They're both wonderful. And they're both cats, because I made them and I told you they're cats. All art is good art." This can be a tricky concept to convey to teachers who are used to specific ways of teaching reading and science and math. "Getting the concept that there's no right or wrong to this, that it's about the process not the product, that the art is wonderful no matter what it looks like because whatever the child creates or says about the creation is correct. This can often be a new concept, especially in a formal education setting."

Through arts-based programs like this, children can gain skills for self-reflection, self-expression, and verbal communication. These become the tools that they carry with them, hopefully for the rest of their lives. Ensuring exposure to and engagement with different art forms, different senses are engaged, different processes of decision-making and problem-solving and organizing take place, and different parts of the brain are stimulated in ways that support healthy brain function. "That not only promotes stress recovery but it also supports learning and development," Sara says.

HEART has collected data over the years to assess how the arts support our well-being, particularly those who are most vulnerable. Their research has shown that self-expression, communication, concentration, and emotional regulation vastly improved in the program. When HEART is in a school, attendance goes up, and learning metrics improve. Most important, interest in learning improves, which is perhaps the greatest gift you can give a person: the curiosity and excitement to learn. This leads to better problem-solving and conflict resolution among peers. Children develop a future-forward mindset. In some of the most marginalized communities, children now dare to dream about what their lives might become. And because they are more emotionally agile, they are open and eager. A comparison of one school in Malawi found that the classrooms using the HEART method exceeded learning indexes by as much as 16 percent.

With Marina, Miss Elizabeth encouraged her to express her grandfather's death through drawing. Whenever Marina withdrew in class, or began to cry, the teacher suggested the Calm Corner. Together, they built it as a ritual, a practice. Marina would spend about twenty minutes drawing. There was no right or wrong way to draw, no instructions for how to do it. Marina began talking about her grandfather in her own time. She was given the agency to move at her own pace, in her own way, and sure enough she began to open up. One day, she took what she drew, folded the paper, and placed it against her chest. She told her teacher she felt better. She said she knew that she carried her grandfather with her, that he was forever a part of her.

HEART offers an evidence-based, scalable approach to creating a culturally sensitive environment where stress is not stigmatized or looked away from. Rather it is an opportunity to build essential preventative and protective skills. Neuroscientific research is undergirding just how vital the arts are in early childhood development, particularly in the ways in which the arts help to build neural pathways that support social and emotional development. Much of what we naturally do as play when we are young children—dance, sing, make-believe, role-play—are natural art forms. They work across the brain, as we have explained, and when brought into the classroom, the arts have been proven to help children develop the neural pathways that lead to improved empathy, self-awareness, and agency. They help children, like Marina, to emotionally contextualize the range of human experience. It puts a whole new spin on the arts in school.

Healing the Mind and Serious Mental Health

At some point, all of us will confront trauma. But most of us will not experience serious mental health concerns that require intensive medical support care. For those of us who do, even then, the arts offer tangible benefits.

In the summer of 1990, Brandon Staglin had just completed his first

year at Dartmouth College in New Hampshire. He was eighteen and headed back to the Lafayette, California, home he shared with his parents and sister, a place he'd lived since he was three. His was a happy childhood. Brandon liked school and got good grades; he loved to play soccer and to meet up with high school friends in the wilderness and philosophy clubs he joined. When he was about seven years old he would spend hours during the summertime between school years listening to Top 40 radio in his room, building LEGO sets, and drawing to pass the time. His love of music grew over the years.

That summer after college, though, Brandon remembers being stressed. He and his first serious girlfriend had broken up and he was struggling to find a summer job. Then, one night, when he was trying to fall asleep, he perceived that the right half of his brain was gone, that it was forcefully taken. He had also lost all emotional connection to his world, and suddenly couldn't access feelings like love and compassion for his parents or friends. Those emotions simply disappeared. He became increasingly paranoid and disoriented, until he was admitted into a psychiatric ward for what was to be his first psychotic break.

"I was having awful hallucinations and delusions, thinking that there was a cosmic struggle for possession of my soul, and that I could go to hell at any minute if I made any slight moral mistakes," Brandon tells us. "It was very disturbing for me to have these thoughts in my head every single moment of the day, and that nearly drove me to take my own life, having been so bombarded by these thoughts for months. And fortunately, I did not. I'm very glad to be alive today."

Brandon was diagnosed with schizophrenia. He went into a treatment program that included medication and continued therapy, and was able to finish college with honors. He found, though, that beyond medication and talk therapy, music became a tool for his recovery. "There would be times when I'd dissociate from reality and feel myself kind of slipping," he says. "I learned that if I put on some of my favorite motivating songs, I would be drawn back into the moment again."

Music, which we dive into in greater detail in future chapters, has seen a lot of research around why it is so effective at reducing stress, anxiety, and depression and puts us into a relaxed, present state. One

theory contends that it's because the brain structures responsible for perceiving emotions and music perception are located close to each other. An interesting finding in recent years is that music most significantly reduced stress in clinical trial subjects when it was played to intentionally create a relaxed mental state.

Lack of motivation, lack of clear thinking, and other cognitive challenges are symptoms of schizophrenia and "music helps to manage the negative symptoms very well, and helps you to function better because those symptoms are more in check," Brandon says. "Medications are essential for many people, but it's not enough, it's not enough for recovery; there needs to be more. And medications can leave you feeling numbed." He didn't want to go through life not feeling; he wanted to have meaningful relationships.

Brandon started playing guitar and took lessons on and off for a decade when he decided to write a song about his experience in recovery from schizophrenia called "Horizons Left to Chase." He practiced it consistently for six months. "Every time I play guitar, for days after that, I feel more motivated, I feel more integrated in my thoughts and feelings, and that's something I really love about music. That sense of energy and meaning and purpose, along with the ability to connect different parts of my thinking, so I'm not drawn in different directions by distracting thoughts. That's been really helpful in my life."

Music also helps him feel more honestly connected to his emotions and to other people. "I feel like my own spirit is augmented by playing music," Brandon tells us. "I feel more a whole person emotionally and spiritually, because I think it actually enhances my ability to make decisions that are pro-social, that are altruistic. I feel more connected with other people in the world through the act of participating in music, whether I'm alone playing it or with other people at the time."

With his parents, Garen and Shari Staglin, Brandon helped to form a nonprofit dedicated to advancing the scientific understanding of mental illness, and developing better diagnosis and treatment. One Mind supports research into the biological underpinnings of mental illness, biomarkers for early detection, and new treatments for illnesses such as schizophrenia, bipolar disorder, and depression. In 2020, One

Mind partnered with Susan's lab to develop a music and mental illness research review. This first-of-its-kind study identified strengths and gaps in the research literature critical for advancing rigorous science in the field. One finding, not included in the paper, was that regardless of the musical genre or delivery, over 90 percent of the studies that compared treatment as usual (TAU) vs. music interventions found that music was more effective.

We know that music therapy improves one's overall mental state, including negative symptoms of schizophrenics, and improves social functioning because music acts as a medium to help process emotions. Anxiety and dysregulation of emotion are lessened as things like rhythm, repetitive lyrics, or chords engage the neocortex of our brain, which helps to calm and reduce impulsivity.

Brandon points to the scientific theories of Stephon Alexander, a physicist and a jazz musician who writes about how music is inherent in the structure of the universe with quantum field theory, the basis for matter, energy, and cosmology. "There's this thing called the cosmic microwave background, which you can detect if you point a radio telescope out into space," Brandon says. "It's reverberation, like the sound in the universe left over from the Big Bang. And so maybe music is just part of everything in that regard."

Brandon notices how, like the tuning forks, even the simple vibrations from his guitar improve his mental health. "When I'm tuning my guitar, when I'm just picking one string at a time and listening to it ring out, I get more focused, I get more in tune with the moment. It's not music at that time, it's just one tone, but it has an effect for me."

The Silent Barrier

Whether our mental health issues are situational or more transient or we live daily with a more serious mental health challenge like Brandon does, one of the biggest inhibitors to our recovery is shame and stigma. More than 75 percent of people suffering from mental illness around

the world go untreated because of this. Brené Brown says it so potently: "What we don't need in the midst of struggle is shame for being human. It corrodes the very part of us that believes we are capable of change." Yet, nearly 9 out of 10 people with mental health challenges say that stigma and discrimination have a negative effect on their lives.

Stigma is a brain-based response that happens both in the person forming a bias and in the brain of the person being stigmatized. It is a complex phenomenon expressed both subtly and overtly in various regions in the brain, and it triggers a physiological response. For a person feeling stigma against someone else, it is a fear-based reaction in the amygdala that is often driven by the unknown. Interestingly, when a stigmatizer learns that the person they fear has a brain disorder or a brain disease, the fear center in the brain quiets and stigma lessens.

With stigma, a person is set apart from others, considered inferior, and seen to represent danger to society. The result is social rejection and social isolation, and these can manifest in three ways: (1) Public stigma involves the negative beliefs that others have about mental illness. (2) Self-stigma is when we turn that bias inward on ourselves. (3) Institutional stigma is when these entrenched biases about the mentally ill become pervasive in policies of government and private organizations and limit opportunities for people with mental health issues. Being stigmatized creates neural correlates in the brain to other conditions such as sadness, irritability, depression, social withdrawal, and insomnia. These each have different neurobiological underpinnings. For example, social rejection, which at its core is effectively what stigma is, results in enhanced activation of the insula and of the dorsal and ventral anterior cingulate cortex, leading to a feeling of isolation.

Stigma affects not only the person with mental health challenges, it has a multiplying effect on families trying to support them. Stigma also prevents all of us from moving into the world and feeling whole and capable of healing. It creates and reinforces negative stereotypes that adversely affect our families, friends, coworkers, and neighbors.

For communities of color, stigma is even more damaging. According to a study by Mental Health America, Black people have reported that mild depression or anxiety would be seen as "crazy" among friends,

and many report that discussions about mental illness would not even be allowable within their family. This is compounded by inequity and representational imbalances within the healthcare field. Only 6.2 percent of psychologists, 5.6 percent of advanced-practice psychiatric nurses, 12.6 percent of social workers, and 21.3 percent of psychiatrists are members of minority groups.

For Judith Scott, stigma nearly killed her. Judith was born in 1943 with Down syndrome and she was institutionalized as a child, at a time when children with such developmental differences were too often sent away. She was separated from her twin sister, and for the next forty years Judith lived in a state institution in Ohio. The managers there believed her to be profoundly unintelligent and mentally inept. In fact, Judith was deaf, a reality that they failed to uncover, and because of their biased assumptions, Judith never received any sign language training. Decades later, her twin sister removed her from that institution and, soon after, she brought her to Creative Growth in San Francisco, California.

Creative Growth is a nonprofit that has, for almost fifty years, used the visual arts to both support those with intellectual and developmental disability, and to help replace our stigma-driven narratives with new, empowering ones about creative potential. Founded by Florence and Elias Katz, their vision has become a model around the world.

Creative Growth was launched with the idea of artists coming together to support people with disabilities and mental health disorders. "To our knowledge, we're the first standalone arts program like this in the world," says Tom di Maria, director of Creative Growth Art Center. Creative Growth welcomes about 160 artists in their studio every week, which is housed inside a large industrial building in Oakland. Some of the artists have been coming for five days a week for more than forty years.

The staff are all artists, but they have a hands-off approach to how they teach art-making, allowing the individuals to find their voices. "We have artists with schizophrenia, with depression and bipolar disorder, with PTSD, with developmental disabilities. We serve adults who have been essentially told that they're not creative, that they can't

communicate, who have been told to be quiet, to not make noise, that 'we don't want to hear your stories.' We sort of turn that upside down and say, 'Everything you have to say is valuable. The way that you can perhaps express this is visually.'"

When Judith arrived, the staff helped her to recognize that being nonverbal didn't mean she couldn't express herself. They asked her: How can you tell us about what you've gone through? And Judith found a very creative way to do it.

She began to create sculptures about permanence, and about protection. She used fibers and other materials to make womblike structures. See image I in the color insert. At first, Judith would hide her work at night when she left, fearful that someone might take it. After years of living in an institution where nothing was sacred, it took her two years to complete her first sculpture. "I like to look at her sculptures and think that all the information is there in terms of what she's communicating to us. Judith's language became her art," Tom says.

Stigma deteriorates mental healing because it brings with it an emotional sense of shame, and shame physically inhibits our ability to both share and to heal. The arts specifically combat stigma by increasing activity in the cognitive control network of the brain, related to interference monitoring and suppression, thus lowering self-criticism, self-judgment, and inhibition. It both helps people to cope and recover while engaging those who see their art, who come away with greater understanding and empathy. The arts help to break down stigma, allowing you to see a person for who they truly are. A 2021 meta-analysis of recent studies on stigma and the arts concluded that arts interventions are extremely effective in reducing mental health stigma.

Our collective stories of trauma and serious mental challenges around the globe are endless, as are the ways the arts sustain us and help us heal. There is more and more evidence that the arts enhance brain function by changing brain-wave activity and accessing the nervous system. The arts offer us a way to slow down, feel our emotional pain, and let it unfold, revealing a changed but full human being.

There is beauty and hope in that.

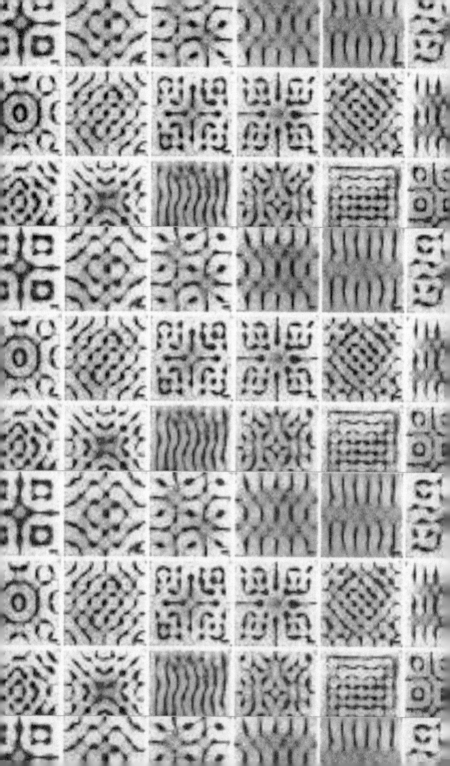

Healing
the Body

If art doesn't make us better,
then what on earth is it for?

—**ALICE WALKER, AUTHOR**

One afternoon, the two of us marveled over a photo of a patchwork quilt on our computer screens. We were on opposite coasts—Susan in Maryland, Ivy in California—but as is is so often the case with us, a work of art had brought us together over a long distance. We talked about how great it would be to stand next to each other in a gallery viewing this spectacular piece.

This quilt, made in 2018, was monochromatic, with each neatly delineated square containing an intricate pattern rendered in cadmium red. One patch looks like a snowflake under a microscope, with crystalline branches emanating from a spiraled center. Another square transports us to the heat and beauty of Morocco, because its tight tes-

sellations of hexagons so resembled the ceramic tiles there. Another reminded us of the pattern of lines left on a sandy beach from the retreating waves of the ocean. This image is reproduced in black and white on the facing page.

Quilts are textured, visual stories. Sometimes, it's the narrative of a place stitched into cotton, like the ones created from scraps of old work clothes by the women of Gee's Bend, Alabama. Other times, they can become commentaries on our shared history, like those of contemporary artist Stephen Towns, who uses fabric, glass beads, metallic threads, and translucent tulle to depict the damaging legacy of slavery in America. Quilts have been made for centuries as a way to capture our world, one square at a time. They are art reflecting life. But in the case of the red quilt that we were looking at that day, it was life *becoming* art.

The red "quilt" was made up of a series of photos taken of human heart cells under a microscope in a lab at Stanford University. A cardiologist there named Sean Wu had been puzzling over a question about the organ's structure. He wanted to generate heart tissue in the lab in order to create models that would help explain certain cardiac diseases. Eventually, he hoped to be able to create heart patches for patients with weak cardiac walls or with damage from heart attacks.

With more than an estimated 37 trillion human cells in our body to work with, scientists are having excellent success generating human tissue in the lab, for everything from brains and bladders to muscle and skin. This new field known as biomaterial design is merging the disciplines of materials engineering and biology in order to grow tissue outside of the body in a lab.

Heart cells are special, though. First, they are incredibly complex and challenging to create. Heart cells are also densely packed, which allows them to work in tandem and beat. If they are designed too far apart they won't sync. Too close together, they could smother and die. And so, from an engineering perspective, hearts are the Taj Mahal, the Empire State Building, of organs. You may imagine what you want to build, but you need incredible structural engineering to make it happen.

A colleague at Stanford, an acoustic bioengineer named Utkan

Demirci, had an idea for Wu. Move the heart cells with sound. Demirci is among a growing number of biomedical researchers tapping into aesthetics, like sound waves, to design cellular structures. Because sound waves move molecules, they can travel through different media—like solids, gels, liquids, and gases—made of molecules. They are versatile. In this case, Demirci put heart cells in a gelled substance, and by tweaking the acoustics he created different sizes and shapes of sound waves (imagine a small ripple amping up into a tidal wave). The cells rode the waves across the gel and into the extraordinary patterns.

As Demirci triggered acoustic waves on a microscale, he and Wu watched the heart cells dance into patterns. They could adjust the patterns within seconds by tweaking the acoustics. "You change the frequency and amplitude, and the cells move into a new spot right in front of your eyes," Wu said in 2018.

The work Demirci and Wu were tapping into is called *cymatics*—the science of visualizing audio frequencies. This process was discovered by Swiss medical doctor and pioneer Hans Jenny, who coined the term and published the first volume on the topic in 1967. Jenny explained in his book *Cymatics: A Study of Wave Phenomena and Vibration* that "acoustic effects of sound waves is not an unregulated chaos. It is a dynamic but ordered pattern."

After their discovery, Stanford University tweeted out the quilt-like image and asked: *Is it art or is it science?*

It is, wonderfully, both. Researchers are removing the "or" to make it "and." Art and science together are potent medicine, capable of radically transforming our physical health.

Think about this experiment the next time you feel moved by your favorite song. You are literally changed, on a cellular level, by aesthetics. In the case of the red quilt, sound caused heart cells to move. All stimuli that we encounter—visual, auditory, somatosensory, gustatory, olfactory, and others—change the structure and function of cells within our brains and bodies. They do so in fundamental ways, including altering cell cycle, proliferation, viability, and binding of hormones. And when we make those aesthetic inputs multidimensional, we open the door for healing to occur.

One of the most important developments in the arts-meets-science approach to physical health has been the ways in which researchers have begun to identify key neurobiological mechanisms. Mechanisms are the many chemical and physical activities that underlie how things work in your body. Digesting your latest meal, for instance, happens because of multiple mechanisms, from saliva production in the mouth to chemicals in the stomach to the ways nutrients are absorbed. We understand how and why the body digests food. And by better understanding the mechanisms engaged when using the arts, practitioners are able to design and enhance interventions with greater precision.

In a 2021 study published in the journal *Lancet Psychiatry,* Daisy Fancourt and her team studied the mounting evidence for the benefits of leisure activities, such as participating in the arts, on human health. They identified and mapped more than 600 mechanisms—from improving respiratory and physical function to enhancing immune function and developing group values—that occur both in our individual bodies, as well as at the group and societal level. These mechanisms are broadly grouped into psychological, biological, social, and behavioral.

Another critical point that Daisy and her fellow researchers made in this study about arts and mechanisms is related to the idea of complexity science. "People have often viewed the field of arts and health as needing to operate like the field of pharmacology," Daisy explained. For example, a drug has an active ingredient with maybe one or two biological mechanisms of action and these have predictable outcomes. "Whereas, our clear point in this paper is that in complexity science, you recognize that there are hundreds of ingredients, hundreds of mechanisms. They all work bidirectionally, not just unidirectionally and they're moderated by external factors."

This summarizes quite nicely why the arts have such a potent effect on our health: Whereas a pharmacological treatment works on one, maybe two, pathways, the arts have the ability to trigger hundreds of mechanisms that work in concert.

"This point is really important to get across," Daisy says, "because sometimes people have seen the complexity and the 'messiness' of arts and health mechanisms as a weakness where in fact, it is the very heart

of why the arts work. It's just that we've been applying an overly simplistic biomedical lens on something that needs to be seen with a complexity science lens."

Today, the arts are being used in at least six distinct ways to heal the body: as preventative medicine; as symptom relief for everyday health issues; as a treatment or intervention for illness, developmental issues, and accidents; as psychological support; as a tool for successfully living with chronic issues; and at the end of life to provide solace and meaning.

From everyday aches and pains to serious illness, this alchemy of art and science is transforming our biology in ways that are both measurable and effective. We're now at the point where doctors as well as social workers and public-health practitioners know enough to be able to recommend various artistic endeavors to effect beneficial outcomes for our physical and mental health. We are also learning that, just like when we are prescribed medications, different types, doses, and durations work differently for different people. You can bring this knowledge home, as well, to begin to create personalized arts practices. Like exercise and good nutrition, the arts on a routine basis will support your health.

There's an Art for That

The arts' unique healing capacities have been proven to address some of the most common yet potentially debilitating health issues. Healthcare practitioners are treating and reducing symptoms in everything from obesity and heart disease to inflammation and arthritis by including the arts. One area where this work has been used is one that affects every single one of us over our lives—pain.

Sadly, chronic pain is a reality for many of us. This type of pain is defined as persistent or recurring discomfort for more than three months, and 30 percent of us suffer from it globally. It limits our daily activities and minimizes our social interactions. Pain is the number one

reason people seek healthcare. The fact is, too many of us are in some form of discomfort on a regular basis. And if acute pain—which disappears once the underlying cause has been treated or has healed—isn't properly addressed, it too can become chronic.

Even though pain is ubiquitous, the medical community doesn't fully understand exactly how it works in the body. Pain moves. It ebbs and flows. It can be mercurial and hard to communicate where it resides in the body, let alone pinpoint what's causing it. This has been a kind of holy grail of medical research for decades as people the world over seek the mechanisms of pain biology, looking at the molecular and neuronal levels, at spinal cord and brain activity. Finding the underlying neural mechanisms of pain and better ways to treat it is now crucial given our society's dependence on pain medication and the addictions these cause.

For doctors, pain can be the most difficult symptom to treat. Not because effective treatments don't exist but because everyone's experience with pain is unique. We all feel it differently, because pain is more than a biological reaction; it's a psychological one as well. Stress can cause us to hurt; our brains can send out pain signals triggered by psychosomatic imaginings when under strain. It can even be cultural. Tolerance and acceptance of pain vary across ethnicity and culture.

All of the pain researchers we've talked to over the years of researching this book have agreed that given the scale and ramifications of pain for people around the world, and the inherent challenges of measuring and understanding its sources, a multimodal treatment, which incorporates myriad interventions, is key. The science and treatment of pain is evolving to integrate the biological, social, and psychological benefits of the arts and aesthetics in order to create individualized treatment.

One way the arts are vital for managing pain is in helping to figure out where it's located in the body in the first place. The arts can be invaluable translators.

Pain doesn't show up on an imaging scan, and it can't be measured through empirical tests. Often, our only way to articulate pain to someone else is by using a self-identified scale. How much does it hurt, on a scale of 1–10?

However, pain is also different from our other somatosenses. The receptors and pathways that allow us to feel pain are very complex. Perception of pain involves not only the activation of the pain sensory pathway but also the integration of higher-order cognitive processes, such as our expectation of whether or not something is going to hurt, our memories of events that caused the painful stimulus, our emotional state, and even our self-esteem.

Allan I. Basbaum, a neurobiologist at the University of California, San Francisco, who studies the mechanisms that result in persistent pain, has said that "it's often much more difficult to put pain into words, which is one of the big problems with pain. You can't articulate it, and you can't see it. There is no question people often try to illustrate their pain." Now imagine if illustrating pain was protocol when you went to a doctor's office. Illustrating pain by painting, drawing, and sculpting can help detect, identify, and convey important characteristics and information. A simple piece of art can speak volumes.

Arts-based communication is particularly valuable when we can't explain our physical experiences in precise language, as is the case with young children. "The arts are like a secret language for children," Abigail Unger tells us. Unger directs the expressive therapies team at Hospice & Palliative Care Buffalo, one of the first of its kind in the country. Hospice Buffalo offers end-of-life and palliative care, serving roughly 5,000 individuals a year, including children with terminal diagnoses. "For children who don't yet have the language or the developmental capacity to recognize and articulate what's going on in their bodies, the arts offer an invaluable outlet. They are a language for everyone, of course, but the arts give children a means of expression when they don't have words."

A major challenge for doctors and caregivers is knowing when a child is in physical pain versus when they are hurting from emotional distress. A story that we heard from an arts therapist working in the field is one that hit home to the two of us as moms, who can still remember what it felt like when our young children struggled to communicate what was going on when they were in distress. This story is of a young boy with a life-threatening illness. We'll call him Ian.

Every night, Ian cried at bedtime. He was often close to hyperventi-

lating because he was so distraught. He told his parents that he was hurting. His mom and dad, desperate to help him, relayed all of this to his care team, who in turn wondered what might be causing Ian's pain to elevate only at night. Physical exams yielded no insights, and pain medications didn't help.

Around this time, an art therapist began working with Ian. She asked him to draw a portrait, and what emerged was a lone figure drawn in black, a knotted swirl of crayon centered on the torso and stomach. Over the course of the session, the art therapist was able to recognize that Ian wasn't in physical pain at night; he was anxious. The therapist asked Ian how he might feel better.

Armed with answers, the art therapist met with the parents and helped them to create rituals around bedtime to address Ian's anxiety and worry.

We don't always know what kids are feeling and experiencing. But by providing alternate ways of processing through making art, adults can access a lot of information.

Research has found that people who engage in arts and cultural activities have a lower risk of developing chronic pain as they age. Headache is one of the most common forms of chronic pain, and a persistent belief is that to treat it, you must medicate and mitigate movement. The classic image of someone suffering from a headache is a person lying on their back in a darkened room, a cool rag on their head. So, it might seem counterintuitive to suggest that when you have a headache you should get up and dance. But according to a study published in 2021 in the journal *Frontiers in Psychology,* there is mounting evidence that mindful-based dance movement therapy, or MBDMT, and psychological approaches to headaches can alleviate them.

In this pilot study, twenty-nine patients who suffered from chronic headaches were put into one of two groups. One was offered MBDMT sessions. The other was not. Researchers used a set of assessments for pain that are standardized in global healthcare.

Those enrolled in the MBDMT group received ten sessions involving dance and mindfulness training at an outpatient rehabilitation center. The classes lasted for five weeks and data were collected before and

after each session, and then once more sixteen weeks after the final lesson. They found that "Per-protocol analysis reveals statistically significant reduction of pain intensity and depression scores in favor of the MBDMT group, and these improvements were maintained in the follow-up assessment." Other arts interventions, such as drawing and music, are also proving effective for headache relief. In one small study, researchers learned that having a personal playlist of music helped to control chronic headache pain. Those who listened to music with the goal of relaxing and alleviating pain lowered their pain and improved their symptoms.

One pressing and long-term challenge with pain has been the rise in opioid use. Over the last two decades, the United States has experienced an unprecedented opioid crisis, along with significant increases in overdose deaths among all age groups.

In 2020, a report by the National Endowment for the Arts analyzed more than 116 studies that looked at arts-based interventions for opioid-use disorders. The data revealed that listening to music reduces pain, lessening the need for potentially addictive medication and improving readiness and motivation to seek treatment. The arts also developed life skills in young people that built their psychological protections to prevent opioid use.

Researchers are offering us insights into how the arts help to transform pain in the body after studying one of the most excruciating medical procedures that exists, the treatment of severe burns.

To prevent infection and to stimulate healing, burn patients must have their bandages replaced regularly and have their wounds cleaned. It's agonizing. When at rest, most patients report their pain levels to be tolerable and controllable by narcotics such as opioids. During wound care, though, their discomfort skyrockets.

Enter SnowWorld.

SnowWorld is the first immersive virtual reality (VR) program for pain. It was developed by Hunter Hoffman, a research scientist at the Human Interface Technology Lab at the University of Washington, and David Patterson, a UW psychologist.

During wound care, burn victims are given a headset that visually

isolates them from what's happening in the room and to their body. Patients watch animations and have earphones that play relaxing music. They are inside a 3-D computer-generated wintery world of cooling and soothing whites and blues. There are snowmen and icy lakes, glaciers and penguins, which the patient can attempt to hit with a snowball. Patients using SnowWorld reported feeling 35–50 percent less pain while using VR as compared with treatment as usual. Burn patients reported that when they used opioids for pain, it diminished the unpleasantness of their pain, but it was using VR that significantly reduced the worst of their pain intensity. Patients reported they didn't think about their pain as much while using the VR program and they actually had some fun.

Research is ongoing to better understand the mechanism around these bedside results, but one working hypothesis is that immersive VR effectively engages pathways that would otherwise be used for pain signaling. As one research study from 2019 explains, "VR creates a positive effect on cognitive variables to both enhance pain control and moderate pain signaling pathways through memory, emotions, and other senses including haptic, aural, and visual."

In fact, a handful of small studies used VR equipment that was designed to be compatible with fMRI machines. They studied a range of patients experiencing different types and levels of pain and confirmed the attention theory. Researchers saw how VR interventions decreased neural activity in the regions of the brain associated with pain, including the anterior cingulate cortex that resembles a collar in the front of the corpus callosum, the somatosensory cortices in the midbrain, insula, and thalamus.

Personalized Arts as Prevention

One statistic that continues to amaze us: The United States' Centers for Disease Control and Prevention, the CDC, estimate that 20 to 40 percent of deaths from five leading health issues—cancer, heart disease, stroke, respiratory diseases, and unintentional injuries—are preventable.

Let that number sink in.

Many of the chronic ailments that affect us can be controlled or avoided through lifestyle choices and changes. Too often, though, we wait for something to go wrong with our health when an ounce of prevention is worth the proverbial pound of cure.

It's widely accepted that certain lifestyle choices help us: Exercise, diet, sleep, and meditation have all been shown to improve our physical state. Now let's look at what happens when the arts and aesthetics become a consistent and intentional part of our lives.

Some of the most illuminating data about the preventative attributes of the arts has been gathered by Daisy Fancourt. As an epidemiologist, she has an incredible talent for mining data from cohort studies. Cohort studies are composed of data that tracks thousands of people, often from birth, every few years of their lives. These studies ask questions about mental and physical health, education, lifestyle, economics, and more. Many of these data sets include questions on arts and culture, which means that Daisy has been able to track nationally represented samples of people living in the U.K. over many decades. She has had unprecedented access to these wide-ranging longitudinal studies, and for the last several years, she's been working with her team to discern whether arts engagement in our daily lives might have health benefits. This work is not theoretical or a model of what *could* happen; it is telling us what has already happened to people who did or did not engage in the arts.

Using sophisticated algorithms, and after adjusting for a range of variables including gender, race, and class, Daisy's analysis offers extraordinary insights into the ways in which the arts help us avert disease and improve our health. The arts, Daisy has concluded, "have a profound effect on our mental and physical health, both on the prevention of problems but also in managing and treating symptoms."

It starts in utero. Daisy has conducted several studies on perinatal and postnatal maternal health and how music and singing connect pregnant women and their newborns. In a 2015 clinical trial, she and a research team began studying women experiencing postnatal depression. "It's a difficult condition to treat because many new moms don't want to take antidepressants whilst breastfeeding, and many don't

have time to go to counseling or psychological therapies," Daisy told us. They became interested in whether singing, which Daisy says has a strong association with mother-infant bonding, might spur recovery.

The researchers ran randomized control trials, where moms were placed in three groups. Some received the usual postnatal care with their doctors; others had that usual care plus social support groups; and the final group, a singing group, received the usual care plus they participated in a ten-week singing program specifically designed for mothers with postnatal depression.

"We found that the singing group recovered on average a month earlier than the other two groups," Daisy says. This faster recovery is important, Daisy notes, because postnatal depression, the longer it goes on, can lead to major or persistent depression. "The longer women have it, the more problematic it is for them, and the more problematic it is for their babies, both developmentally and in terms of future bonding," she added.

In a follow-up study, the researchers identified a number of mechanisms underlying why singing worked. "Including a greater reduction in cortisol stress hormones when mothers sang compared to when they played with their babies, there was also a greater increase in perceived mother-infant closeness," Daisy explains. Mothers reported that singing not only calmed them but also gave them tools that they could use to help their babies to sleep and stop crying, which made them feel more capable and less depressed.

It continues into childhood development. The data indicated that children who participated regularly in arts are less likely to develop social issues in their teenage years. Arts-engaged kids have fewer problems with their peers, teachers, and adults, and they are less likely to develop depression. Overall, they are more likely to live healthier lives and make better decisions.

In one specific example, children who read fiction most days exhibited better health behaviors and outcomes. They were less likely to try drugs and smoking, and they were more likely to eat fruits and vegetables throughout adolescence. This was not limited only to bookish kids who were whizzes at reading. Ability didn't matter, Daisy found. What

mattered was simply the act of reading, whether it was a comic or a novel.

According to the American Art Therapy Association, artistic expression and the creative process enhance cognitive abilities, foster greater self-awareness, and help teens regulate their emotions. The arts help them with focus, problem-solving, and decision-making skills, so when presented with health choices they make better ones as their brains are dramatically changing during critical developmental periods.

Daisy's rigorous studies have been able to show that the arts help cardiometabolic diseases, maternal healthcare, early childhood development, and more. But perhaps the most stunning fact that Daisy has uncovered is what the arts do for overall longevity: People who engage in the arts every few months, such as going to the theatre or to a museum, have a 31 percent lower risk of dying early when compared with those who don't. Even if you bring the arts into your life only once or twice a year, you lower mortality risk by 14 percent.

The arts literally help you live longer.

This may be partly owing to the preventative benefits of engaging in the arts and aesthetics. Additional studies by Daisy and her team have revealed the ways in which cultural engagement can deter dementia and chronic disease. Over the life-span, participating in arts activities like going to museums, concerts, and the theatre, are associated with a slower rate of cognitive decline as we age. These activities are also associated with a lower risk of developing dementia.

One reason that the arts are so effective in this manner, Daisy theorizes, is because of a scientific theory known as cognitive reserve. This theory suggests that there are multiple factors in our lives that help to build the resilience of our brains against neurodegeneration. The arts are "helping to provide cognitively stimulating activities, they're providing social support, they are also helping to provide novel experiences and giving opportunities for emotional expression," Daisy wrote. "They are a form of education and skills development. And all of these factors are part of cognitive reserve. They help to build brain resilience."

Traditional healthcare is now bringing arts programs and aesthetic treatments into hospital settings. Aromatherapy is being used to stop

nausea; singing and music are being brought into surgical suites to reduce agitation in patients, doctors, and nurses; video games are a treatment for stroke rehabilitation. Today, there is a groundswell of interest in both arts-in-health and expressive-arts therapy in healthcare, resulting in a proliferation of bedside programs involving not only the visual arts and music but also dance and creative writing. Arts practitioners are working in hospitals as part of the care-plan team, working with clinical staff.

For many years, the organization Americans for the Arts has funded studies to discern how, why, and where hospitals and healthcare facilities use the arts. In one survey, they learned that nearly 80 percent of hospital administrations say they invest in the arts because they've found that they dramatically improve the patient experience by both creating a healing environment and motivating patients during treatment and/or recovery. The arts support physical recovery through arts therapies as well as emotional wellness. These reports and others have found that hospitals with arts programs report shorter patient stays, decreases in staff and clinician burnout, and a greater sense of well-being for both patients and staff. Studies have shown that making art, and the creative process it involves, helps hospitalized patients heal in quantifiable ways. Studies demonstrate statistically significant decreases in a broad spectrum of symptoms, including pain, fatigue, depression, anxiety, lack of appetite, and shortness of breath. Art in healthcare settings also helps to reduce apprehension, tension, nervousness, and worry.

The Art of Living Well

Research shows us that arts engagement increases our longevity. Living longer is one thing. Living fully and *well* over the course of your life is another.

Physical health isn't merely about an absence of disease. It's about thriving with less emotional pain and suffering over the course of your

life, even when conditions compromise your biological state. Physical health is the foundation for everything in our lives, and, as such, it has a profound effect on our mental and spiritual health. Consider what runs through your mind when you don't feel well, or when you've been injured. It's a full-bodied response that's about more than the acute issue at hand: *Will I get better? What will happen tomorrow, next week?*

Uncertainty is often at the core of our concerns over health; we struggle with not knowing. In addition to whatever health issue you're experiencing, you may feel worried, fearful, hopeless, or helpless. There's the anxiety of waiting on a diagnosis, or the frustration and tedium of rehabilitation or recovery. There's the isolation that can come with being sick, whether it's from a contagious virus or the fact that no one is experiencing exactly what you are. It can be quite lonely, and this adds to the mental turmoil that things may never be the same. We all tend to go to a place of self-reflection and questioning when our physical health shifts. It is in this place of confusion and fear that the arts lighten—and in some cases alleviate—mental and physical symptoms around illness.

BJ Miller is a colleague and friend who is particularly wise about how to live in the aftermath of a tragedy, or with serious physical health issues. BJ lost both of his legs and one of his arms in a tragic accident in college in 1990. In those first shattering, soul-altering weeks in the hospital after his accident, he wasn't merely thinking about mending his bones and flesh, his nerves and tissue, he was also asking: *Now what?*

"I wondered about how I conceived of myself in the world, and what this new body was going to mean," BJ told us. He had no choice but to face existential questions about purpose, personhood, and the capacity for transformation in the midst of such a huge crisis. BJ has always loved art. He was majoring in East Asian studies at the time the accident occurred. As a result of his life-changing injuries and those long days in the hospital, he switched to art history. Being in the hospital day after day led him to think about art and aesthetics in a different way. "Why do humans make art?" he wondered. "Why do we create things from our experiences?"

BJ had an epiphany: Aesthetics and the arts are not rarefied; they are basic to human life. Today, BJ is an internal medicine doctor focusing on palliative and hospice care.

Palliative care is meant to relieve suffering and provide the best possible care for people with conditions that may not go away. Accompanying a life-altering diagnosis, or an accident like BJ's, are other symptoms related to both treatment and mental processing. Pain, shortness of breath, fatigue, constipation, nausea, or loss of appetite may be a new normal and can be accompanied by depression, insomnia, and anxiety.

A recent scientific literature review examined the ways in which arts engagement has been used to treat both pain and emotional distress in people with life-limiting illness. Looking at a range of patients from different countries, either creating or engaging in arts helped to increase a sense of well-being, reframe a sense of self, and foster communication and connection with others.

Forty years after the accident, BJ uses an integrative approach composed of an array of novel therapeutic methods, including arts and aesthetics. He calls it palliative aesthetics.

Palliative aesthetics, he explains, allows individuals to focus attention on their body, not just for symptom suppression but also as a source of knowledge for meaning-making. "The body is key for elevating knowledge to wisdom," BJ says. "The body is the site of consequence—where life and death are meted out—and therefore well suited to judge what is right for oneself; an apt word might be 'attunement.' In order for a truth to register as authentic, it must be felt."

He uses guided imagery, a form of focused relaxation where one recalls or imagines pleasant physical sensations and mental images. Studies have shown improvements with cancer-related pain and overall comfort through such techniques. BJ also incorporates music therapy to enhance his mood and reduce pain and fatigue.

Another one of BJ's go-to aesthetic provocations for his patients is to ask them to keep an eye out for those moments in their day when they feel even slightly OK. "I ask them to notice when they feel sufficient, adequate, whole," BJ explains. He instructs them to pay atten-

tion: Where are they? What are they looking at or touching? He might even ask them to take a photo on their phone or make a note. Then they discuss this at their next visit. Over time, these aesthetic exercises tell both patient and doctor where and with whom they feel better, and then BJ helps to remind them of what works. In many ways, BJ is conducting individualized versions of the *A Space for Being* exhibit: asking people to become more aware of their aesthetic surroundings in order to connect back to their physiological needs, in the process building habits for greater comfort and joy.

Restore and Repair

Making a lifestyle change can be hard. We all know that. When trying to eat healthier, most of us appreciate that an apple is better than a doughnut, but choosing a Honeycrisp over a honey-glazed can be hard. "Adherence" is a word you will hear in healthcare a lot, and it refers to how well a person participates in their own care. Do you follow a healthy diet? Exercise? Prioritize sleep? And if you have a specific condition, do you take your medicine and follow the doctor's orders? Are you motivated, engaged, committed to healing? So much of our physical health is a mental choice, and how you attend to it. "Adherence" is such a cold word. What we're really talking about is whole health. How do we find the meaning necessary to make sound choices, and how, once something happens, do we support our own treatment?

The need to treat the whole person explains why one of the top rehabilitation doctors in the world relies on the arts to help patients.

David Putrino is someone who frequently meets people on their hardest days, because as the director of Rehabilitation Innovation of the Mount Sinai Health System, David helps people recover from life-altering accidents and ailments. Many of them are facing the very same questions that BJ was asking himself. What's the meaning of a life when your physical condition dramatically alters?

At Mount Sinai, David marries aesthetics and the arts with technology to treat people who have suffered serious injury or illness such as stroke, ALS, and traumatic brain injury.

"Broadly speaking, it's my job to aggressively pursue technologies and ideas and principles that I think can take what we offer patients to the next level," David says. In his work, David has been applying neuromodulation. "We're manipulating physiology through sensory input," he explains. "There's a ton of literature showing that if you provide aesthetic sensory inputs, you will demonstrably and reliably manipulate physiology."

David works the full spectrum, from Olympians at the pinnacle of human performance all the way through to those locked-in with ALS. And he works with people across the life-span, from newborns and their parents all the way through to individuals who are at the end of their life and experiencing age-related issues. This gives David a perspective on human performance and potential.

What's so unique about David is that he believes rehabilitation to be, at its essence, about optimal human performance. "You shouldn't just rehabilitate a stroke survivor to the point they were at before they had the stroke, you should be pushing them along the wellness spectrum, beyond where they were," he told us. "That should be our guiding principle."

David uses all sorts of technologies, regardless of how high- or low-tech, with the goal of improving a human life. In one case, it was a mere $10 that forever changed a person's life.

This particular young man had suffered a bad spinal cord injury. Prior to visiting David's lab, he had shut down. He wouldn't engage in physical therapy. He wouldn't do speech therapy. He wouldn't speak to the neuropsychologist assigned to his case. "He just wasn't interested in being involved in his care," David says. "He would sit there completely disaffected and stare off into space and ignore his therapists."

One afternoon, Angela Riccobono, the psychologist who works with David, came to him with an idea. "Before his injury he was a DJ," she said. "We need to get this guy DJing again. That's the only thing that's going to bring him back to us."

For this young man, an inexpensive mouth stylus and an iPad al-

lowed him to DJ again. Within one session of setting up the iPad and getting him going, he asked David if they could FaceTime his father so that he could see him DJing. After this, he started going to see a neuropsychologist and getting actively involved in his physical therapy. He asked to join a group that Angela had set up for people with spinal-cord injuries. "He even asked if he could start a special interest group for people who are newly spinal cord injured and are interested in DJing," David says. "There was this complete transformation in this guy's trajectory."

Having a sense of value when you've lost something that you can't get back, that you can't fix, is so important. You have to, in some ways, come to some terms with your body, but also find new meaning. Creating that sense of engagement and meaning through his chosen art form as a DJ was transformative for this man.

We all need that purpose in life, and when our physical selves change our ability to pursue our passions, that can be life-destroying. David's work helps people to not only heal physically but, when they have no other option, to reframe their stories and bring passion back into their new reality through things like the arts.

David also reminds his patients about the ways in which all those sensory inputs from daily aesthetic experiences can influence how they feel: how different types of light affect mood, the ways in which scent, touch, taste, and smell can, unconsciously, contribute to how they are feeling. He even reminds them—as arthritis sufferers know all too well—how weather patterns influence pain.

"Despite the fact that there is a long literature of patients telling physicians that the weather influences their pain, there is not a single study into an intervention for pain that includes weather as a covariate. Can you believe that?" David says. He currently has a graduate student researcher exploring the influence of weather patterns on pain. "Obviously, we can't change the weather, but we can help forecast pain by forecasting the weather. You can say to people with chronic pain: *Hey don't be discouraged, the next few days are going to be really tough for you. Your condition isn't getting worse, the weather is changing.* And this can bring a lot of peace of mind to patients with chronic conditions."

Aesthetic experiences like changes in barometric pressure, wind, and temperature are really influential. David is bringing aesthetic and sensory experiences into medicine with something as simple as acknowledging that weather matters.

Dance Medicine

When we're kids, many of us experience the world through movement. We skip, we twirl, we shuffle, we dance. Something happens, though, as we get older. Dance goes away. Or, it is reserved for special occasions and celebrations like weddings.

As the research tells us, you don't have to be good at dance, or any art, for it to work on you. What happens in the brain as we move has been studied using technologies such as PET scans, and the underlying neural systems and subsystems involved in dancing include areas associated with rhythm and spatial awareness. When it comes to your health, you may want to start to mambo. Or moonwalk. Or Macarena.

Dance is being prescribed and used for so many physical health benefits these days. Obviously, it's an effective and fun way to lose weight and support cardiac health. It's being proven, as we've mentioned earlier, as a way to relieve chronic headaches and migraine. One of our favorite Rumi sayings nails it: "Dance, when you're broken open. Dance, if you've torn the bandage off. Dance in the middle of the fighting. Dance in your blood. Dance when you're perfectly free."

One particularly compelling way dance is being used is to treat neurodegenerative disease.

Parkinson's disease (PD), which affects more than 10 million people worldwide, compromises the precious gift of movement. PD is a brain disorder that leads to a range of physical difficulties including balance, coordination, shaking, and stiffness. The symptoms usually begin gradually and worsen over time. Typically, people with Parkinson's have great difficulty walking. This instinctive human movement is diminished as the basal ganglia region, the part of the brain responsible

for automatic movements, experiences a precipitous drop in dopamine levels due to the neural damage caused by the disease. The loss of dopamine results in abnormal nerve firing that inhibits movement.

The basal ganglia are responsible for our movement patterns and our learned steps so that eventually walking and other daily movements become habitual. The basal ganglia communicate with the cerebellum, which plays a role by helping with rate, range, and direction of movements. Neuroscientists now know that the cerebellum is important in the development of habitual movement formation.

Watch a baby learning to walk versus any pedestrian rushing along a busy street and you understand how, over time, many of our movements become part of our daily activities without our conscious awareness. These patterns become ingrained at a very early age, and soon we don't even have to think about walking; we just initiate movement and off we go. But with Parkinson's, that automaticity becomes unreliable as the brain signals become less stable.

When people with Parkinson's enter a Dance for PD class at the Mark Morris Dance Group building in Brooklyn, New York, however, something extraordinary happens.

During a dance class, in a brightly lit studio, people with PD dance the hula and the tango. They fox-trot and do the box step. And as they do, their tremors subside. Their gait improves. Those who could barely walk into class loosen into full expressions of fluid movement. "I'm not sitting there thinking about my body, I'm just trying to move," Patricia Bebe McGarry, a writer and performer, explained in a video about her experience in this dance class. "There is something magical that takes place in there."

It may feel like magic to a Parkinson's patient whose symptoms have temporarily ceased, but it is a biological reality based in neurochemistry: Dance marshals multiple parts of the brain, as we've discussed, including the basal ganglia, the cerebellum, and the motor cortex.

Dance for PD began in 2001, and within eight years the results that instructors were seeing prompted scientific studies into how, exactly, dance helps Parkinson's. With dance, people's gait improved. They had reductions in tremor and improvements in facial expressions that had

been diminished by the disease, says David Leventhal, who is one of the program's first dance instructors and is now the program director for Dance for PD. The studies tracked how the motor improvements that happened in class were significant, measurable, and most important, transferable, or replicable, outside of class.

A three-year longitudinal study published in 2021 confirmed these initial findings. Researchers followed 32 PD dancers who participated in a class once a week. They found that those in a dance class experienced less motor impairment and showed significant improvement in areas related to speech, tremors, balance, and rigidity as compared with those who did not do any dance exercise. They also reported an improvement in their mood and quality of life.

Using EEG, other researchers have seen changes in the brain waves of PD patients who dance. Blood-flow increases were also seen in the basal ganglia, a region responsible for smooth muscle control and the coordination of rhythm.

"People who were shuffling and not thinking about their walking were suddenly fully conscious and thoughtful about what they were doing in our class and why they were doing it," David explains. "Dancing helped them pay attention to the quality of their movement. By rehearsing, then these movements start to become automatic again. So, it almost seems like dance is rewiring their brains to have movement in a new way that then becomes automatic."

Among the many areas that ignite through music is our motor cortex. It kicks in when the rhythm of a song excites us and we decide to dance. All types of dance forms share common traits in that they're all built from the same elements like weight shift, balance, locomotion, amplitude, coordination, rhythm and musicality, story, expression, and narrative. "And incidentally, those are the elements that work for people with Parkinson's," David says.

The reason tango works is that it requires intense focus on balance and weight shifts, and awareness of where your balance is in relation to your partner. It's also improvised, so you're having to make cognitive choices about where you and your partner are going to go next. But those same elements are also a part of West African dance and modern dance. Hula does all of those things too. "So, it's not so

much that one form is better, it's that we, as teachers, draw out the elements that are most effective for someone with Parkinson's," David says.

Through these studies into the ways in which dance supports the PD brain, neuroscientists are beginning to better understand the ways in which dance works in all of us by mapping how it promotes blood flow and brain-wave activity, as well as a quartet of feel-good neurochemicals: dopamine, oxytocin, serotonin, and endorphins. Other studies have discerned that dance helps develop new neural connections, particularly in the areas of the brain involving executive function, long-term memory, and spatial recognition.

Music Making and Memories

Using dance to treat a movement disorder might seem unusual at first, but as the evidence mounts, it's clear why dance classes for PD are becoming a more common treatment. This reminds us of how ideas that once seemed improbable or were dismissed by the establishment can, with time and research, translate into accepted and proven interventions.

Concetta Tomaino was considered eccentric for bringing a guitar into a dementia ward in 1978. Today, Connie is the executive director of the Institute for Music and Neurologic Function in New York State, which she co-founded. She is a world-renowned music therapist whose decades of research and clinical practice have radically changed how music is used in the treatment of brain disorders. But back in the late 1970s, she was just a young graduate student with a seemingly wild theory about how music could benefit human health.

Connie arrived at that nursing home, guitar in hand, and climbed the stairs to the top floor, where people with end-stage dementia were housed. "Back then, people were overmedicated, usually very lethargic, and they had tubes in their noses and mittens on their hands so they wouldn't pull out the tubes," Connie told us. "This ward was a place most visitors and therapists wanted to avoid."

119

We understand so much more about dementia now. It isn't a specific disease; rather, it's a general term used to diagnose people with a bevy of neurodegenerative decline affecting language, learning, memory, executive and motor function, and social cognition. Globally, more than 55 million people live with some form of dementia, and 10 million more are diagnosed every year, according to the WHO. It's a challenging disease, in that it affects each person differently, manifesting in myriad ways, all of which Connie experienced on that first visit. Some of the people on the ward that day were sound asleep in chairs. Others were screaming. Some were flitting around the ward, lost and unable to pay attention, because a sustained focus that switches between tasks is highly impaired with dementia.

"And I show up with a guitar," Connie says with a laugh.

A nurse approached her, a sympathetic smile on her face. "Well, you're so sweet," the nurse said, "but these patients don't have any brains and so they won't know what's going on. But you can play for us."

Connie intuitively started singing "Let Me Call You Sweetheart," a familiar old song that she believed most people on that ward would know. Suddenly, the patients who were screaming fell silent. Those who were asleep woke up. And half of them began singing along.

Connie knew music was sound vibrations. "Something had to be happening in the brains of the patients in order for them to recognize what I was doing as a song," she explains. "And not only recognize it but sing the words." This resonated with Susan, who sings familiar songs each week with her cousin Wendy, who has dementia. It is one of the only times Wendy is fully present and alive. Susan has a playlist that includes all the songs Wendy loves, from "Amazing Grace" and "You Are My Sunshine" to "Happy Birthday" and "Yankee Doodle." It is beautiful, Susan says, to see the light in Wendy's eyes come on and know they have connected, if only for a few minutes.

After, Connie pulled that nurse aside and said, "How can you say there's nobody there? They recognize the music!"

When sound becomes music, its capacity for mitigating the symptoms of dementia or rewiring the brain after a stroke is now well docu-

mented. Neurologic music therapy, or NMT, uses shifts in rhythm, pitch, and volume to help cue movement. Music profoundly affects neurologic function. Music harnesses the many frequencies open to the human ear by creating compositions of varying tone and cadence. Music has timbre, pitch, amplitude; melody and harmony; rhythm and tempo; and it carries cultural significance. Volume affects how we perceive it—have you ever stood near the amplifier stacks at a rock concert and felt the bass literally booming through your body?

Because of its complexity, we know that music affects many regions of the brain. The auditory cortex lights up as we hear musical sounds and perceive and analyze tones. A song can trigger the nucleus accumbens and the amygdala, where we form emotional reactions. And then there's the hippocampus. It's here that we create context and memories around the experience of hearing music. Songs that we know and love go through the hippocampus to be stored and recalled, and so when Connie or Susan played or sang a familiar tune, the dementia patients and Wendy came alive.

So how is it that someone with dementia can recall lyrics to songs when they might not be able to remember their own name?

In a time before fMRI allowed us to easily see inside the brain, Connie had to create other ways to address questions like these. In the 1980s, she found a kindred spirit in the neuroscientist and writer Oliver Sacks. He had already published *Awakenings,* about a group of patients who had survived a 1920s global epidemic of encephalitis lethargica, a sleeping sickness that rendered them lethargic and with movement disorders. Sacks had discovered that administering a new drug, L-dopa, awoke these people after forty years. And *The Man Who Mistook His Wife for a Hat,* released in the mid-'80s, was being widely read. "He was this quirky guy who really didn't socialize that well, but he sent me a note because he heard I was the new music therapist," Connie says.

They became fast friends. "Back then, if you were a music therapist and a medical professional thought what you were doing was vital and important . . . well, I latched on to him immediately."

Oliver had experienced people becoming animated and mobilized

around rhythm, and he was curious about how rhythm stimulates us. But he hadn't yet connected dementia and music. Connie began telling him about her patients and how they were coming alive through music. "I had him work with some people, and he saw it too," Connie says.

Connie and Oliver created an assessment tool for understanding the different levels of neurological challenges that someone experienced, and how they might be stimulated through music. It was personalized medicine before we had a name for it.

One of the best forms of music therapy, they discovered through their research, is live interactive music, where the therapist guides and supports a patient through music-making. The patient doesn't have to be musical, but in those improvisations, the therapist is able to adjust the music in the moment to help the patient respond. A therapist might create the right environment through music to allow for people to sing, talk, or walk.

For years, Connie worked with people intensely in this way. And they were recovering. People who were deemed unable to speak began talking. Those who couldn't move began walking. "We realized there had to be something changing in the brain that allowed this to happen. These deficits weren't permanent to some degree," Connie said on the Library of Congress's *Music and the Brain* podcast.

What Connie and Oliver were figuring out was how the frequency or range of tone might provide different levels of comfort for a person, and help them to feel more connected. Several different research studies have been published showing that music played at a certain frequency decreases levels of cortisol, while increasing oxytocin, a hormone sometimes used therapeutically to treat depression and anxiety.

Think about sounds that may excite or relax you. Someone whispering versus someone screaming. The sounds that are the most calming are the ones that are in our normal vocal range. "These mid-range sounds tend to make people feel very calm," Connie said on the podcast. "Slow rhythms also do this, so think about a lullaby and create that kind of calming, self-soothing sound. It's usually a very small range of sounds that's very slow in rhythm."

Music that evokes autobiographical memories is associated with strong emotional responses. "We know that emotions are keenly connected to all our ability to either respond to something or withdraw from something," Connie says. "When somebody's listening to personally preferred, pleasurable music, some areas of the brain deactivate, like the amygdala, which is involved in withdrawal and fear."

Music that triggers nostalgia and memory activates the medial prefrontal cortex and the hippocampus, the seat of our memory-making. Familiar music is encoded in the hippocampus. A study in 2019 found that the human brain recognizes autobiographical music at super speed, in some cases in as little as 0.1 of a second. Think about the game Name That Tune and how you can remember a familiar song almost instantly.

Even back in the 1980s when Connie and Oliver were just beginning their research, scientists were concluding that patterns of sound in music reinforced the way neurons record information. "Neurons are firing in sequences and patterns, right?" Connie says. "So you have music, which is a sensory stimulus that actually matches or enhances something that's inherently already human in the way we encode information. This wonderful art form, generated by us, gets reinforced through these sound patterns."

Cognitive function comes down to how our neural networks interact with one another and recruit salient information. The more salient a stimulus is, the better the possibility of remembering or recalling information. For people who have dementia or cognitive impairment, music allows for more pathways to be aroused and stimulated. "So, if one pathway is damaged—say, for language—well, then you're going to need a couple of cues and a couple of hints to recall the information. The multiplicity of sound that's inherent in music, with all those associations and feelings and emotions, is what then allows for these very well stored subcortical processes to then come to the forefront and allows a level of function to come back," Connie explains.

Music is such an effective tool for rehabilitating neurologic and cognitive function, physical ability, and quality of life. Today, Connie brings her experience and research into professional development and

training programs that help those working with dementia patients to use music as a healing tool.

What Treatment Looks and Sounds Like

In 1906, a German psychiatrist and neuroanatomist performed an autopsy on the brain of a patient who displayed abnormal symptoms while alive. Over the course of several years, this woman's behavior, as well as her speech and language, became erratic. She forgot who people were, became paranoid and, as her condition worsened, suffered total memory loss. When her doctor dissected her brain, he found unusual plaques and neurofibrillary tangles in her cerebral cortex. He quickly alerted his colleagues of this "peculiar severe disease." The doctor was Alois Alzheimer.

More than a century later, the medical community is still trying to understand Alzheimer's disease (AD), a neurodegenerative brain disorder. The mechanisms for how the disease progresses are complex and hard to pin down. We do know that less than 1 percent of people with AD have a specific genetic mutation that causes the disease. Rather, lifestyle and environmental factors are believed to be major determinants.

What Dr. Alzheimer originally saw in that autopsied brain were deposits of amyloid beta protein, now known as amyloid plaques, as well as interwoven bundles of fibers known as tau tangles. These are thought to be two of the primary biomarkers of AD, but many yet-to-be-identified factors are also believed to be involved. Damage from AD usually begins in parts of the brain related to memory, such as the hippocampus. As it progresses, AD can affect the cerebral cortex, leading to deterioration of language, reasoning, and social behavior. This is all a medical way of saying that this disease attacks us at the very heart of what makes us human, slowly destroying brain activity and taking our memories, our relationships, and our independence along with it.

AD is now the most common form of dementia in adults, and the

sixth leading cause of death overall. Recent assessments of people over sixty-five suggest that AD may actually be the third leading cause of death. You will not find more passionate people than those who seek a cure for AD, and yet this disease has been stumping modern medicine for decades. While we are learning more and more about the role of the accumulation of plaques and tangles in our brain, the current treatments for the disease are all still focused on ameliorating the symptoms and trying to slow the progression.

If we know that aesthetic inputs affect us on a cellular level—as those heart cells dancing in the Stanford lab showed us—might targeted aesthetic treatments help with something as complex as AD?

This is a question that has motivated Li-Huei Tsai, a neuroscientist and the director of the Picower Institute for Learning and Memory in the Department of Brain and Cognitive Sciences at MIT. Li-Huei has spent the last three decades working to understand and treat neurodegenerative diseases, in particular AD. "It has not turned out to be a disease attributable to just one runaway protein or just one gene," Li-Huei explained in a 2021 op-ed in *The Boston Globe*. "In fact, although Alzheimer's is referred to as a single name, we in the Alzheimer's research community don't yet know how many different types of Alzheimer's there may be and, therefore, how many different treatments might ultimately prove necessary across the population."

AD researchers have traditionally pursued small-molecule pharmaceuticals and immunotherapies that target a single errant protein, the amyloid. But Li-Huei believes Alzheimer's to be a broader systemic breakdown, and she has thought about more encompassing, and hopefully effective, treatments. For several years now, her lab has pursued novel approaches using the aesthetic interventions of light and sound.

We know the influence that light and sound have on the human body. People suffering from seasonal affective disorder benefit from light therapy. Blue light before bed stimulates our brain and disrupts sleep. Sound vibrations, as we shared in Chapter 2, change our physiology. But how might this work on a brain experiencing AD?

Our neurons generate electrical signals to communicate at several different frequencies, and these form oscillations, or brain waves.

These are measured in cycles per second, or hertz, and there are five types of brain waves that are read on an EEG: delta, theta, alpha, beta, and gamma. Delta, the slowest of our brain waves, occur when we're asleep. Theta waves happen when we're extremely relaxed and are awake, but are in a dreamlike state. Alpha waves happen when our brain is, in effect, idling; we're relaxed, but ready to respond if necessary. Beta waves happen when we are alert and paying attention. And gamma waves are the fastest, most subtle of the brain oscillations and are associated with our perception and consciousness.

Researchers have noticed something notable in mice who have been genetically modified to have AD for the purposes of research. They have disruptions to their gamma oscillations when they are performing a task such as running through a maze.

It's believed that gamma oscillations, which range from 25 to 80 Hz, play a role not only in conscious cognition but also in memory formation. There's evidence that gamma rhythms are important for hippocampal memory processing. It follows, then, that a brain disorder like AD, which impairs memory, might include disturbances in gamma wave rhythms. Li-Huei had a theory: Would introducing gamma oscillations from another source—light and sound—help to resynchronize neurons and reduce Alzheimer's pathology?

Li-Huei turned to optogenetics, a form of noninvasive sensory stimulation, to encourage groups of brain neurons to move and, hopefully, synchronize their firing patterns again. It was a curious first-year student in Li-Huei's graduate program who then suggested researching gamma oscillations at 40 Hz. Gamma waves at 40 Hz have already been shown to affect human brain waves, significantly increasing the overall brain oscillation. Current research suggests that exposure to a light or sound at 40 Hz promotes gamma brain-wave activity through brain-wave synchronization.

In 2016, the lab developed a device that produced 40 Hz of gamma waves through a flickering light device. Mice with AD were exposed to the light for one hour a day. State-of-the-art technology, such as magnetoencephalography (MEG), electroencephalography (EEG), and fMRI were used to investigate and visualize brain oscillation changes.

After just one hour of light, "we saw profound reduction of amyloid peptides," Li-Huei says.

The reductions were primarily in the visual cortex of the brain, so Li-Huei and her team wondered if adding in sound would allow the treatment to reach other areas of the brain. They exposed mice to one hour of sound tones that were set at 40 Hz. This happened for seven consecutive days. One week of this sound therapy dramatically reduced the amount of beta amyloid in the auditory cortex, the area of the brain associated with processing sound, as well as the hippocampus, which is located nearby. After one week of this treatment, the mice had also vastly improved cognition and were able to better navigate a maze.

With sound and light together, there were even greater results. As Li-Huei recounted her findings to us, we were astonished. "When we combine visual and auditory stimulation for a week, we see the engagement of the prefrontal cortex and a very dramatic reduction of amyloid," Li-Huei explains. There was also a reduction in tau tangles, and the synaptic density that had been compromised by AD increased along with neuronal density.

Sound and light seemed to be erasing AD pathology and improving cognition. "Some people have said to me that this is too good to be true. How can anything be so effective and also be so simple?" Li-Huei says. "I know, it might sound like a fairy-tale kind of story, but that's what we're seeing."

Now that she knows light and sound work, the next step is determining exactly why that is. There have been numerous theories, but currently Li-Huei believes that increased gamma oscillations in the brain engage many different systems and cell types. Because of this, the gamma waves may help with amyloid removal, for instance, through various brain waste-clearance mechanisms. The light and sound treatments stimulated the activity of cells known as microglia, which are debris-clearing immune cells that influence brain development. The treatment not only spurred changes in microglia but also in the blood vessels, "possibly facilitating the clearance of amyloid," she told us.

There's a fluid that fills the cavity in our brain that's called cerebro-

spinal fluid (CSF). The CSF can enter the brain tissue and travel along the blood vessels. The CSF then will mix with the interstitial fluid of the brain. "So, if you have any kind of a waste substance in the brain, outside the cell, the CSF can flush it out and clear it through the lymphatic system," Li-Huei says. "We found that increased gamma oscillations actually promote the CSF entering into the brain and promote this kind of waste-clearance mechanism."

The combined visual and auditory treatment has now been tested in healthy human volunteers to assess its efficacy and safety, and the researchers are beginning to enroll patients with early-stage Alzheimer's for a study.

Li-Huei is now translating the breakthrough science in her lab into therapeutic devices. One device is composed of a two-by-two-foot light box containing hundreds of white LED bulbs and a sound bar capable of delivering sound clicks at 40 Hz. A person can sit in front of it about six feet away and use it for about an hour a day. Early studies of the effects of this aesthetic intervention have found that using light and sound in this way induced those gamma oscillations in the brain, maintained functional connectivity in several brain networks, and slowed brain atrophy. Just as sound waves move heart cells, light and sound are changing brain oscillations to support healing.

Attention to Life in Death

"No one suspects the days to be gods."

Ralph Waldo Emerson wrote this in a letter to a friend in the late 1800s, and he meant it as a reminder that the splendor of nature, and of our lives, exists all around us if only we could just learn to pay attention and see it clearly. So much beauty and meaning is obscured by our preoccupations, and we miss the treasure that is this moment, this day.

The end of a life deserves this kind of attention. It is, like a birth, momentous. There is sorrow. There is fear and questioning as shifts in

physical and mental capacity come and go. Caught in the wake of emotions and in the medical realities that often surround palliative and hospice care, we can miss the chance to seek meaning and authenticity in our final days.

Two of the biggest regrets of those who are dying, according to Bronnie Ware, a palliative care volunteer who wrote the bestselling memoir *The Top Five Regrets of the Dying,* are the wish that they'd lived a life true to themselves versus what others expected, and that they'd had the courage to express their feelings more often.

For Abigail Unger, director of expressive therapies at Hospice & Palliative Care Buffalo, it is never too late to live that life, even when one is dying.

Regardless of age, race, gender, setting, or diagnosis, the expressive arts therapies—art, music, dance and movement, the healing touch of massage—provide opportunity for meaning and solace to those with terminal illnesses and those who are on that journey alongside them—patients and their families at Hospice & Palliative Care Buffalo.

For some, that journey has been a long one. Abigail and her team work in various care environments, including nursing homes and assisted living facilities with the elderly, where they use music and art therapies to help individuals take stock of their lives, and to consider what they hope to leave behind. "Music and art are things that can last forever, past an individual's death," Abigail told us one afternoon from her office in Buffalo. Behind her, pinned to a corkboard, were drawings from people she's worked with and song lyrics they've written together. Abigail studied music and anthropology, and is trained in voice and on multiple instruments with advanced coursework in social work; it is the combination of the arts and the social sciences that has helped her to build an effective, evidence-based arts therapy program.

Abigail, for instance, helps individuals create autobiographical songs that express their love and capture the essence of who they are. Frequently, Abigail and her team work with those suffering from dementia, and it is the music that brings them back to life, if even for a few moments, as Connie Tomaino's research has shown. As one daughter of a dementia patient told Abigail, "I want to thank you. I never

imagined that some of my best memories with my mother would happen here, in a nursing home, at the end of her life."

Patients and families have told Abigail that the "musical medicine" does more for them at times than the traditional medication that their doctor provides. Expressive therapies can trigger neurological and physiological responses that can help relieve various symptoms and distress—physical, mental, and emotional—as well as improve quality of life and well-being at the end of life. Dopamine, serotonin, and oxytocin released in the making of music and art can help to relieve anxiety and depression. The act of communicating about their lives through songwriting and making autobiographical art can help to ease loneliness and isolation, engaging one in both self-expression and meaning-making as well as fostering interaction and connection with others. When the expressive art involves some form of touch, be it through hands-on art- and music-making, dance and movement, or intentional massage, the act of touch releases oxytocin, which has been found to promote sleep and lower blood pressure and heart rate in those who are in palliative care.

The Essential Care for Children program at Hospice & Palliative Care Buffalo offers home-based programs for kids, their siblings, and caregivers. "To even conceive of a child being ill and dying is so unjust," Abigail says.

The program has also had exceptional success in creating an environment conducive to caring for families as a whole. Everyone in the orbit of the individual patient is going through major transitions. The expressive therapies team works with parents, siblings, and caregivers to help give voice to their experiences as well. Legacy, family bonding and coping, and opportunities to process issues and experiences of well-being and comfort are often goals for patients.

One of the reasons Abigail and the credentialed arts therapists are so successful is that they use music and expressive arts therapies to meet patients where they are. "If I see a certain patient every week with session goals of increased self-expression and moments of joy and socialization through music, but upon arrival discover this individual is in pain, I am going to address the pain with our music instead," Abi-

gail says. "Because we have established a rapport, I may facilitate progressive muscle relaxation and create a music experience that addresses and, ideally, cares for both their experience and the expression of that experience."

Abigail continues, "We always meet the patient where they are and then help to get them to a more regulated state as needed." The expressive therapies team often finds that there is almost a sense of "dosing" the arts interventions based on the presentation or the experiences that arise when working with a patient. If somebody is agitated, the provision is a customized arts intervention to soften the edges, relax, and ideally restore a restful state. On the flip side, if somebody is depressed, isolated, and withdrawn, arts therapies can initiate change and movement to draw out expression and to engage an individual.

This kind of work facilitates what's known as entrainment, which is perhaps the most widely studied social motor coordination process and is often innately at play within the experience of music, dance, and movement.

Have you ever noticed that when two people are rocking in chairs next to each other, they end up rocking in sync? The same goes for walking. Or have you ever noticed how entering a lively social event can amp up your own energy levels so that you suddenly feel like you, too, have been hit with a jolt of energy?

Entrainment is when our bodies, through sound and electron brain waves, sync with one another. Music also changes physical states. It triggers oxygen and blood flow, aids in orientation and cognition, and promotes engagement with others through movement and activity.

Another important aspect of end-of-life care, according to Abigail, is acknowledging, validating, and witnessing what's happening for the patient and their family. That's very different from attempting to change someone at the end of their life. In fact, not everyone is interested in singing and dancing at the end. A poignant reminder that no therapy is one-size-fits-all but that there is something out there in the field of arts and aesthetics that could benefit everyone.

Marian Diamond learned something valuable when conducting her experiments about how the brain changed in an enriched environment:

the power of choice and autonomy. She found that when mice had the opportunity to play on an exercise wheel, it changed their brains for the better, but *only* when they took to that wheel voluntarily. When they were forced onto the wheel, it was actually stressful and damaged the brain, thus mitigating any positive effects of enrichment. Finding an arts and aesthetic therapy that helps the brain is as important as finding one that does not create additional stress for a person.

After someone dies, Hospice Buffalo also offers grief and bereavement sessions to family for up to one year, using creative arts therapy to help make sense of the loss.

The arts offer measurable health benefits throughout your life. And they provide meaning, beauty, and connection until our very last moment on Earth.

Feeling Good

Modern medicine is moving toward treating the whole person, not just the illness. Healing your body—or preventing diseases in the first place—is about far more than addressing symptoms. The arts and aesthetics are increasingly being used as medicine around the world precisely because they have the capacity to engage multiple physiological and neural systems that not only help the body to heal but that also mend the mind and lift the spirit.

One study of 195 Cleveland Clinic patients with a range of medical conditions revealed that engaging in the arts significantly lowered their pain and improved their moods. Healthcare practitioners, along with many others, have also been experimenting with aromatherapy. Patients waking from anesthesia or those experiencing anxiety about being in the hospital are using specific natural scents like peppermint and lavender.

And the design of healthcare spaces is seeing an overhaul with the neuroarts in mind. We know, for instance, that light influences both mood and physiology. Access to natural light and greenery promotes

healing: In one study, patients who had windows with a view of nature had shorter hospital stays than those who did not, and, interestingly, they took fewer pain medications.

Neuroarts-based design choices are even helping to mitigate serious conditions resulting from intensive care hospital stays, such as post–intensive care syndrome, or PICS. This is a set of physical, mental, and emotional symptoms that is partially attributable to the fact that patients have completely lost their circadian rhythm in a space where lighting rarely changes. Your circadian rhythm is set to the rise and fall of the sun. As the sun sets and the light diminishes, it triggers your melatonin secretion, which helps you fall asleep. In ICUs, though, the light level rarely changes, and this can severely disrupt our natural sleep cycles. Simple adjustments to lighting design is one resolution.

Imagine if the arts, in service of our health, were reliably delivered on a day-to-day basis to ease some of this world's enormous suffering. Imagine how we all might show up to the rest of our lives. Martha Graham, the great dancer and choreographer, once said that "the body is a sacred garment." Physical health and well-being is the foundation for everything in our lives.

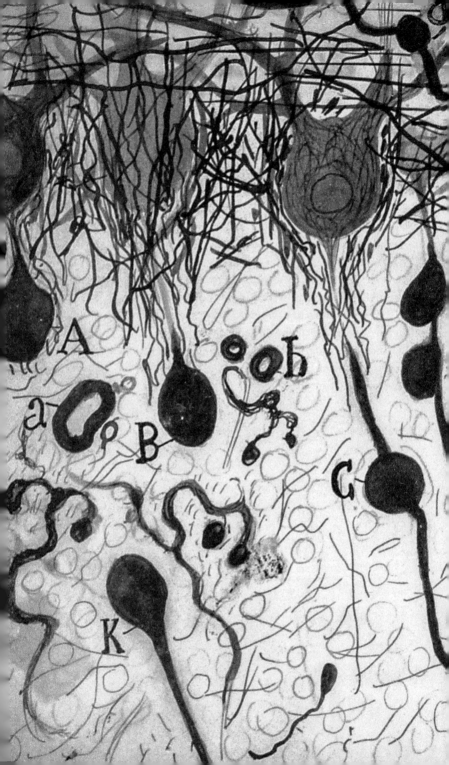

Amplifying Learning

What you learn today, for no reason at all, will help
you discover all the wonderful secrets of tomorrow.

—NORTON JUSTER, AUTHOR

One of our favorite writers, the late Kurt Vonnegut, famously gave advice to a high school class when they asked him to define a successful life. His counsel, written to them in a letter, was this: "Practice any art, music, singing, dancing, acting, drawing, painting, sculpting, poetry, fiction, essays, reportage, no matter how well or badly, not to get money and fame, but to experience becoming, to find out what's inside you, to make your soul grow."

Vonnegut liked to say that a person got an enormous reward from these activities: "You will have created something."

Creating something is at the core of learning. Generating new synaptic connections in the brain is, quite literally, how we create knowl-

edge. Learning is what our brains and bodies are doing all the time. Neuroscientist V. S. Ramachandran captured the essence of this phenomenon in his book *A Brief Tour of Human Consciousness,* writing, "It never ceases to amaze me that all the richness of our mental life— all our feelings, our emotions, our thoughts, our ambitions, our love life, our religious sentiments and even what each of us regards as his own intimate private self—is simply the activity of these little specks of jelly in your head, in your brain. There is nothing else." This fascination with how our brains work is beautifully represented in the playful image on the facing page created by Santiago Ramon y Cajal, the famed Spanish neuroscientist who created many drawings to illustrate our early understanding of neuroanatomy.

Here, we're going to explore the ways in which the little specks of jelly in your head gain and consolidate knowledge through the creation of the arts and immersion in aesthetic experiences.

We're not talking about education. Education is the human-created system used to deliver information, one that hasn't really changed much in the last two hundred years or so. Pedagogy is not to be confused with the neurobiology of *learning.* The brain doesn't care about filling in bubbles on standardized tests or heated debates about curricular assessments. Our brain is structured to build new connections and to constantly evolve, and how we learn is not the same as a societal education system too often built around memorization of rote data and recall.

Knowledge is more than just cognitive intelligence. The best learning is a knowing that cultivates wise discernment and understanding, and that evolves and grows over a lifetime. We are driven to learn. We long to fit the puzzle pieces together, to solve the mystery, to figure things out. We are a curious and questioning species by nature. Our desire to learn is innate, and if we're lucky, we won't have it tamped out of us. The best kind of learning sparks curiosity and, in return, endless discovery; it's your own renewable energy source.

Learning is, from a neurobiological perspective, a dynamic process driven by experiences that change your brain in enduring ways. When your brain is learning, it's making and shifting synapses to sculpt new

circuits that weren't there before and that encode memory. Salient experiences enhance synaptic plasticity, as noted in Chapter 1. Neuroscientist Rick Huganir explained it to us this way: "The more salient something is, the better we learn. This is why a dynamic presentation grabs your attention and also excites you," he says. "It's not the boring lecture that helps you learn, it's the salient experience that helps consolidate that memory."

Learning comes in many forms: cognitive, emotional, embodied. There is explicit learning, where you actively seek knowledge, and implicit learning, where you passively take in experiences that change you. Many elements go into making experiences more salient for learning, among them novelty, humor, curiosity, attention level, creativity, motivation, environment, and the unique way your brain develops. Lifestyle factors also dictate how ready your brain is to receive and retain information, such as having enough sleep, a healthy diet, and hydration. As the people you will meet in this chapter show, the arts create more salient experiences, triggering plasticity, neural connections, and greater understanding. When the arts and aesthetics are integrated into education, work, and life, we strengthen our capacity to learn.

The Arts Advantage: The Early Years

Gustavo Dudamel can pinpoint the precise moment when his life changed. It came in 2007 when he was not yet the famous and highly decorated music and artistic director for the Los Angeles Philharmonic that he is today. Dudamel was a twenty-six-year-old leading Venezuela's Simón Bolívar Symphony Orchestra. And he was doing so in front of a packed theater of classical-music lovers in London.

To better understand the magnitude of this moment, it helps to know how Dudamel got to stand on the podium that night. He was born in 1981 in a poor community in Venezuela, but despite growing up with modest means, Dudamel started learning the violin at age

four. This was thanks to El Sistema, a music program founded in Venezuela in 1975 to bring free musical instruction and instruments to impoverished youth. El Sistema teaches children how to play in the context of an orchestra. Really, it aims to instill vital early childhood development skills through the arts. Their mission isn't to create professional musicians (though, as in Dudamel's case, that is one excellent outcome) but rather to foster important cognitive, social, and emotional skills in early childhood and build a foundation for a successful life.

The Simón Bolívar Symphony Orchestra was composed of other Venezuelan children who had, like Dudamel, learned to play thanks to El Sistema. Dudamel led the players through a tour-de-force performance that was capped by not one but three encores, including Leonard Bernstein's "Mambo" from his *West Side Story* score. The musicians, solid in their craft, erupted in a boisterous interpretation of Bernstein's song. The drums and horns laid out a mambo beat; the string section stood and danced as they played. Soon, the audience was out of their seats, too, enrapt and smiling, laughing and clapping along. Dudamel led his colleagues, his friends, with an infectious joy, and when the final note played, the applause was deafening. "It was a historic moment," he said in a 2021 BBC interview recalling that night. "For me as a conductor, it was the moment where the rocket went up."

The El Sistema philosophy has been modeled in dozens of programs around the world, several of which have been studied by researchers interested in quantifying how art at an early age influences brain development. Dudamel helped to build a youth orchestra in Los Angeles based on the El Sistema model, and it provides free instruments and intensive music training to 1,500 students, aged six to eighteen, from underserved neighborhoods in Los Angeles.

In one longitudinal study, the results of which were published in 2018 in the *Journal of Youth Development,* researchers from Florida International University examined whether participation in an El Sistema–inspired program, the Miami Music Project, enhanced students' social, emotional, and academic learning.

The research team tracked 108 participating students aged eight to seventeen over the course of a school year to see if social-emotional

A

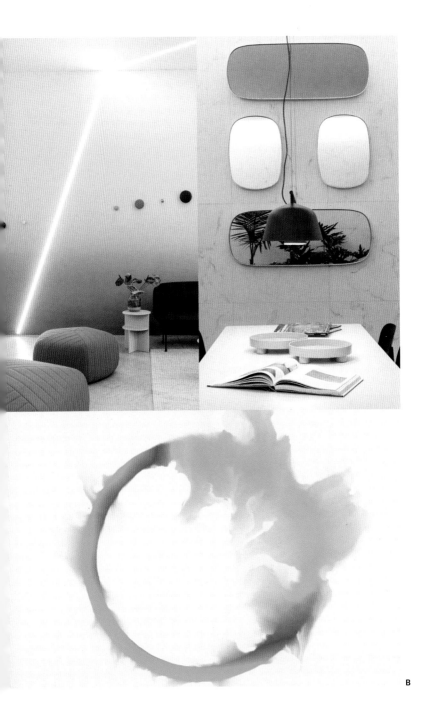

c

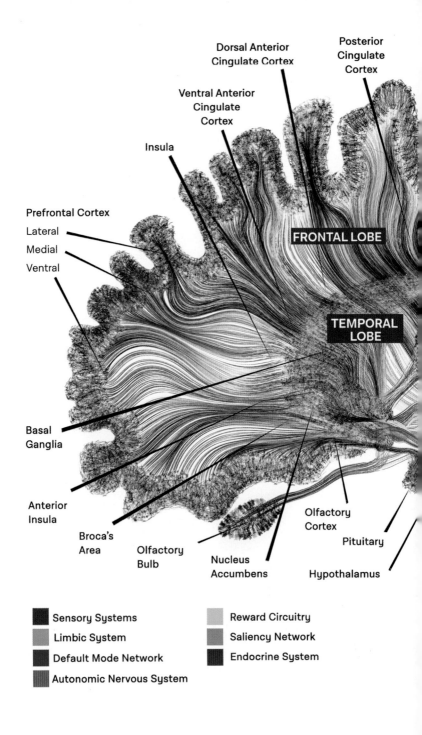

Dorsal Anterior Cingulate Cortex

Posterior Cingulate Cortex

Ventral Anterior Cingulate Cortex

Insula

FRONTAL LOBE

Prefrontal Cortex
Lateral
Medial
Ventral

TEMPORAL LOBE

Basal Ganglia

Anterior Insula

Broca's Area

Olfactory Bulb

Nucleus Accumbens

Olfactory Cortex

Pituitary

Hypothalamus

Sensory Systems

Limbic System

Default Mode Network

Autonomic Nervous System

Reward Circuitry

Saliency Network

Endocrine System

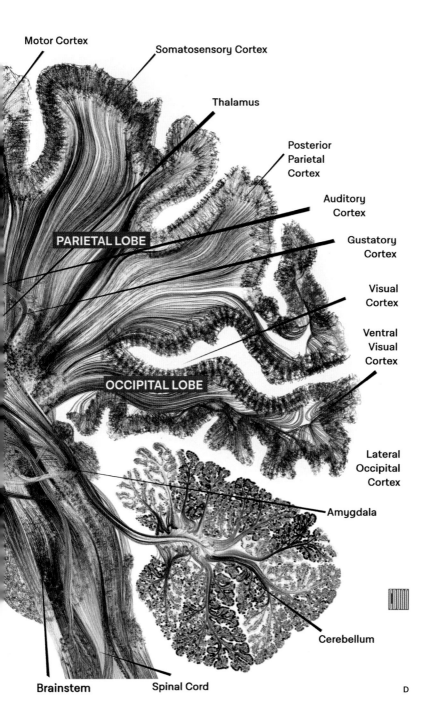

Motor Cortex

Somatosensory Cortex

Thalamus

Posterior
Parietal
Cortex

Auditory
Cortex

Gustatory
Cortex

PARIETAL LOBE

Visual
Cortex

Ventral
Visual
Cortex

OCCIPITAL LOBE

Lateral
Occipital
Cortex

Amygdala

Cerebellum

Brainstem Spinal Cord

D

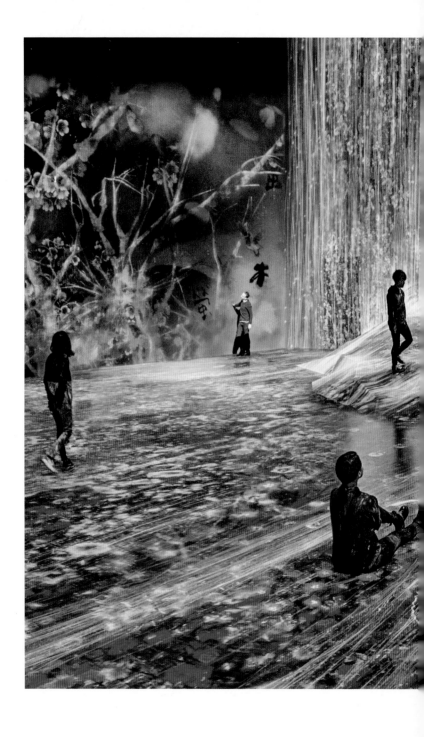

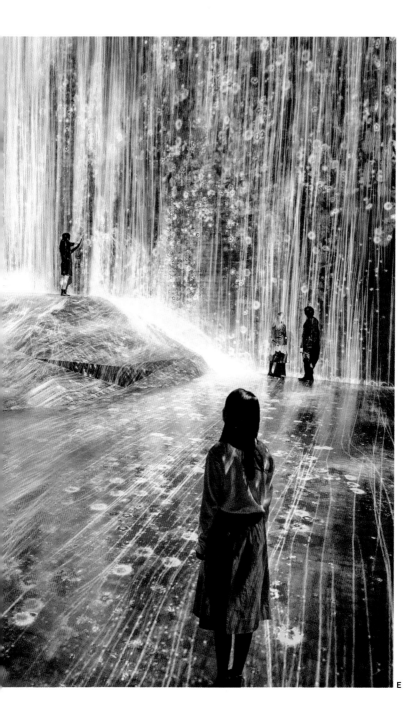

E

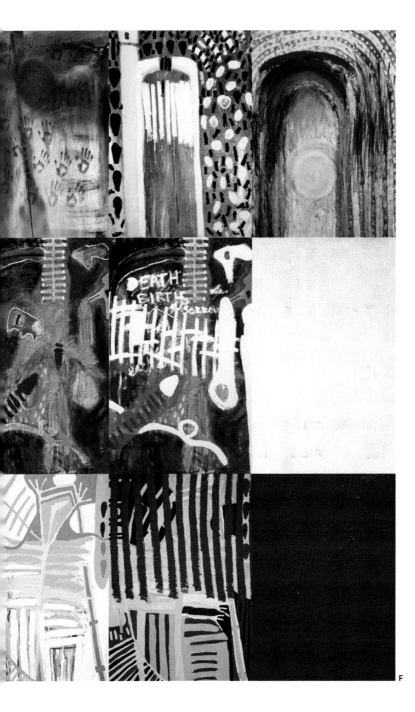

F

G

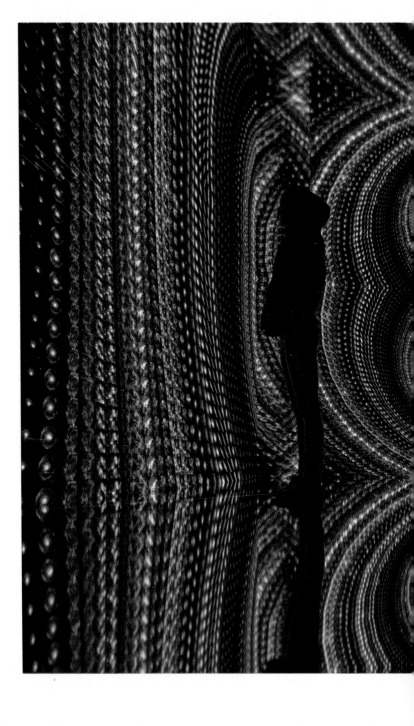

skills, such as competence, confidence, caring, character, and connection improved. They employed standardized measurement scales to assess these qualities. For instance, character was determined using a self-reported methodology known as the Grit Scale, which asked the students to rate themselves based on questions like "I finish whatever I begin."

They also interviewed parents and teachers, collecting information on stress, discrimination, academic grades, history of musical involvement, music class attendance, frequency of home practice, progression with learning music, and participation in concerts.

By the end of the year, their results revealed that participants had gained "significant increases" across all characteristics as compared with the control groups. A majority of parents also reported that their child's academic performance improved over the year.

In Los Angeles, neuroscientist Dr. Assal Habibi from the Brain and Creativity Institute (BCI) at the University of Southern California has been studying the brains of young musicians in the Youth Orchestra Los Angeles (YOLA) too. In 2012, the Los Angeles Philharmonic Association partnered with BCI on a five-year longitudinal research collaboration of participants in its youth orchestra. Assal monitored changes in twenty children who were learning to read music and play orchestral instruments beginning at age six, and they compared them with children in control groups.

Using fMRI, Assal found that musical training changes the brain structure and boosts engagement in the brain networks responsible for decision-making. In one set of published findings, her lab showed that when young musicians performed intellectual tasks, they demonstrated a greater engagement of a brain network involved in executive function and decision-making. They also concluded that "music training accelerates brain maturity in areas of the brain responsible for sound processing, language development, speech perception, and reading skills." Playing music not only stimulates multiple regions of the brain—motor, auditory, visual—it strengthens the neural connections between them, and enhances memory, spatial reasoning, and literacy skills in the process.

Connecting the Dots Between the Arts and Plasticity

What these studies help illuminate is how the arts amplify the social, emotional, and cognitive elements of learning at an early age. And it goes back to brain plasticity.

Think of how much is learned in the early years of a life: crawling, walking, talking. These learned skills are sculpting the circuitry of the brain though plasticity. As you get a little older and begin to practice skills, neurons connect and those activities become easier. Practice a song, and soon you know it "by heart," which, technically speaking, is "by brain." Learn a dance, and soon you can perform its steps without consciously thinking because the neurons connect to dendrites and over time that builds a habit.

Your unique life circumstances and surroundings also help to form your brain connections. The brains of humans are born immature for a reason. By delaying the maturation and growth of brain circuits, initial learning about the environment and the world around us can influence the developing brain in ways that support more complex learning. This is why the environment, and engagement from the moment you are born, is so critical. A more enriched environment contributes to better neural connections—as evidenced by that research from Marian Diamond, and many others since—such as the enrichment the musicians in El Sistema are exposed to. Impoverished environments too often result in reduced synaptic circuitry.

There's been a lot of interest in how the arts specifically enhance learning through plasticity. One study from 2010 looked at the adult brains of professional musicians, and the findings offer insights into childhood brain development. Researchers saw that musical expertise had an effect on the structural plasticity of the brain in the hippocampus. The hippocampus is an area of the brain that facilitates the storage and retrieval of information. The ability to learn and play music is very complex, and it marshals the hippocampus and its many connections to other brain areas. When compared with nonmusicians, the musicians had formed more neural connections and gray matter.

Originally, neuroscientists hypothesized that the hippocampi of musicians had more gray matter than nonmusicians because they were born that way, already equipped with the tools they needed to learn and play music. But now neuroscientists hypothesize the opposite: Because they practiced their instrument and mastered their art over the years, musicians built more robust synaptic connections in their brain. Art enhances the ability of the hippocampus and the other areas of your brain to perform the tasks that they were designed to do by increasing the synaptic circuits. This helps not only in the playing of music but in any life activity where learning and memory are needed.

In other words: Practicing music increases synapses and gray matter.

The results of the study correlate with the findings in the YOLA study in Los Angeles. The researcher found that children receiving music instruction had changes in the size of the brain regions that are engaged in processing sound. It got bigger. And "the young musicians also showed a stronger connectivity in the corpus callosum, an area that allows communication between the two hemispheres of the brain," according to the findings.

These neurological benefits extend beyond music. The National Endowment for the Arts, NEA, has been studying and supporting studies that examine the effect that the arts have on young brains for decades, offering insight into how the arts support emotional resilience in children and adolescents as they learn.

In 2015, Melissa Menzer, a program analyst in the Office of Research and Analysis at the NEA, performed a literature review focused on the social and emotional benefits of arts participation during early childhood. A literature review is when an investigator gathers and synthesizes the published studies and data from other researchers in order to identify what can be gleaned from the full body of work.

Menzer was specifically interested in studies focused on the social and emotional benefits of arts participation in early childhood, including music-based activities like singing, playing musical instruments, dancing, drama/theatre, and the visual arts and crafts.

Included in that literature review was a reference to a 2011 NEA report indicating that "in study after study, arts participation and arts

education have been associated with improved cognitive, social, and behavioral outcomes in individuals across the lifespan, in early childhood, in adolescence and young adulthood, and in later years."

Children who regularly participated in dance classes had increased those mood-boosting neurochemicals we've already mentioned, which resulted in social-emotional, physiological, and cognitive development, but it also offered a path for safe exploration and expression of feelings and emotions. It also helps to build strong spatial cognition in children, which has been associated with increased skills in math, science, and technology later in life. And perhaps most vital for childhood development, Menzer found a research study indicating that children who regularly attend a dance group develop stronger prosocial behavior, like cooperation, while overcoming anxious and aggressive behaviors, when compared with kids who didn't dance.

The 2015 NEA literature review also found that when kids are engaged in the arts in the pivotal age range of 0–8, they were better able to collaborate with peers and communicate with parents and teachers. The studies cited in the literature review reflect similar results that other researchers are finding when studying El Sistema students.

Other studies of arts in education over the years have proven that students involved in arts are good academically. Students with access to arts education are five times less likely to drop out of school and four times more likely to be recognized for high achievement. They score higher on the SAT, and on proficiency tests of literacy, writing, and English skills. They are also less likely to have disciplinary infractions. And when arts education is equitable so that all kids have equal access, the learning gap between low- and high-income students begins to shrink.

One word you'll often hear in research and education circles is "transfer." It refers to the way that one skill—learning an instrument, for instance, or engaging in the act of painting or drawing—transfers over into other aspects of our lives.

In 2007, psychologist Ellen Winner and professor Lois Hetland, chair of art education at Massachusetts College of Art and Design and a senior research affiliate in the Harvard Graduate School of Education, were two of the first to study the ways in which learning an art

translates into other life skills. Hetland and Winner developed a quali-
tative ethnographic meta-analysis of skills being learned, specifically
through the visual arts. Beyond improving the skill of the art form
being taught, they wanted to quantify what else individuals were learn-
ing in the process.

They concluded in their book, *Studio Thinking: The Real Benefits of
Visual Arts Education,* that, through the visual arts, individuals were
taught to observe and see with acuity; to envision by creating mental
images and using their imagination; to express themselves and find their
individual voice; to reflect about decisions and make critical and evalu-
ative judgments; to engage and persist, by working even through frus-
tration; and to explore and take risks and profit from their mistakes.

Building Executive Function

Many of the skills identified by Hetland and Winner fall into a funda-
mental area of learning known as *executive function.* Executive func-
tion is, quite literally, your capacity to manage your thoughts, actions,
and emotions in order to achieve your goals. Executive function refers
to a number of cognitive activities that take place via neural networks
in multiple regions of the brain, including the prefrontal cortex, pari-
etal cortex, basal ganglia, thalamus, and cerebellum, and it allows you
to plan, make decisions, and inhibit impulses that might distract from
your goals. Strong executive function is critical, particularly in an ever-
evolving world that requires you to think on your feet and follow
through on tasks. Imagine if every time you set out to do something,
like read a page of this book and retain that information, you got men-
tally distracted and couldn't remember what you just read. That's a
lack of executive function. These neural connections evolve over child-
hood and adolescence, and the more you build these neural networks
in your early years, the stronger the scaffolding for learning and execu-
tion of ideas and action.

Ellen Galinsky has studied executive function and learning for many
years, coalescing her findings in numerous books, including the best-

selling *Mind in the Making*. She has served as the chief science officer at the Bezos Family Foundation for six years and has been the president of the Families and Work Institute for more than thirty years.

Ellen interviewed more than 100 researchers for *Mind in the Making*, and, she told us, "one of the things I discovered is that even though researchers might have different names for it, the importance of executive function to learning is huge." Ellen was also one of the first researchers to ask children what *they* think for a series of ongoing studies called *Ask the Children*. Such a simple concept, but you'd be surprised how rarely that happens. She discovered that too many kids were turned off by learning, which seems shocking given that we are born to learn. Little children want to see, taste, touch, and experience everything, and so, Ellen concluded, we as a society are doing something to thwart that innate drive we all have to understand our world, to learn, and to wonder. That finding led to *Mind in the Making*.

In these most critical years where children develop attention-based executive function skills, we are losing the engagement and interest of too many kids. There are three primary neurological aspects of executive function—working memory, cognitive flexibility, and inhibitory control. Executive function also depends on reflection. These mostly take place in the prefrontal cortex, but they must connect with other parts of the brain in order to work. Since the most effective learning involves recruiting multiple regions of the brain, this, Ellen explains, is where the arts come in. The arts activate the neural connections related to executive function as well as other regions of the brain and actively strengthen them.

A lack of executive-function skills leads to kids who struggle not only in school but in life. Social function and overall cognitive and psychological development can be impaired. Studies have begun looking at the ways in which arts intervention helps to foster executive function in children's brains. In one such study, seven-year-olds were split into two groups, one that had arts integrated into their curriculum for a period of six months and another that did not. Afterward, the researchers tracked progress related to executive function, such as collaboration, conflict management, inclusion, vocabulary, and confidence, which are all considered indicators of strong executive-function

development and academic outcome. Those who were in the arts-based group were reported to have much higher skills related to these attributes.

In another study, researchers followed a group of adolescents enrolled in a high school theatre program. They conducted open-ended interviews with teenagers every two weeks over a three-month period and observed rehearsals, noting that during those sessions teens experienced a range of emotions from frustration and nervous anxiety to anger and joy, and that theatre offered a constructive space for those emotions to play out safely. Drama helps with perspective-taking and empathy-building, which are vital to executive function. In the case of theatre, student actors are being asked to inhabit roles, to sympathize with characters, and to collaborate closely with other students in order to realize a shared outcome—the play.

Actors must draw upon the cognitive aspects of memory, observation, and imagination. Acting also triggers mirror neurons in the brain, which are how we understand ourselves and the actions of others. Mirror neurons are activated in the actors, as well as the audience. When you watch an actor give an authentic performance, you can feel what that character is feeling. In daily life, when you see someone smile, the mirror neurons in your brain for smiling fire as well. Mirror neurons help you to bridge the gap between self and other in order to build empathy, understanding, and to create shared human experiences.

Learning is about so much more than textbook mastery. True learning is the scaffolding for a vibrant, resilient life, and the arts are vital to building that cognitive infrastructure in children through the formation of strong executive function.

Higher Learning

Something had been eating at Daniel Levitin for years as it related to learning and higher education. Dan is a neuroscientist and cognitive psychologist and a popular professor. For years, Dan taught an Introduction to Cognition class at McGill University in Canada. Seven hun-

dred students crowded into a large lecture hall, and Dan did his best to make it personalized. He remembered as many names as he could over the semester, but seven hundred? Impossible. He was working really hard to teach, and yet he wasn't sure how much his lessons were sticking. It's that transfer idea again: Does a person in such a large lecture format retain the information so that it becomes real knowledge?

Many of these students could pass the quizzes and write a decent paper on the subject during the semester, but did that translate to them taking away that information for life?

Dan was dismayed to learn that studies on memory found that one month after a college course ends, students typically retain 80 percent of the material, but after a year or more, it was more like 10 percent. "There's an implicit contract that we're educating these students, but we're not. We're entertaining them," Dan told us. "There's not a lot of *learning* going on there."

Dan had an idea. He started playing music as the students filed in. "I'd tell them about what they were listening to, and it motivated them to come to class early because they didn't want to miss the music," Dan told us.

The music worked to create a positive culture in the classroom, so Dan decided to use principles of music, like pitch and tone, to help explain key ideas about brain cognition. Dan made a bet that his students would take in the content better when the arts were involved. And more so, they would remember it.

In general, memory is our capacity to recall something. To remember a poem by heart; to locate the book we put down yesterday; to dive into a lake and know how to swim; to pair a face with a name.

There are three functions that neuroscientists consider the trifecta of cognitive processing: attention, learning, and memory. These behaviors are all intricately connected and are the basis for why we have a brain. Our brain helps us to survive in our environment, but our environment is always changing, so our brain has to adapt. A major task of your central nervous system is to link sensory information and internal representations—ideas—to adaptive responses. This is where our trifecta of cognitive processes comes in. *Attention* is the process

that allows us to focus on certain environmental conditions. In order for learning to occur, we must focus on or attend to certain events while we block out other events. *Learning* is the acquisition of knowledge about the world. *Memory* is the retention or storage of that knowledge. In order for learning to be adaptive, or useful, we must have a mechanism to store what we have learned. These three concepts are intricately connected. You can't learn if you don't pay attention and you can't remember if you don't learn.

New information is encoded by the hippocampus and then converted into long-term memories, which can be recalled years later. Learning involves clusters of neurons making new connections throughout the brain; the more you train those neurons to fire together, the easier it becomes for a pathway to form and become strong, and this is why practice and repetition are keys to mastery.

When your neurons fire in such a way that we can recollect an original experience, that's one type of memory. Short-term memories, as the name suggests, stick with you only as long as we need them, like memorizing a street address for a restaurant you may only go to once.

What helps a memory become long-term is how much emotion and novelty are associated with an experience. This is because the hippocampus, which is converting new information into long-term memories, also receives inputs from the thalamus, prefrontal cortex, and amygdala.

Dan understood that to encode something into the long-term memory, the students needed compelling lesson plans. There have been numerous studies on how listening to and performing music supports not only the laying down of memories but also our capacity for recall. Music activates areas of the brain associated with memory, reasoning, speech, emotion, and reward. Two separate studies, one in Japan and one in the United States, both found that healthy older adults scored higher on memory tests when their weekly classes included musical accompaniment.

An enriched presentation using music helps with memory because it triggers those important chemical reactions in our brain that spur plasticity. If your professor is using a Taylor Swift song to explain human perception, for instance, it hooks you. "Professor Levitin was funny,

engaging, spontaneous, and dynamic, and I found myself literally sitting up straight in my chair to pay attention," recalled one of his students, Dale Boyle. "The way he linked cognition to music was the motivation I needed to do well in the course."

In a clever turn, Boyle wrote his thesis on Dan's use of music as a teaching tool. He spent months studying the data on how arts in the science classroom supported learning retention, and how well Dan's students retained information owing to the novelty of the presentations.

A novel program at Arizona State University, ASU, is unleashing motivation and learning through the arts by using a fully immersive virtual reality program. In 2020, ASU partnered with Dreamscape Immersive, a company that marries computer programming with Hollywood movie savvy. The co-founder and CEO of Dreamscape Immersive, Walter Parkes, is a former film producer known for blockbuster movies like *Gladiator,* and he's been working with ASU as they refine a platform that can track users—in this case students in science and technology classes—as their avatars interact in real time with the virtual world. Imagine learning about planetary science and biology through a program called Alien Zoo, which whisks you to a wildlife sanctuary for endangered life-forms. The story of Alien Zoo was developed by Parkes, along with Steven Spielberg.

Students using the program, which replaced traditional teaching methods in an introductory biology course, said it made them feel like real scientists. ASU's Action Lab has found that this immersive aesthetic learning experience increased knowledge retention by 18 percent after a single one-day session.

Another key component that researchers have identified as being crucial to learning: humor. When Dan Levitin teaches a class, he uses humor a lot. Dan is really funny. He's self-deprecating and he likes to use comedy to make a point. He uses this to great effect in the classroom.

The brain loves humor as a cognitive state because it upends our careful predictions about what might happen next, or what should happen. Comedy and improv are two performance arts that are increasingly being studied by neuroscientists who want to better understand the ways in which performers make such surprising and quick creative connections.

Brain-imaging studies show how humor stimulates the brain's re-

ward circuitry and elevates dopamine levels, that neurohormone associated with motivation and pleasurable anticipation. The art of humor is particularly strong in the hands of an adept performer skilled in timing and delivery. When our expectations are subverted—when a punch line of a joke really lands after a clever setup—the areas associated with appreciation light up in the brain. Laughter helps your brain to work better. And it can be a precursor for your own creativity, as it primes you to be more open to new and surprising concepts and ideas.

Dan once wrote and performed a song to the melody of Madonna's "Like a Virgin," but with lyrics relevant to the day's lesson plan about emergent cognition. Whether you thought it was funny or corny didn't really matter: it worked. In Boyle's study of Dan's teaching style, he analyzed a cluster of data and realized that humor "served to create salient moments that held students' attention in the classroom and triggered their memory of material."

There's a myth that learning is meant to be serious business. When you see a visual of someone "learning" it's usually a person bent over a book or in quiet contemplation. Rarely do you see a photo of someone in the throes of a full belly laugh, head thrown back, eyes watering from laughing so hard. But our brains love humor. Genuine laughter lights up multiple regions of the brain, starting with the frontal lobe, your control tower, as it unpacks the information coming in to discern whether it's funny or not. From there, electrical signals spark the cerebral cortex into action, and you laugh, which activates the brain's reward system, releasing dopamine, serotonin, and the same kinds of endorphins let loose in response to sex, food, and exercise. Dopamine is vital to learning: It helps with goal-oriented motivation and in the laying down of long-term memory, which is crucial to retention. Humor is a learning juggernaut.

Playful, Artful Learning

Though it gets buried in adulthood, the urge to play exists in all of us. It has been a major part of how we've evolved as a species. As Plato

famously said, "You can discover more about a person in an hour of play than in a year of conversation."

Play is a key component of the arts and aesthetics in myriad ways. Art and play are like two sides of the same coin, with play being a part of artistic expression, imagination, creativity, and curiosity.

Roberta Michnick Golinkoff, a professor of education at the University of Delaware, and Kathy Hirsh-Pasek, a professor in the Department of Psychology at Temple University and a senior fellow at the Brookings Institution in D.C., have identified play as a key ingredient for learning. The title of their 2003 book pretty well sums up their philosophy and their years of research around play and learning. It's titled: *Einstein Never Used Flashcards: How Children Really Learn and Why They Need to Play More and Memorize Less.*

"If you're not having a good time, you're really not learning," Roberta told us. "And there are so many ways in which we can infuse play into classrooms and informal learning environments." This is supported in the research on the neuroscience of play and learning. Play, the research notes, is universal to our species, and when humans play it positively influences both their cognitive development and their emotional well-being.

There are, Roberta and Kathy point out, two major kinds of play, free play and guided play. Free play is under a child's control and not designed to satisfy any external goal. Kids excel at this. Think about playing dress-up or make-believe. Play with an adult who has a learning goal is guided play. When it's done well, it supports the learning of new skills.

Roberta and Kathy use the example of bowling. In most alleys, you can ask for bumpers to be raised so that the ball never rolls into the gutter. When a person is first learning to bowl, the bumpers help to make the skill more fun if they get to discover the joy of knocking a few pins down. "With guided play, we set up the environment for kids so that they can learn different things," Roberta explains.

When children have an opportunity to learn in a playful way where they have some agency, where they're active, where they get to be involved and collaborate, it leads to the gold standard of learning: trans-

fer. "You can take something you learned in one context and apply it to another, and when you can create environments in which these things are exemplified, that's when you get real learning," Roberta says.

One teacher they mentioned set up a center with all kinds of writing implements and paper. "Now, this was kindergarten before kids really knew how to write," Roberta says. "But what did it do? It spurred writing during their free time. They would come up and ask the teacher: 'How do I write this letter? How do I write my name?'"

Kathy and Roberta's latest book, the bestseller *Becoming Brilliant,* offers an honest assessment of where we are: Kids today will have jobs and careers that are nothing like anything their parents and elders recognize. They need to be able to adapt to rapidly changing realities. They need to be able to entertain different ideas and approach them without consequence.

And yet with all the changes under way, we're still pretending that content in education is king, but it is not the only thing that is important. Really what kids need to learn, they told us, are the "6 C's": collaboration, communication, content, critical thinking, creative innovation, and confidence. Play and the arts, based on their research, build the 6 C's. An initiative that the two of them are involved in, one that Susan also helped to build, is called Playful Learning Landscapes Action Network.

By 2050, nearly three-quarters of the world will live in urban settings, and this network is designing play into that eventual reality. The landscapes incorporate evidence-based designs that use the arts, and games, to transform everyday public places—bus stops, libraries, parks—into hubs of playful learning. In one game called "jumping feet" a series of stones with drawings of either one or two feet are placed at strategic distances, with signs that encourage kids to jump in specific patterns. It's a twist on hopscotch that uses cognitive-science methods proven to improve attention and memory.

Studies of pilot programs in the cities of Chicago, Philadelphia, and Santa Ana have found that these playful environments encourage children to talk about numbers, letters, colors, and spatial relations with

their caregivers, and they can increase children's understanding of mathematical concepts, including fractions and decimals, among other skills. They also create intergenerational and peer-to-peer learning where the world becomes a playful studio. Once you open up to the idea of playful landscapes being everywhere and anywhere, suddenly your surroundings become a world of possibility.

Supporting the Neurodivergent Brain

Up to this point, we've been talking about ideas that are good for any kind of brain. It is estimated that as many as 20 percent of people worldwide have some form of neurodiversity, which is a term that acknowledges that we all process the world in unique ways and there is no one correct path to thinking and learning. Neurodiversity has emerged as a term that not only encompasses brain research, but just as important, describes a social-justice movement supporting diversity and inclusion.

When we began exploring the ways in which the arts help people learn, we circled back to neuroscientist Rick Huganir. He reminded us that how we learn is often genetically determined. They are the result of genetic mutations or even mutations in a single key protein. For example, twenty years ago Rick's lab discovered a gene called SynGAP1, and mutations of that gene are known to be responsible for a range of intellectual differences.

A key to supporting neurodivergent individuals is better understanding the specific ways our brains learn.

According to the CDC, for example, 1 percent of the world's population has been diagnosed with autism spectrum disorder, or ASD. Autism is not a learning difference; rather, it's a spectrum disorder that can sometimes include learning challenges as a component. ASD presents in different ways for different people, including some who want to build stronger social and communications skills. Those with autism can sometimes have difficulty interpreting social and visual prompts.

For instance, a smile on a person's face doesn't translate as kindness. A frown doesn't register as upset.

In 2013, neuroscientist and neurotechnology entrepreneur Ned Sahin was thinking about how best to support those with autism. "There are people who just suffer, and it's not regular life challenges, it's that their inner world is not being recognized by the outside world," Ned would later explain in an interview. He talked about how those with autism often feel "locked in and misunderstood by the world."

Around this same time, Google Glass was first released. The smart glasses presented an opportunity to software designers who could create programs to run on the device, similar to how you can pick from thousands of apps for a smartphone.

One way that children with autism learn social cues is through traditional cognitive behavioral therapy training, which is a form of talk therapy.

Ned had the idea that a wearable device that could offer real-time feedback would help reduce the time to enhance these social skills. Ned brought the enjoyment of cartoons, which fits into a larger framework of gamification, to the technology of smart glasses and created a program that supports the social and emotional learning of children on the autism spectrum. His software program offers visual cues while wearing the glasses. Using different colors, emojis, and cartoon drawings, the glasses help cue the wearer to register the feelings of the person they are communicating with.

Ned reached out to Google in 2014, and had several conversations with Ivy, who had just started working at the company to help with the Google Glass project. Ivy sent over boxes of the device to support his research.

Today, Ned runs a company called Brain Power, based in Massachusetts, which is helping those with neural differences by selling the software to schools.

A different software program—also powered on Google Glass—has been transformative, as evidenced through initial clinical trials at Stanford University. Designer Catalin Voss worked with Stanford researchers who specialize in autism to create a software program called the

Superpower Glass. Over two years, the investigators gave these smart glasses to seventy-one children with autism and had them use the software in their homes. Their results, which they published in 2019 in *The Journal of the American Medical Association, Pediatrics,* found significant gains in those using the device in addition to traditional behavioral therapy. Using a standardized test known as the Vineland Adaptive Behavior Scales, frequently used for tracking behavior of those on the spectrum, the researchers saw that those who used the intervention at home had a higher average gain on the socialization scale when compared with those observed using only standard-of-care therapy.

To learn anything at all, one of the most important cognitive states has to be present from the very beginning: attention.

Attention directs our consciousness to focus on some things and not others, and it is a fluid state that moves through varying degrees. "Attention is your ability to selectively focus and sustain focus," Adam Gazzaley explained to us one afternoon. Adam is a neuroscientist and professor of neurology, physiology, and psychiatry at the University of California, San Francisco, and the founder and executive director of Neuroscape, and he's been studying the brain's capacity for attention for decades. "Your ability to move your attention flexibly, which is called switching, is quite limited," he said.

Sustained attention is a challenge for all of us. Adam, along with psychologist Larry D. Rosen, disabused us of the myth that humans can, in fact, multitask. In their 2017 book *The Distracted Mind,* they explain that the human brain isn't actually capable of doing multiple things at once. The human brain never multitasks, Adam said. Our brain is actually toggling quickly *between* tasks.

For many, the ability to maintain levels of attention is a challenge. It's estimated that as many as 366 million adults around the globe live with attention deficit hyperactivity disorder (ADHD). Six million children have been diagnosed with ADHD in the United States as of 2016. ADHD can make it difficult to sit still, focus, and stay quiet. Because

ADHD affects divided attention, or what has previously been described as multitasking, it can inhibit organization. This often means that the experience of a traditional classroom setting is horrible. Young people with ADHD are often labeled as having behavior problems and being classroom disruptors. These labels are misplaced and can forever damage a child's belief in their own intelligence and abilities. There is the roller-coaster ride that can come from trying different medications, not to mention the staggering cost of these pharmaceuticals, which can run in the hundreds of dollars per month.

Adam has a solution for ADHD: immersive video games.

That's right. The great scourge of parents everywhere in the "drop that controller and pick up your homework" debate can be an excellent form of learning when designed with neuroarts in mind. To boost a child's attention, it may help to let them play Adam's video game, NeuroRacer, for thirty minutes a day.

Adam has studied how neural networks in the brain underlie our ability to pay attention, or our failure to. He started researching what happens in the brains of those with ADHD in order to translate brain science into devices and processes that help at the neuronal level.

Our capacity to pay attention is crucial for everything we do in life. "When attention is degraded or it doesn't develop well or it's simply fragmented by too much switching in life, everything is impacted," he says. "How you interact with your family, how you go to sleep at night, how you perform your schoolwork and your homework or your other work."

Adam wondered how he might harness the brain's plasticity to lead to improved attention. The best way to stimulate plasticity, he knew, was through immersive experiences. But he needed to figure out how to create experiences that selectively targeted neural networks in such a way that they created improved attention span. Learning is, by its very nature, a moving target. When our brain shifts to create new neural circuits, it's not the same as when we started, so Adam puzzled over how you create a process that adapts with the brain's plasticity.

That's when he took a page from engineering and looked into the closed-loop system.

The example he used with us is that of a clothes dryer. "A closed-loop dryer would be one that, instead of just setting a time and then going back and checking if your clothes are dry, as our dryer works, which is very inefficient, the dryer has sensors that detects the moisture in your clothes and basically turns off when your clothes are dry," he explained.

"So, a closed-loop system has sensors to take in input about what they want to change, and then has a processor that makes a decision based on that data. That drives an outcome, and the outcome here might be, how long does the dryer work? So, what I wanted to create was a tool where your environment, the stimuli, the challenges, the rewards are all updating in real time based on your brain."

Video-game design and augmented reality are dynamic aesthetic enhancers. The artistic components that create a successful game—an immersive world, strong art and graphic design, vibrant colors, sounds, music, storytelling, and characters—are what make gameplay so compelling. And there is also the emotional attachment to the narrative and your role in the story.

Adam set about designing an aesthetically rich video game as a closed-loop system that would support and build the brain's capacity to pay attention. He partnered with talented video-game developers in order to create something that worked *with* an attention-deficit brain. "I took the art and aesthetics of the game quite seriously," he said. It took a year, and in 2013, he released NeuroRacer.

His immersive game challenged the neural networks that are fundamental to cognitive control and attention abilities: interference resolution, distraction resistance, task-switching. By playing, the hope was that the game could reshape those circuits. And these benefits would transfer by lasting beyond the game and be carried over into the rest of your life. "If a kid gets better at a test in school but is not actually able to perform that work in the real world, you'd sort of consider that a failure of the education system, right? Because the goal is not just to get better at your test and not to get a great SAT, but to actually be smarter and savvier and wiser," Adam says.

As a player in Adam's game, you're in an environment where you

have a series of goals and they're challenging you in an adaptive way. "One task is navigating through this 3-D world," Adam describes, "where you have to go over these icebergs and waterfalls. Then at the same time, you also have to respond to targets and ignore distractions. This is like cognitive control through the roof. You have two tasks that are both equally important to you that are occurring simultaneously in the presence of distractions."

The game starts easy and gets harder as your attention capacity improves. "But I think the cleverest part of the design is about reward," Adam says. "We reward you on each of the individual tasks, but the real reward to advance only occurs when the performance on both improves. Really, what it is training is rapid and effective and targeted switching between these tasks. We force your brain to figure out how to do both."

Adam and his team found that improvement in attention for players did extend outside of the game, and their research made the cover of the scientific journal *Nature*. Adam's group was able to prove the sustained benefits to neural mechanisms after playing this video game.

Next, Adam started a company called Akili that took the game to the next level by infusing it with more sophisticated levels of art, music, story, and reward cycles for the players. That version of the game went through multiple clinical trials, including a Phase 3 placebo-controlled trial in children with ADHD. For the trial, a kid played for thirty minutes a day, five days a week, for one month and that was considered, to put it in pharmaceutical terms, "a dose."

In 2020, the game, now called EndeavorRx, was approved by the FDA as a Class 2 medical device to treat children with ADHD. "This is the first non-drug treatment for ADHD and the first digital treatment for children in any category, so it was really pretty exciting when it happened," Adam says. His video game is now being prescribed by doctors. What's extraordinary about Adam's work is his capacity to understand how learning differences—like attention deficits—actually work in the brain, and how arts-infused experiences can address them.

Learning Through Making

Players of Adam's game, and the students at ASU using virtual reality learning, get to manipulate virtual objects and avatars as they learn. But let's not forget how much learning comes from the simple act of hands-on activities and the act of making something.

Ivy is someone who knows how to play with materials and ideas. She grew up in a house of makers. Her dad was an industrial designer who worked with the famed Raymond Loewy, the father of industrial design in the 20th century, who was known for such creations as the Coca-Cola bottle, the Lucky Strike package, and a number of Studebaker car models. Ivy was encouraged to look at materials and objects with fresh eyes. From an early age, she noticed form, color, material, and tactility, and she frequently experimented with making things by hand.

She began her career designing jewelry and was one of the first to incorporate metals like titanium, tantalum, and niobium into bracelets and earrings. She experimented and discovered how these metals make gorgeous spectrums of color after being charged with electricity. She wove threads of iridescent tantalum into cufflinks and earrings. Her pieces are now in the permanent collections of ten international museums, including the Smithsonian American Art Museum in Washington, D.C. But it was the act of discovery through the making that was so gratifying. How sometimes you just need to use your hands and your gut to play and discover. Learning doesn't happen simply by absorbing what's coming at you. It's tactile. It's making. Learning is experiential.

Lorne Buchman has a name for this process. He calls it "make to know," which is also the title of a book he published in 2021. Lorne is an international leader in art and design education and the president of ArtCenter College of Design in Pasadena, California. "I think it was Galileo who said that one of the top three great experiences of humankind is our capacity to learn," Lorne told us. "I think that's exactly right. One of the great pleasures that we have in life is our ability to learn."

What Lorne has come to understand through arts-based studio education and the research for his book is how a practice of making helps us learn. We don't have to be studio artists to benefit. There is a connection between the brain and the hand that supports an embodied cognition, a knowing. Handicrafts in particular, which require dexterity and patience and a respect for the material, help make connections for us. "Make to know isn't like building a plane as you fly; it requires discipline, talent, experience, and skill," he explained. "Uncertainty is, by definition, a frightening, destabilizing place to be, but it's also a highly creative place, so you do need a level of courage to go into that space. So, what gives us that courage?"

Put simply, curiosity and hard work. The confidence, the courage, the faith, and the energy to be able to go to these places of uncertainty, he says, "and really explore and discover," is when we make without preconceived notions. Each thing we create yields new questions. "Then the questions and the conversations can happen, born of that applied making."

Lorne uses himself as an example. He once tried his hand at theatre. "I was a bad actor," he laughed, "because I had a vision for what the character needed to be, and every minute in rehearsal or performing, if I wasn't meeting the vision, then I got all preoccupied, and my anxieties would come up, and everything would go awry. That's really important to remember: if we're always working toward manifesting the preconceived vision, then the work becomes about that instead of being alive and discovering and creative."

Research out of Nigeria that was published in 2015 in the journal *Higher Education Studies* looked at what happens when students are given hands-on projects in order to learn math and science concepts. The researchers not only found "positive improvement on both the students' performance and participation in mathematics and basic science activities," they also saw how the teachers became more engaged. Because the students were able to exhibit their math and science skills in artistic ways by making and manipulating objects like clay, rocks, paint, and more, they had an opportunity to show teachers they understood what they were learning. A kid who may do poorly on written

quizzes was showing aptitude for the subject when given a chance to make something. "Teachers also confessed that they benefited a lot from the task and this has also triggered them to explore other ways of assessing their students for meaningful acquisition of mathematical and scientific knowledge," the researchers wrote.

Today, there's a momentum toward hands-on learning that is rooted in agency, discovery, and playful engagement with materials and ideas. The Tinkering Studio, which is located inside the Exploratorium, a museum of science, art, and human perception in San Francisco, creates interesting "tinkerable experiences," as they call them, for visitors to explore. They've developed different kits composed of carefully curated materials that allow for a wide range of exploration within a given science and art phenomena. There's a project for making musical rhythms, another for developing animation, and yet another for playing with circuits and electricity. Each activity allows for open exploration where there is not a single right or wrong answer, only curiosity and learning through making. Here, people get to think with their hands and build their knowledge and understanding by fabricating personally meaningful artifacts, from cardboard, wood, and kinetic sculptures, to a "painting" made of our life. Mike Petrich and Karen Wilkinson, cofounders of the Tinkering Studio, are expanding this work around the world. "We work in the traditional places you might think you'd find us like museums, libraries, after-school programs," Mike tells us, "but we also work with populations of learners in prison systems, early-childhood educators, and even the Dalai Lama's monks: the geshes. We partner with anyone who wants to expand their learning capacity."

Susan understands these tenants of making to learn. Susan launched an arts-based learning company in the early 1990s, called Curiosity Kits, which was among the first to merge the budding cognitive neuroscience of child development and learning with sensory, hands-on experiences. Creating more than six hundred activities for children four to fourteen years old, Curiosity Kits designed tactile adventures in the arts, sciences, and world cultures. For example, kids constructed kaleidoscopes, sculpted Native American pottery, and built bluebird houses and butterfly boxes. Driven by curiosity, these projects amplified chil-

dren's understanding about an interest or subject area and built connections with family and friends that were engaging and fun.

Saliency, attention, humor, and play. Executive function and making to know. The arts integrated into classrooms support learning. But what all of this learning is for, really, is to prepare you for being an adult moving through the world. When we participate in the arts as kids, we tend to be adults who continue to make or behold the arts. But it's never too late to start, no matter your background or experience with the arts.

Many adults relegate art and the making of it to those they deem professional artists. Much of what we encounter in our busy lives moves us away from daily artistic practice. John Dewey, a psychologist and an educational reformer who is considered to be one of the fathers of functional psychology, once wrote, "Art is not the possession of the few who are recognized writers, painters, musicians; it is the authentic expression of any and all individuality." Ivy likes to say that our lives are a canvas, and we're painting on it every single day. The arts and aesthetics are the conduits for a full and vibrant life.

Learning at Work

In 2008, Starbucks was in trouble. Brand loyalty was down, as were average transactions at stores, and people inside the company simply couldn't connect. They were having trouble trusting one another. Howard Schultz, the former CEO, returned from retirement to help bolster the company, and among his first acts, he entrusted Keith Yamashita to run a leadership retreat with his top twenty-two executives.

Keith is the founder of the consultancy SYPartners, where he has been brought in to train leaders at companies like Apple, eBay, IBM, and the Oprah Winfrey Network. Keith's academic background is a trifecta of design, data economics, and organizational behavior, and he chose to focus on creativity within businesses because, as he explained to us, this is where so many of us spend the majority of our lives.

"I wish in the realm of business that we spent as much time on creative skills as we do technical skills," he told us. "The technical skills are what helps to get things done. Can I navigate a spreadsheet? Can I code? Can I express my ideas? Those are all super important. But to what end? The creative skills are where the ingenuity comes from."

Keith thought about all of the different ways that they might engage the leadership of Starbucks. "There were lots of rational things wrong in that company at that time," Keith says, "and we could have spent the entire time on analytics. But what that group needed was to get in touch with what really mattered for them."

Imagine you were one of those twenty-two Starbucks executives being tasked with turning the flailing company around. You're called to an important meeting about the future, and instead of walking into your corporate headquarters or a boardroom or the CEO's office, you are summoned to a rather beat-up loft in downtown Seattle. As you enter, you're given just two things: a card with simple instructions, and an iPod Shuffle. Listen to the music, you are told, and think about what makes for a cultural icon.

You put on the headphones and cue the playlist. It's every single song that the Beatles ever recorded. You walk into the loft and it's filled with Beatles paraphernalia: posters, photos, documentaries. For nearly an hour, you are left alone to explore as the music plays.

Keith and his team then called the group to order and sat them down in two rows of eleven, facing each other. "It was very, very tightly together. I mean, uncomfortably tight," Keith said with a laugh. "And we asked a single question: What made the Beatles iconic?"

The floodgates opened. This was a group who grew up with the Beatles and they told stories about the first time they'd heard a certain song, and about the memories that came back to them in a rush. "Then they started to get at a much richer dialogue," Keith says. They had squabbles. They aired differences. "They had people there who, like Yoko, came in and stirred them up."

And that's when Keith hit them with a second question: If Starbucks were a cultural icon, what would you hope for in its reinvention?

"And out came the true emotions and even tears," he says.

That was the start of what was a three-day retreat, where the leaders of the company rewrote their mission statement from scratch as a multi-stanza poem about the future that they wanted to co-create.

Those three days led to a three-year reinvention of the company. "The neuroaesthetics of the experience made it possible," Keith says. "The songs that were playing through their head to re-trigger the emotions of their youth."

Keith uses this example to point to a larger trend that he's seeing in the workplace. "I believe we're at the very end of the efficiency movement in business. We can't get any more 'lean' or any more efficient," he says. "We need to live as embodied humans, not just as cerebral beings. This means embracing all the senses and artistry and art of a life. For whatever reason, we've starved ourselves of all these other components in the sake of efficiency. Now, I think, it's about joy, full human expression, and an embodied life where things matter."

Creating an experience like this one doesn't have to happen offsite. There's a way to create a threshold within a business space where you can go from the busy transactional world of the workday to one that is more embodied.

In 2017, Google set out to understand the future of leadership development and created an initiative that soon became the Google School for Leaders. The company knew that attracting, retaining, and developing managers and leaders was critical for its continued growth and success. Google's own internal research supported the need for managers and leaders to learn not just new skills but new ways of thinking, or in Google's parlance, "both skill sets and mindsets."

Formalizing the School led to the creation of a purpose-built, physical learning space dubbed the Schoolhouse. The lead strategist for the effort, Maya Razon, recognized the power of neuroaesthetic principles to support leaders' learning and engaged Susan's lab at Johns Hopkins to help design the School's interior space.

"Our research showed that where we learn and how we learn is at least as important as what we learn," says Razon. "The future of learning and leadership development is clearly multi-dimensional and experiential. Our multi-sensory approach to designing the Schoolhouse

activates a learner's senses and helps them embody their learning experience for better understanding and retention. It's also simply a playful, fully customizable, beautiful space. The feedback has been inspiring, and the collaboration with Susan and her lab was a critical element to the Schoolhouse's success."

What neuroarts-based learning promises is more than just the retention of new information. It has the potential to elevate how you live in the world, how you create a dynamic model of living, one where you experience a fulfilling and purposeful life. This leads us to the neuro-aesthetics of flourishing.

6

Flourishing

GOLDFISH

Defining myself is like confining myself
So I undefined myself
To find myself

They say a goldfish will only get as big as its bowl
But when you put it in a tank, the space can change the way it grows
It needs to have the room or its potential doesn't show
So its environment's essential for unleashing the unknown

I ponder if it knows that it could grow beyond the bowl
That it could have a pond the size of an Olympic swimming pool
That the world is so much larger than the boundaries that it's known
Somehow I empathize with this little golden soul

'Cause I, too, have unexplored and unexpressed goals
That were suppressed by an environment I couldn't control
Am I still playing small because it's all that I've known?
When there's a giant in my bones that I'm not sure I've ever shown

I ask myself this question when I'm purposely alone
When my body grows to take up all the rooms inside my home
I expand in all directions
Every single inch consumed

I'm a billion feet tall now
My head over the moon
I look down on the Earth as it slowly spins around
I look down on the countries and the cities and the towns
I look down on the square blocks and buildings all around
I look down on my street and rip the roof right off my house
I look down on myself sitting, writing on my couch
Look, I barely pay attention, I'm the one that's looking down
How unaware I am of where I am
It's profound
So, I put the roof back on and shrink myself back to the ground
It's crazy how I fit infinity inside my doubt
How I stuff the universe into the tiniest amounts
How I keep the solar system in the corner of my mouth
How I speak into existence but forget what I'm about

And most days I'm not sure which side of the glass I've been on
I win a Grammy in the shower every time I sing a song
But when the spotlight is on, my first instinct's to run
I have to superglue my feet to even tell you where I'm from
I've been training for a quarantine since I was very young
For an introvert, it slightly hurts to tell you that they'll come
I would rather get into a staring contest with the sun
Although I'll never get to see who won

It's nature and it's nurture twisting into jungle life
Fighting the competition, branching out to reach the light
I tried to listen but could only hear my ancient heart
It screamed at me to make my life into my greatest art
But where to start?

These walls are keeping people out and keeping people in
I guess it's good to know where someone ends and someone else begins
But our boundaries become prisons when we see what could have been
The biggest goldfish ever measured 18 inches snout to fin

—IN-Q

L ike the poem we share here by IN-Q, many of us think about our purpose for the short time we are here on this planet. IN-Q, an award-winning poet, keynote speaker, and bestselling author, believes that when you change your story you can change your life. "There's a saying about what emotion is: It's energy in motion," he tells us. "If you have trapped emotion and it can't move through you, it can block you from being present in your life, from your passion and curiosity."

What helps to unblock us and gain access to a full and passionate existence? What constitutes a good life?

These are the questions that have occupied us for centuries. Aristotle and the ancient Greeks attempted to define an enriched state of being, calling it eudaimonia or, roughly, happiness. Today, the study of thriving has entered a renaissance. A burgeoning subfield of neuroscience and psychology is now dedicated to identifying and understanding the neural mechanisms that contribute to a state of flourishing. Researchers around the world are exploring what's known as the salubrious, or positive, attributes of the human condition. Less a philosophical discourse as it was in Aristotle's day, and less focused on one emotion—happiness— these contemporary inquiries marshal technology, interdisciplinary collaborations, and empirical investigations to illuminate the elements of thriving, or, a rich and meaningful existence.

Identifying universal traits for flourishing is a complex task. One of the pioneering researchers leading this work is Tyler VanderWeele, an epidemiologist and the head of Harvard University's Human Flourishing Program. In 2017, he developed a base measurement of flourishing built on five metrics: (1) happiness and life satisfaction, (2) mental and physical health, (3) meaning and purpose, (4) character and virtue, and (5) close social relationships. "Conceptions of what constitutes flourishing will be numerous and views on the concept will differ," he wrote. "However, I would argue that, regardless of the particulars of different understandings, most would concur that flourishing, however con-

ceived, would, at the very least, require doing or being well in [these] five broad domains of human life."

Flourishing, we believe, is about living an authentic and full life. It's feeling present and alive by noticing and appreciating what you already have around you. It's about being in touch with yourself—what many refer to as mindfulness—in order to live with a sense of purpose and meaning, a moral compass and sense of virtue. Flourishing includes caring about the welfare of others and contributing to the greater good.

When you are flourishing, you are curious, creative, and open to new experiences, and there is a conscious commitment to fostering a positive mindset. You're nurturing your mental, physical, and social health. And you're appreciating the time you have on this planet.

Too often we equate a "good" life with perfection, and with everything going right. Flourishing removes such an unrealistic bar because, as we know, no one is ever perfect and no human life passes without challenge. Instead, this approach embraces a lifelong quest to gain insights, to grow and to thrive. And it is a choice to put ourselves on a dedicated path of personal growth.

From a neurobiological standpoint, flourishing is not a single state of mind; it's a combination of several psychological and neural states that work in tandem to bring you the sense that you are in sync with yourself and the world at large. Based on the neuroscience research we've gathered and the people we've interviewed, we've come to realize that several states—awe, curiosity, novelty, and surprise—help contribute to flourishing. These are natural and innate to all of us, but when you adopt an aesthetic mindset and embrace the idea that you can flourish, you'll soon discover your capacity to cultivate and enhance these states of mind through the simple practices you'll find in this chapter.

In a 2020 research study, the investigators combed existing scientific findings in the areas of psychology, the cognitive and affective neurosciences, and clinical psychology as they relate to well-being. The question they posed: Can we foster flourishing by training the brain through mental exercises that induce neuroplasticity?

Take just one area that they studied: purpose. This is, essentially, your sense of self. Empirical studies are beginning to illuminate why purpose in life has such a strong effect on us. Having a sense of purpose in life has shown a reduction in the negative effects of chronic stress and, in some cases, higher purpose in life "also predicts accelerated recovery from stress in the elderly, as measured by salivary cortisol levels," researchers wrote.

When we intentionally include certain acts in our lives that bolster our sense of purpose, it "increases resilience, promotes healthy behaviors, and alters the brain and peripheral biology in meaningful ways," they wrote.

Through his research at Harvard, Tyler has already determined some evidence-based ways to train your brain to flourish. One is creative writing, including an exercise where you imagine your best future self then write about your life as if it has already happened. Small, randomized studies have suggested a simple habit such as this increases your optimism and life satisfaction.

Flourishing is a kind of muscle that gets stronger when used. And as with anything practiced, it becomes a habit (think back to the neuroplasticity of learning explained in the previous chapter). Like coming back to a yoga mat or a running routine, like choosing a healthy diet, like understanding how much sleep you need each night, you will begin to see patterns that foster and support a flourishing life.

In this chapter we explore six foundational attributes of flourishing. They include curiosity and wonder, awe, enriched environments, creativity, rituals, novelty, and surprise. You can create your own path to a flourishing life by incorporating a combination of these states of mind.

Cultivate Curiosity and Invite Wonder

On a Thursday afternoon at Johns Hopkins Hospital in Baltimore, twelve physicians and several interns-in-training sit in a conference room and stare at an image projected onto a screen. It's a painting of

what appears to be a living room, where six people of mixed race have gathered. Some perch on a vibrant yellow-and-orange couch; others stand. One woman in a teal and green wrap dress has her back to the viewer, showing her black hair knotted into an elegant and intricate braid. The participants weren't told that this is a 2013 work by Nigerian artist Njideka Akunyili Crosby, or that it's composed of acrylic, charcoal, pastel, colored pencil, and collage. In fact, they've been told nothing about the art; they've simply been asked to look.

These doctors and interns spend their days in the intense, high-stakes environment of one of the world's most prestigious research hospitals. They rarely have a moment to rest, let alone look at art. And yet the room is pin-drop quiet, the kind of quiet that accompanies absorbing thoughts.

Meg Chisolm breaks the silence. "What's going on in this picture?" she asks.

Meg has gathered this group for a moment to flourish.

As a psychiatrist, Meg first began to understand the need to encourage flourishing before having a name for it. She was working as a clinician caring for people with psychiatric illness and substance dependency. After ten years, it had become clear to Meg that in order to help her patients achieve a full and vibrant life, she had to do more than eliminate the symptoms of their acute illness. "I needed to help them strengthen other aspects so that they would be able to lead the life that they truly wanted," she told us.

In 2015, Meg joined the Paul McHugh Program for Human Flourishing at Hopkins, where she is now the director. The goal of the program is to bring the science of flourishing to medical learners and physicians. Meg has studied the latest work of many neuroscientists, psychologists, and others to better understand how to build this program. Among them, she analyzed the work of psychiatrist Martin Seligman, who developed a positive psychology model for flourishing known as PERMA: positive emotion, engagement, relationship, meaning, and accomplishment. These inquiries have led her to conclude that the arts are the most effective way to help her students explore what it means to be fully human and to flourish.

Next, Meg prompts the doctors to talk about the painting. A few tentatively raise hands, offering timid answers. She encourages them. "What more can you find?" This question reminds them to ground their interpretation of the painting in the visual. More ideas emerge. And suddenly, the conversation shifts. These busy and ambitious people begin talking animatedly about emotions, about meaning, about the nuances of the painting.

This exercise, known as visual thinking strategy or VTS, was developed at the Museum of Modern Art in New York over thirty years ago by Philip Yenawine, then the museum's director of education. Philip was tasked with assessing whether his team's programming was improving people's understanding of the art hanging in their galleries. With the help of a researcher, he conducted a study and found, among other things, that 80 percent of visitors shared a dominant emotion: curiosity. They were intrigued by the story that the art was trying to tell them.

Curiosity has been baked into the human brain as an evolutionary need. Cognitive neuroscientists now believe that it developed over millennia as part of our threat-detection systems (alongside other neural activities such as worry) in order to help us make the best decisions in an unpredictable world. It allowed our forebears to make inquiries like, *Is this red berry safe to eat? What happens when I knock rocks together and create a spark? What if I whittled this wood into a sharp point?* Curiosity has shaped our modern world, as intrepid explorers of the mind, and material have given us everything from the lightbulb to the Mars Rover.

Neurobiologically, curiosity activates a number of areas in the brain, but the area most responsible for our curious nature is in the hippocampus. When you explore and ultimately satisfy your curiosity with an answer, dopamine, the brain's reward chemical, floods your body. This can bring with it feelings of happiness and satisfaction.

As a result, humans find "intense, lasting fulfillment in seeking new knowledge, new experiences, and in embracing uncertainty," according to psychologist Todd Kashdan, who wrote the book *Curious? Discover the Missing Ingredient to a Fulfilling Life.* "Choosing to explore the unknown rather than avoid it is key to a rich, meaningful life."

The arts are particularly good at cultivating our curiosity because, by their very nature, they tap into our need to understand and to be moved, and at the same time to be comfortable with ambiguity. When we see something or feel something that speaks to us, we become interested and we want to know more. The simple act of observing art without judgment and seeing what emerges becomes an excellent prompt for personal insight. Art, in this way, becomes a vehicle for curiosity and, ultimately, discovery about ourselves and the world.

Curiosity is a building block of flourishing. Research has shown that it induces higher levels of positive emotions that lead to happiness. It expands our empathy and strengthens our relationships, with studies revealing how highly empathic people are those most curious about others. And as Meg well knows, curiosity helps in healthcare, as doctors become more open to their patients' experiences and it makes them more empathetic and observational practitioners.

"I use art because it's a nonthreatening way into having important conversations," says Meg. "It's a prompt for reflection where people gain personal insights and get to appreciate other people's perspectives, and also critique our own culture of medicine in terms of how it supports these pathways to flourish."

The exercise Meg led that day at Hopkins was not about right answers; rather, it was about being present and paying attention. Attention is essential for sparking curiosity. Attention is how the brain neurologically controls and directs consciousness, and this happens primarily in the frontal lobe, with communication to the parietal lobe. When you pay attention to a thought, emotion, or perception, your brain activity increases. Your conscious life effectively becomes what you pay attention to. And curiosity is an emotional state you can strengthen with practice.

Wonder, curiosity's cousin, happens not only when we go seeking answers to questions, but when we are surprised by something unexpected. A maestro of creating wonder is Barbara Groth. Barbara has spent her career experimenting with its possibilities.

In 2015, she created the Nomadic School of Wonder, which creates immersive experiences rooted in nature, art, community, and play. "Wonder can be difficult for people to describe," Barbara told us from

her studio in Santa Fe, New Mexico. "It's like love in that we all know what it's like in some way, we know the experience, but we struggle to put it into words."

Wonder is a complex feeling that creates a heightened state of consciousness and emotion. It's akin to curiosity, but it's more expansive in scope and contains attributes of surprise and joy. It has been defined in scientific literature as our innate desire to understand the world, which simmers inside each of us waiting to be ignited. Wonder often seeds our curiosity.

According to wonder researchers, beauty is primarily what triggers it. The field of neuroaesthetics began with efforts to try to understand the neurobiology of beauty. Semir Zeki began his investigations with beauty precisely because he wanted to better understand the brain-based explanation for what we find beautiful. He learned that there are some universal phenomena that we find beautiful—a sunset, for instance. But a global definition for what is beautiful and what is not is elusive because of what we explained early on about your brain and the default mode network: so much of what we register as beautiful is personal. There is still debate in the field about whether or not there is a central location for beauty in the brain.

The arts, which frequently contain the beautiful and the unexpected, are excellent facilitators of wonder. You are struck by something, and this astonishment becomes fertile ground. Wonder snaps you to attention and is one of the most effective ways to spark curiosity.

The idea for a school dedicated to wonder came to Barbara after she helped care for loved ones who were dying. "I noticed that life took on a Technicolor vibrancy when in the presence of people who had a limited time left," she told *Forbes* in a 2021 profile of her work. "I wondered, How could we live in this state of being before we faced our last days on the planet? While daydreaming one afternoon, I wrote down the words 'nomadic school of wonder' and instantly felt like that was the answer."

The goal of her school is to reawaken people to the magic that is present all around us, and she does this by creating immersive trips and experiences. She also, like Meg, dabbles in the terrain of the uncertain.

"Our minds, especially our adult minds, are so uncomfortable with uncertainty," Barbara says. "The arts allow us to dance on that edge of uncertainty and invite in creativity, expanded awareness, expanded perception, play, and more prosocial behavior."

Barbara and her team of artists and collaborators begin with a stellar natural setting, taking people to the fjords of Iceland; the islands of Newfoundland, Canada; or the redwood forests of California. Being in such vibrant, multisensory, and aesthetic natural places is enough to stimulate positive changes in the brain. A 2017 study published by researchers from the Max Planck Institute for Human Development, Center for Lifespan Psychology, used a technology called infrared spectroscopy to collect neurobiological data on people walking or sitting in a forest and paying attention to what's around them. They found that this simple act induces relaxation. When we relax, endorphins flood our body, blood flow increases, and our heart rate calms, which all support clearer thinking. True relaxation has been likened to a form of mild ecstasy in that it can signal to our frontal lobes a state of blissful sedation.

For one experience, Barbara took participants to Fogo Island in Newfoundland, with Ivy as part of the gang. Fogo Island is a beautiful place, both for its wild and vast terrain and for its people.

When Barbara's guests arrived on the island, artists in outrageously wild costumes greeted them. It immediately alerted participants that "something has changed, something is different. There's a threshold difference here," Barbara says.

Barbara and her team had, prior to the trip, co-created an experience with the local community, picking a theme for the adventure that was site specific. On Fogo Island the theme for the trip was belonging to one another and to nature and to ourselves.

For Ivy, the experience took everyone out of their daily routines. As soon as they arrived, they immersed themselves in the rugged beauty of this remote North Atlantic island and the culture of the people who live there. By design, each new experience filled them with surprise and delight, whether it was dancing with the locals at a shed party, taking cooking and crafting classes, or dressing up in costumes to reenact a

historic May Day parade. There were moments when they stepped back in time, and she remembers feeling in her body what it was like to live on an island at a time without electricity. At the end, they all felt changed for the better in a lasting and meaningful way.

In this way, Barbara says, "Wonder feels like a dance with a great mystery."

In fact, it is the nature of mystery and the unfamiliar that often sparks wonder and stimulates our curiosity. In the early 1990s, George Loewenstein of Carnegie Mellon University developed what's known as the information gap theory of curiosity. Curiosity, he explained, is essentially the gap between what we know and what we want to know, and that mystery becomes a pressing mental desire that propels us to seek an answer.

As recounted in a journal article published in *Neuron* under the title "The Psychology and Neuroscience of Curiosity," study participants were placed inside of an fMRI and then given a series of trivia questions. They were not told whether they got the answers right. Next, they were presented with a different set of questions that included the answers. Turns out the brain's reward systems were working overtime when the subjects didn't have immediate access to the answers. The reward systems released feel-good brain chemicals like dopamine, serotonin, and oxytocin that triggered sensations of pleasure and positive emotions. Living in the mystery, and pursuing the act of potential discovery was, in and of itself, the reward.

Both Meg and Barbara use art experiences that activate those reward systems as participants are stirred to answer a question about art, or to discover new places.

And you don't need to travel to Newfoundland, or visit a gallery, or take a class with Meg to foster wonder and curiosity. You can actively invoke them by consciously applying an aesthetic mindset. It can wash over you in the most basic moments.

Barbara shares, "I can walk out my front door here in Santa Fe and have the experience of wonder and curiosity. I think of it as going on a walk and doing what the poet Mary Oliver said, which is to pay attention and be astonished. I can have incredible experiences seeing

these crows flying by in a big sky and just taking a walk and paying attention. And this beauty, this presence, that I receive through my senses, washes over me and gives me a sense of belonging to something bigger than just myself."

Put Yourself in the Path of Awe

When Barbara talks about an expansive feeling of belonging to something bigger than herself, she is describing a perceptual experience that is beyond wonder or curiosity. It is the uniquely profound neurological phenomena known as awe.

To better understand this brain state and the effect it has on us, we're going to take you back to 1959, to a beautiful day on the coast of Southern California.

Jonas Salk, the virologist who had recently discovered a vaccine for polio, and Louis Kahn, the architect known for his monumental and modernist buildings, stood on a spit of land high above the Pacific Ocean near San Diego. Together, they visualized a campus for the future of scientific exploration. Salk had worked within the rigid confines of academia for years, and he daydreamed of a research facility where labels fell away and disciplines merged, where the brightest scientists in the world could explore the fundamental questions of life. Salk had asked Kahn to be his architect because they shared a belief that scientists and artists have much in common in how they question—with curiosity and wonder—the mystery of human existence. Salk's directive was clear: design an institute that marries science and art, that can stand the test of time, and that fosters creativity and innovation. Build me a place, Salk told Kahn, "that Picasso would want to visit."

Salk understood the ability of a place to inspire. In the early 1950s, the polio virus had been at an epidemic level, crippling and killing mostly children by the hundreds of thousands every year. Salk was working sixteen-hour days in the cold, fluorescent-lit, and labyrinthine

basement laboratory at the University of Pittsburgh in search of a cure, and he was exhausted. He took time off and traveled to Italy for a much-needed break.

Salk walked the ancient hillside towns of Umbria, the air fragrant with the herbal tang of olive trees. There he made his way to the Basilica of Saint Francis of Assisi, the massive thirteenth-century Franciscan monastery that rose like a beacon on a hill. Its stone, dug from nearby Mt. Subasio, shone pink in the warmth of the sun and brilliant white by the moon. As Salk entered through ancient oak doors the heat of the day evaporated inside the cool earthen musk of the chapel. Beneath him, the stone floor was worn to a shine by the footfall of thousands of pilgrims. Above him, the royal blue and terra-cotta of fourteenth-century frescoes in the vaulted arches reflected the light from the mullioned windows. And like many of us inside a majestic building, Salk's every sense unleashed, igniting a feeling of endless possibilities.

Dacher Keltner has a theory about what triggered Salk's breakthrough. He was awestruck.

A professor of psychology at the University of California, Berkeley, Dacher directs the Berkeley Social Interaction Lab and is the foremost theorist of the psychology of awe and wonder. His research and insights about the essence of human existence have been foundational to our work over the years. We reached out to him to explore this intangible, profound emotion.

"Awe is embedded in our DNA. We are literally hardwired for it," he told us. You often feel it when you look up: at the Milky Way, or a forest canopy, or a rainbow. Nature is the wellspring of so much of our awe, and human beings have been aspiring to bring this feeling into the built environment—meaning anything that is human-made, from buildings to cities—since the earliest drawings decorated the walls of our caves."

Awe can literally stop you in your tracks, and it induces significant physical effects. You might shiver. Your pulse quickens. You might feel a warmth in the chest and tears in your eyes brought on by awe's influence. When you are in these heightened states, default mode network

regions of the cortex of your brain downregulate. You stop analyzing. You let go. Then, in this stillness of your mind, something extraordinary happens. Neurotransmitter floodgates open, and your synapses are bathed in a state of sanctity. Elation and euphoria crescendo into what is described as a "peak experience" or "transcendence."

Awe alters your mind from self-centeredness to community-centric, making you more prosocial and breaking down me-versus-them thinking. Dacher describes this as "the small self." It heightens your curiosity and creativity. And it has the capacity to make you more generous, tender, empathetic, and hopeful. Awe is the emotion that ignites a primal feeling of empowerment that drives you to take action and even to make self-sacrifices if required. "A little dose of awe is transcendent," Dacher says.

There is an evolutionary importance to awe, Dacher explains, because it encourages us to move forward with new ideas, with purpose and a sense of possibility.

Salk and Kahn may not have had a name for it at the time, but they both understood they needed to make the elusive emotion of awe visible.

In 1963, the Salk Institute for Biological Studies was completed. Salk and Kahn succeeded in evoking the emotional resonance of transcendence Salk knew was possible. In this design, the blue Pacific Ocean and California sky became as much a part of the campus as the buildings, intertwining the rhythm of nature with monolithic concrete, glass, and teak towers that frame the travertine courtyard. A water channel known as the Channel of Life runs the length of the plaza, seeming to empty into the sea: an eternal offering of renewal. The campus is fully exposed to the natural elements. Every day the buildings are transformed with the ever-changing light and casting of shadows.

Twice a year during the equinox, the sunset aligns with the Channel of Life, a photo of which we have included in the color insert (see image G). The two of us journeyed there at the winter solstice, like many others have, to witness what borders on the spiritual. Standing in the outdoor plaza, we could not help but marvel at the raw courage of the two people who made this place.

The procession of buildings drew our eyes out to the sea, and we felt part of something bigger, vaster, and expansive. We watched as the sun moved across the sky and filled the channel with what looked like liquid gold. It crackled with life, and it seemed as if the buildings were alive and the landscape was breathing. Nature and architecture merged in a sacred moment.

We both left the Salk Institute changed from when we entered, only moments before. We felt the transcendence Dacher described and that Jonas Salk experienced.

We all have felt awe in certain settings. But we wanted to know more: Can an art experience create awe that's measurable? And can awe spark the kind of changes in us that promote flourishing?

To better understand how awe-inspiring art moves us we immediately thought of Cirque du Soleil.

If you have ever seen Cirque du Soleil it's easy to recall the childlike, eye-popping sensorial experiences unfolding all around you. Millions of audience members have shared anecdotal stories of the overwhelming feelings that flow through them during a performance. But we were given an empirical look into the awe-inducement of this arts experience thanks to neuroscientist Beau Lotto.

If ever there was a scientist who possessed the same vagabond spirit and adventurous talent as a cadre of circus performers, it's Beau. His research explores the ways in which we experience the world through our own versions of reality, and at his U.K.- and U.S.-based neurodesign studio, Lab of Misfits, he has attracted a multidisciplinary team of talented researchers and artistic renegades.

In 2018, Beau and his team went to Las Vegas, where Cirque du Soleil has performed its iconic show *O* at the Bellagio since the 1990s. A 1.5-million-gallon pool anchors this extraordinary performance, where eighty-five acrobats and synchronized swimmers seem to fly through a fantastical world. A carousel hangs forty-nine feet above the stage, and the combination of color, costume, lighting design, and human spectacle creates a breathlessly beautiful show.

Beau aimed to quantify what was happening in people's brains during something as aesthetically dynamic as *O*. Over ten performances,

he and his team recorded the brain activity of more than two hundred audience members as they watched the daring feats of the performers. They also measured audience behavior and perceptions before and after the performance.

Their results were astounding: The brain activity across audience members was so consistent, and correlated to the neurobiological state of awe, that Beau and his team were able to train an artificial neural network to predict whether people were experiencing awe to an accuracy of 76 percent on average.

The study uncovered some other intriguing findings. People who are actively experiencing awe have less need for self-regulation and a higher tolerance for uncertainty. Their tolerance for risk also increased. "They actually seek risk, and they are better able at taking it," Beau recounted in a popular TED Talk in 2019. "And something that was really quite profound is that when we asked people, 'Are you someone who has a propensity to experience awe?' they were more likely to give a positive response *after* the performance than they were before."

The Lab of Misfits discovered that an audience member walked out of the Cirque performance a different person, physiologically, from the one who had entered. This peak aesthetic experience had changed them. The neurochemical state of awe, triggered by the performance, changed their perceptions of themselves and the world. So, attending an event like Cirque du Soleil, which inspires an emotion as neurobiologically rich as awe, can help us to move toward more positive emotions and perceptions. "Experiencing awe enables someone to change their view of themselves and their place in the world," Beau explained in a 2021 podcast. "When experiencing awe, differences between people become irrelevant because awe enables us to embrace, appreciate, and celebrate diversity."

This is no small matter. Psychiatric researchers Diana Fosha, Nathan Thoma, and Danny Yeung wrote of how evolution has deemed both negative and positive emotions as good for us—even if things like anger, sadness, and longing don't seem so great—because we can learn from them and adapt accordingly. Anger, when examined, can offer exceptional insight into what you're passionate about. But evolution plays

favorites with emotions, and we tend to privilege the negative emotions associated with survival. As they explained in a 2019 article for *Counselling Psychology Quarterly*, "much more brain 'real estate' is devoted to the avoidance-oriented negative emotions than to the affiliative, approach-oriented emotions." For example, bad memories are made five times quicker, and last five times longer, than positive ones.

We have all experienced this, where our mind goes to what could go wrong versus what might go right in any situation. Given that our brains naturally lean toward negative emotions, the two of us wanted to know if Beau had any suggestions for how to moderate this annoying human tendency, to generate a flourishing attitude. "The word that I use when it comes to flourishing is 'movement,'" Beau told us. "It's a willingness to invite change. Inviting artistic moments of awe and wonder is one way to generate that movement."

Beau likens it to the practice of yoga. He's someone who has a personal yogic practice, where he doesn't take to his mat simply for exercise but to build habits of mind. For him, yoga is more than moving through a series of postures, it is a spiritual practice. "Yoga is really a practice for when you're *not* on the mat," he says. "It's how you bring what you learn there into the rest of your life."

The awe found in the arts and aesthetic experiences can become part of your practice for expanding flourishing.

Put Yourself in Enriched Environments

The Nomadic School of Wonder. The Salk Institute. Cirque du Soleil. These all have something essential in common: the vibrancy of a multifaceted, immersive environment. Arts experiences and aesthetic places like these provide enriched environments. Places that offer a variety of multisensory stimulation, which, in turn, triggers the neuroplasticity in your brain.

Anjan Chatterjee, whom you met in Chapter 1, has been researching the ways in which architecture contributes to our overall well-being.

He is interested in how certain architectural features, like ceiling height, light from windows, and volume of a room, affect neural and mental processes. Anjan conducted a study in Spain where he put participants into an fMRI machine and monitored their brain activity while looking at two hundred images of interiors. He continued this study online in the United States, giving participants these interior photos and asking them to rate them based on sixteen different psychological parameters such as beauty and comfort. Anjan found "three components that were robustly associated with feeling good about the spaces," he explained in a 2021 interview. "Coherence, how organized a room appears; fascination, how interesting the room is; and hominess, how comfortable one would feel in the space."

Despite architecture and design being subjective overall, there are general principles of visual and spatial design that register for all of us and are, Anjan says, based on biological facts.

Certain architectural elements have the ability to not just make us feel fascinated or comfortable but to heighten our sensory experiences to the point of connecting us with the spiritual, not unlike what happened to Jonas Salk. Julio Bermudez, a professor in the School of Architecture and Planning at the Catholic University of America, is studying the ways in which the design of buildings, like the Basilica of the National Shrine of the Immaculate Conception in Washington, D.C., changes our neurological states. The Basilica, like many of our great religious and sacred spaces, contains soaring ceilings, domed roofs, exceptional light, and grandeur. Consider, too, the epic buildings of humanity: the brilliant symmetry of the Egyptian pyramids, the mysterious configuration of Stonehenge. There's Agra's Taj Mahal, Istanbul's Blue Mosque, Barcelona's La Sagrada Família. Each leaves us speechless, unable to find words to match our feelings.

"We know from thousands of years of history that people have spent their best resources and incredible amounts of time to design and construct architecture that allows people to access states of being or understanding that are spiritual—feelings such as calmness, awe. Wonder, enlightenment. Well-being, wholeness, joy," Bermudez said in a 2021 interview.

Architecture critic and author Sarah Williams Goldhagen believes that the future of architecture lies in harnessing the new knowledge of neueroaesthetics to build environments that better support human feelings and well-being. She wrote about the neuroscience and cognitive psychology of the built environment in her 2017 book *Welcome to Your World: How the Built Environment Shapes Our Lives*. "Architects always aim to create experiential effects through design," Sarah told us, "and in the past, their methodology for doing so primarily involved drawing on personal memories and experiences, mixed with maybe a little sociology and often a lot of historical precedents."

Now, though, she says the growing body of research emerging from environmental psychology and the cognitive sciences is giving us a "solid evidentiary foundation for how people experience design elements in built environments." She continues: "Do high ceilings prime expansive thinking? They do. Do shiny, blood-red surfaces raise stress levels? They do. And so on. Why wouldn't architects want to make data-supported decisions about what design features to select to create a given experiential effect?"

Reconnect to Your Creativity

Somewhere around third grade you most likely received the message from a teacher, or other adult in your life, that you couldn't be an artist if you didn't have "talent." And you also figured out that creativity was not as important as getting the answers correct on the endless bubble tests in school.

Artist and founder of Art2Life Nicholas Wilton has made it his mission in life to reconnect people to their creativity, to that spark that never left but might have been dormant for years. Nick lives in California, and he is a painter in his own right. His works are atmospheric and richly layered and they've been referred to as visual poems. For good reason. They seem to offer a dialogue between thoughtful and controlled brushstrokes and spontaneous creative bursts.

Nick started teaching art to get out of his studio, and because he has a very generous philosophy about art-making. He has welcomed thousands of students of all ages from around the world—including both of us—and encouraged them to come to the canvas with authenticity and joy.

"Art-making is, really, about feeling more alive in your life," Nick told us. "The creative path is an unfolding process of becoming ourselves and it's a wonderful journey we get to take."

The biggest deterrent to embracing our innate artistic selves is the inner critic that shuts down our creativity. It's our human need to know what we're doing, where we're going, and our desire to be good at it.

Nick encourages his students, instead, to examine what it is that they want to experience or need to say. "I teach how to feel the energy of a mark or a color, what says yes to you more than something else. It's discerning what's important to you and how it comes out in the art you make." By inviting yourself to be open to the unknown, the object created is no longer the goal. "It's reframing art-making as a process of becoming yourself, and the things that you're making along the way are just the artifact of that process," he says. His students tell him that they carry the creativity unleashed in his classes into the rest of their lives, whether that's in how they parent or work; how they garden or cook.

Creativity is, put simply, the ability to imagine and come up with original ideas and solutions. It's a willingness to leave what is known, what exists, and open up to what is possible. Creative thinking allows us to connect information in new and meaningful ways and, as such, it's the birthplace of innovation and invention, making it one of humankind's most valuable skills. A skill that we all possess and use every day, even if we don't realize it. When you have to make up a recipe using spare ingredients in your pantry, when your child asks you to tell them a story at bedtime, when you create a clever DIY workaround for a home repair, you are engaging in creativity. It's spontaneous improvisation using your imagination.

Our brains are structured to support that kind of leap-taking improv.

There's this moment in Miles Davis's classic "So What," the first song on his bestselling jazz album *Kind of Blue*, where the master trumpeter goes off script. He deviates from the composition and begins a soulful rhythm capable of transporting you to the legendary smoke-filled clubs of New York's Fifty-second Street in the late 1950s. In jazz, improvisation is vital. Players talk to one another in a musical dialogue that requires a beautiful synchronicity and a willingness to be fully present in the moment.

In the early 2000s, Charles Limb was an otologic surgeon specializing in hearing at Johns Hopkins University. He'd spent a career understanding the anatomy of the ear, helping people restore their hearing. Charles also loves music, especially jazz, and he became curious about what occurs in the brain when someone performs a rehearsed versus an improvisational piece of music. A lifelong musician himself, Charles had a theory that the brain processes involved in these two types of performance aren't the same, and that they generate two completely different states of creative mind. What is happening inside the mind as a musician riffs? Susan's lab was among those to help underwrite these explorations.

Charles designed a special plastic electric keyboard without any ferrous metals so that it could go into a fMRI machine and not disturb the magnets. Inside, professional jazz musicians played two pieces: one they'd rehearsed and another that was improvised. In both scenarios, the scans revealed that many parts of the brain were recruited to make music, creating a galaxy of interconnectivity. He published his findings in 2008 in the journal *PLOS One*.

When the rehearsed piece was performed, the musicians' brains surged with energy, activating the prefrontal cortex. When the artists hit the keys to create a spontaneous riff, however, a significant portion of the prefrontal cortex, the lateral prefrontal regions, went silent. At the same time, Charles saw the medial prefrontal regions light up, an area recruited for self-expression. When this part of your brain is activated, what you experience in that moment is known as "flow," a state of complete immersion in an activity. Psychologist Mihály Csíkszentmihályi describes flow as "being completely involved in an activity for its own sake. The ego falls away. Time flies. And new ideas emerge."

When you enter this state, there is a physical feeling of bliss that can't be explained—it is a wordless sensation.

"Improvising was completely open ended, meaning there was no script, there were no preset rules," Charles told us. "You could perform those songs a hundred times and it would be different every time. After doing these neuroscience of jazz experiments, we started to understand that the brain really does change when it's in this spontaneous creative flow state."

Now a professor at UCSF School of Medicine, over the years, Charles has conducted several additional studies on creativity, and has seen similar brain responses in rappers, cartoonists, and those who do improv in theatre and comedy. Onstage, actors and comedians give over to the moment as they allow preconceived notions to fall away, and they just go with it. They enter a flow state, both neurobiologically and emotionally. This flow state reduces activity in the prefrontal cortex and increases our alpha brain waves, which occur when we are in a meditative and relaxed state. Flow in the brain is what undergirds peak performance.

But where do creative ideas come from in the first place? What makes some people capable of encouraging and using their creativity more than others? Those are questions that occupy Roger Beaty, director of the Cognitive Neuroscience of Creativity Laboratory at Penn State University. Roger studies the psychology and neuroscience of creative thinking using a bevy of instruments, including neuroimaging and psychometric approaches. His goal is to determine how people create new ideas and solve problems.

"Contrary to romantic notions of a purely spontaneous process, increasing evidence from psychology and neuroscience experiments indicates that creativity requires cognitive effort," he said in a 2020 podcast on the subject. Part of this effort is to overcome the distraction of prior knowledge, he explains, meaning the ways in which we believe things should work. In one test of creativity that is commonly used people are asked how many uses they can come up with for existing objects like a cup or a stapler. Most people struggle when they have notions of how an item is supposed to be used.

"In light of these findings, we can consider general creative thinking

as a dynamic interplay between the brain's memory and control systems," Roger explains. "Without memory, our minds would be a blank slate—not conducive to creativity, which requires knowledge and expertise. But without mental control, we wouldn't be able to push thinking in new directions and avoid getting stuck on what we already know."

Based on Roger's research, and that of other neuroscientists exploring creativity, we're seeing how creative thinking comes from the interaction of our brain's default and executive control networks, and "that these connections allow us to spontaneously generate ideas and critically evaluate them, respectively," Roger says. "And we are learning about how our memory systems contribute: the same networks that we use to recall the past also allow us to imagine future experiences and think creatively."

Engaging in the arts is one way to activate these systems and to spur creativity. Taking a break from a task at hand, for instance, and allowing your mind to wander as you engage in the act of art-making can spark seemingly spontaneous solutions. You've allowed your brain to go offline for a moment and daydream. It's believed that the seat of mind wandering may be your default mode network, and it is a fascinating and important neurological skill. Basically, your brain disrupts some of its own cognitive activity—such as actively processing your external environment—in order to protect your internal imaginings. Mind wandering in this way has been shown to increase our creativity.

Develop Rituals to Rewrite Your Inner Script

It's hard to change a habit. We tend to do things the same way we always have, because neuroplasticity cuts both ways. Our routines create neural pathways, which create habits of mind, even when those habits or routines aren't always good for us. If you want to enhance flourishing, you can't accomplish this by doing the same thing in the same way. As the writer Annie Dillard wrote: "How we spend our days is, of course, how we spend our lives."

The brain is designed to be shaped by our daily experiences, and recurring patterns of emotional, cognitive, physical, and circumstantial events comprise who we are. Practice and repetition rewire the brain. Our repeated patterns can help our brains to be agile, to conserve energy, and to flourish, or they can keep us stuck.

As Tyler VanderWeele noted in his research at Harvard, one of the keys to a flourishing mindset is imagining one's best potential self by shifting personal narrative to ones that are more positive. The stories you tell yourself day in and day out matter. Your brain loves stories, and they shape how you contextualize yourself.

It can be challenging, though, unearthing what lurks beneath our consciousness in order to discover, reframe, and rewrite our stories.

Alex Anderson is on the staff at the Stella Adler Studio of Acting, and he told us the story of one of his students, a man living in New York. This man was struggling to memorize a two-page monologue and every week at rehearsal he shook his head in defeat. Finally, during one rehearsal he explained that he struggled memorizing his lines because he had a learning disability. Growing up, a teacher at his school had told his mother that he was slow, and throughout his life, his mother had reinforced that story. Now this was the way he saw himself.

A fellow actor, who knew this man well, was perplexed. She looked at him and said, "You don't have a learning disability."

It was like a light went on in his eyes. Someone had seen him through a different lens, a new story.

The next week he stood onstage and delivered his monologue flawlessly.

This actor was a part of a program run through the Art Justice Division of the Stella Adler Studio of Acting known as Ritual4Return. Over twelve weeks, this man and other formerly incarcerated individuals were learning new rites of passage through theatre in order to successfully reenter society.

When returning to society after time spent in prison, the world often has a story about who you are. These stories can become internalized and hard to shake. "You can live a lifetime numbing yourself out and then have that reversed in a moment, if somebody simply sees you on-

stage," Tom Oppenheim, the artistic director of the Stella Adler Studio of Acting, told us. "Growth as an actor and growth as a human being are synonymous."

Each of us acts every single day, whether we are on a stage or not. When we walk into the office, for instance, we play the role of the worker. We come home and play the role of parent or spouse; we are a good neighbor or volunteer. We all inhabit narratives. These roles are known in neurology as first-person perspectives of self. In describing the inherent value of acting, Meryl Streep said, "Acting is not about being someone different. It's finding the similarity in what is apparently different, then finding myself in there."

Neurologically, acting onstage and inhabiting a role are slightly different. Acting allows us to consciously embody a character, whether that character is fictional or an autobiographical representation of self who is performing. This embodiment of a character can result in neural changes in networks associated with perspective-taking, empathy, and identity change, according to another a study published in the *Royal Society Open Science Journal*. For this study, researchers looked at the neural underpinnings of acting. The researchers put actors in an fMRI machine and then had them perform Shakespeare and found that being in character produced global reductions in brain activity representing what they called a "loss of self." Allowing yourself to fall into a role helps you to leave inhibitions behind, and allows you to then feel emotions in a new way. A surprising finding of this study, which aims to establish the cognitive neuroscience of acting and role play, is that even when we are not acting, when we are simply pretending to speak in a foreign accent, the brain responds similarly, and shows a penchant for perspective taking.

By asking participants in the Ritual4Return program to play fictional characters, as well as to perform autobiographical stories onstage, Alex's program is helping participants to embody a new perspective of themselves.

Before becoming a social worker and taking his position at Stella Adler, Alex had been a gang member who was incarcerated for a time. To join the gang, Alex had had to go through certain rituals. Then, as

someone who spent a lot of time going in and out of prisons, he got comfortable with the rituals of incarceration. "I started to realize that if rituals can be used to get people repeatedly in and out of correctional facilities, they can also be used to elevate people. In other words, it can go in the opposite direction if it's used right," he told us.

Rituals created through arts interventions have been shown to create lasting and effective change. A culturally based ritual can be a transcendent series of experiences, and when Alex began to put them in place for himself and for others, he saw the change that he sought. They have rituals for greeting one another, through drumming circles, or connecting with music and spoken word. This is one way to rekindle the societal kindnesses that can get lost in prison, and to establish a space of respect and care. Rituals like this offer our brains a sense of stability and control that helps alleviate stress.

Alex is creating other arts-based rituals centered on helping those who have been incarcerated, helping them to interact with a society that has often left them behind, and to deal with job and relationship stress. "Sometimes if you don't come out with this support, and with this connection to help you, you develop the wrong rituals. Or you take on rituals from other individuals," Alex says. "And a lot of those lead you right back down to social degradation. And before you know it, reincarceration."

Advances in neuroaesthetic research are helping us to better understand the creative and transformative process of rituals and rehearsal. Theatre is more than a setting for performance; it is the place where you learn to work, in concert, with others, to create a shared work of art. In one study of how actors onstage approach rehearsals, the participants spoke of how they worked to "silence the critical voice, removing the clutter, so that [they] can be open to [their] interaction with other actors and the text," writes John Lutterbie in his study of the neuroscience of rehearsing. "Indeed, in everyday life as well as the theater, we have all had the experience of trying to quiet the voices inside our heads."

Theatre answers a profound human longing to be acknowledged, a longing to be seen. "Sometimes the trauma and the stigma goes so deep

that it sort of stops their development and they stay at that space wherever they were until art gets in and sparks their imagination and changes that whole dynamic," Alex says of the people in this program. "It's like a whole other language that art speaks to inspire an individual."

The act of rehearsal is key to disrupting habits that no longer serve us in order to replace them with new habits that do. By offering individuals who are returning to society an opportunity to rehearse, in a safe space, the kinds of daily activities that they will encounter in society, they are given a chance to practice living, but with less risk. And research is showing that when emotions, symbols, and knowledge are examined through a ritual participation in art practices, they help to create a stronger sense of meaning and self-identity. Art infuses the process with a level of saliency that makes it stick.

Induce Novelty and Surprise

Ritual and routine are important, but the human brain also craves novelty and surprise to flourish. It gets, well, bored sometimes. Sometimes what we need is to get outside the "normal" and be wowed.

If one of the tests of creativity is to imagine unexpected uses for everyday objects, then the artists and designers of Meow Wolf must score off the charts. At their House of Eternal Return, a seventy-room immersive arts experience created inside a renovated bowling alley in Santa Fe, New Mexico, a laundry dryer becomes a portal into another world, a room of light becomes a wormhole into a metaverse, and walls become touchable murals of light where you can create your own work of art. What this group of ingenious artists made is a monument to creativity, wonder, and most of all, surprise. Even the way the collective got its name—having a dozen or so original artists throw two words into a hat and then drawing at random—speaks to the novelty that they hope to bring to the everyday. As they say in their mission statement, they hope to "inspire creativity in people's lives through art, exploration and play so that imagination will transform our worlds."

There is, first, the imagination of the artists. These are talented and creative souls who found themselves, in 2008, working outside of the established art world. They gathered to create their own projects, starting with immersive pop-ups and building from there. "We were a group of friends and artists who coalesced around this practice of creating immersive environments," says Sean Di Ianni, co-founder and former board member of Meow Wolf. "We were a totally open door kind of anarchic art collective."

We are a species of makers. We can't flourish if we're not creating. Self-expression is crucial to who we are. The founders and artists involved in Meow Wolf didn't wait to be brought into the accepted commercial enterprise of the arts economy; they created their own system.

And as a beholder, what we experienced at Meow Wolf is novelty and surprise.

When House of Eternal Return opened in 2016, the artists anticipated about 125,000 visitors a year. See image A in the color insert. They got that many people in the first three months. "The world was increasingly hungry for something, and it happened to be . . . what Meow Wolf had already spent years doing," the journalist Rachel Monroe wrote in a *New York Times Magazine* cover story in 2019.

In the neurological study of aesthetics, sometimes researchers see preferences for familiarity, but often they see preferences for novelty, where there's just enough of something new in art for you to stop and think: "Oh, that's cool."

If we see a beach, that's one thing. We know it's a beach and we may find it aesthetically pleasing. But if we stumble onto a piece of Earth art like *Spiral Jetty*, Robert Smithson's 1,500-foot-long sculpture composed of mud, salt crystals, and basalt rocks on the shore of Utah's Great Salt Lake, the brain is taken by novelty. Novelty is anything that registers as new and different to our brain. Our brains are intricately tuned into novel stimuli. We attend to stimuli that are different. Think about listening to the droning of a monotonic lecturer versus one who has energy and whose auditory volume and pitch change. This applies to all of our senses.

An early study on novelty, in 2012, found that experiencing something as novel stimulates activity in our hippocampus through the re-

lease of dopamine. Specifically, there was activity in the substantia nigra/ventral tegmental area (SN/VTA). In this fMRI study, researchers saw that novelty induced activity in this brain area, and stimulated more engagement as a result.

Novelty is often what triggers surprise, which is anything that defies our preconceived expectations. Researchers have been studying the reason we feel surprise, and how it works in the brain, since the 1980s. This is an emotion that is considered to be adaptive, in that it frequently stimulates new behaviors. Surprise is processed in a section of the basal ganglia known as the nucleus accumbens. When we register this emotion, our pupils dilate, suggesting arousal. Our attention focuses on the object in question, and our brains become absorptive, taking in as much information as possible to help guide what we decide to do next. When the surprise is pleasant, our reward system kicks in. It feels good, in cases like Meow Wolf, to be surprised, and it wakes us up to the world in a fresh way.

Even the most awe-inspiring thing, if you keep seeing it again and again, doesn't hit the same biological note. Your brain habituates to events that do not change because this conserves energy. These events, or stimuli, are no longer salient, so the brain does not have to waste energy on them. Habituation is one type of learning that occurs in your brain. The brain pays attention, then, to new experiences. That which is vivid, startling. What's around the corner? What's that element of surprise? It can be as simple as changing your route to work, going to a new museum, testing a new recipe.

An experience like Meow Wolf is an explosive hit of novelty and surprise. When you walk out, your curiosity has been sparked, your thoughts become more expansive, you are neurologically primed, as the artists hoped you would be, to transform yourself and maybe, even, the world. "These shows have a lot of portals—like a refrigerator that takes you into an interdimensional travel agency. But the best portal is the one that leads out of Meow Wolf," Sean says. "It's the one that leads into the rest of the world, where maybe you start to notice things. Maybe you notice something mundane, a piece of trash on the sidewalk or a building, or a parking meter, and you see it fresh. You

notice all that's around you." And you notice it in a surprisingly new way.

Your brain likes that.

Putting It All Together

There are many people we've had the honor of meeting over the years, and through the writing of this book, who exemplify a life lived from an aesthetic mindset and who flourish. When thinking about those who have harnessed the arts to explore what it means to be fully alive, one person immediately comes to mind: Fred Johnson.

Fred is many things. He is a former Marine who was sent to Vietnam at the height of the conflict. He is an acclaimed musician who toured the world with jazz legends like Miles Davis and Chick Corea, and could easily have been one of the improv maestros studied by Charles Limb. He is an accomplished singer whose voice gives joy to those who hear it, and yet he is also someone who spent years studying the silent art of mime in the tradition of Marcel Marceau because embodying movement in this way so intrigued him. He embraced the ritualistic power of an art practice to explore, with attention and curiosity, that which interested him, and was awakened to the importance of our words and how we communicate through the art of silence.

Later, Fred was chosen by two masters in West African storytelling to be trained in the centuries-old tradition of the traveling Diali (pronounced "jolly"), which is the person responsible for maintaining the oral history of a place and for healing people through music and poetry. Fred's entire life has been an unfolding of authentic passions, and a willingness to take risks and try new things. He maintains an attentive and humbled attention that leads him to discover, share, and celebrate his gifts, and to honor the gifts of others.

Go back to his beginning, and you learn that Fred is also an adoptee, a Black boy raised in an adoptive home, who for much of his life had no idea where he came from. "It's a powerful thing to not

know who your mama is," Fred told us. "You might say that I came into the world in a place of great disadvantage."

Fred became a ward of the state as a baby. The first five and a half years of his life were spent in and out of foster homes and orphanages. "And yet through some of the most challenging experiences I've had in my life, the greatest outcomes were there," he says.

Fred is a natural flourisher. He learned early how to pay attention and generate a measure of creative curiosity, even in the most difficult of circumstances, through music. "The one thing that I had in those developmental years was the sound of my own voice and my motion," he says. "I was a perpetual sound maker. It was how I put myself to sleep, by listening to the frequency and vibration of my own voice, like a form of infantile chanting."

When Fred was old enough, he worked to memorize songs and to practice singing. "It was the first time that I experienced people moving towards me and not kind of repelling and moving away from me," he says. He felt awe in these moments of connection.

Fred recognized music as a passion, and he pursued it, despite his harrowing upbringing. He adopted a purposeful, positive mindset and used the practice and performance of music to help him build the skill of creative engagement with himself and the world. "If I hadn't had music, I might not be here today," he says.

When Fred was sent as a young man to Vietnam, the lethal brutality of war instilled a renewed vigor for his life's passion. He wanted to use his gifts to connect with others and to offer them the same kind of meaning and purpose that music had brought him. "The only way that I could get myself back after the war was to serve others. That was my way of dealing with the measure of moral injury that I felt participating in the Vietnam War," he says. "I committed the rest of my life to giving life in whatever ways that I can. I had to find my voice again after the war, and I found my voice by helping others."

Ever since, Fred's journey has been one of using his voice to both heal and flourish. He finds balance within himself in part by bringing balance to the world. As the artist-in-residence and community engagement specialist at the Straz Center in Tampa Bay, Florida, he has

found an ever-changing enriched environment to replenish his mind and body.

Fred has reached out to disenfranchised communities to help them find their voice. He's encouraged veterans, like himself, to tell their stories through theatre, stories, and music. With his Voices of the Community program at the Straz, he has brought Indigenous artists and artists of color together to perform their work and learn from one another in order to "give new voice . . . empower and educate and hopefully inspire so that we can create new ways of being together in the community," he said in a radio interview about the program.

Fred excels at creating not only events but also rituals, to help seed the soil for people to flourish. It was while doing this international work that Fred met the two elder storytellers in the Diali tradition who inspired how he does this. "They taught me how, before any public gathering, we can center the community in a wholeness and a commonality through music, food, songs," Fred says. "A coming together of our hearts and a totality of our being, so that when we have conversations about what we should do together and how we should govern together and we can move forward together, we are already in a sensory alignment and an intentionality for the greater good. The role of the Diali is to be a storyteller and a healer and a dream weaver, to remind us that together we can create. Together we can manifest. And it's important for us to dream and to imagine and to aspire and to celebrate."

Susan often collaborates with Fred and has experienced him in action on many occasions. At one particular event, a meeting of more than a hundred neuroscientists discussing their research, Susan had invited Fred to join and imbue some of his magic into the day's convenings. Fred sat quietly and listened as the scientists presented their work, including one physician who read a passage about managing trauma. "The words he said were so penetrating and heartfelt," Fred recalls, "and to me, the art of living is to be present in space so that we can really connect to the wholeness of what it is that we have to offer each other, and what it is that we can be together and how we can manifest in that way."

Fred asked permission to sing the words. He awed the room, offering a novel way to experience and embody the words being spoken. Fred reminded everyone how, even in the most mundane moments, we have the capacity to connect in surprising and meaningful ways. After Fred had finished singing, Susan recalls that everyone understood that story in a new light.

In 2018, though, Fred's own story unfolded. After extensive Internet research, his biological siblings found him. The reunion was beyond emotional. "I've been given the ultimate blessing to know who I am because I spent my whole life looking forward because I was afraid to look behind," Fred says. "Literally, the day that I was connected with my family, I woke up the next morning and I felt like my peripheral vision had expanded exponentially. I could see in all directions."

Fred exemplifies the essence of a flourishing life through the arts. Living in joy, in heartache, and in wonder, and forever opening, opening, like a blossoming, into the fullness of self and community. Fostering authentic flourishing in others is at the heart of Fred's life. "The essence of humanity is for us to awaken to our true selves and to our connectedness," he says. "I believe that the creatives of the world, now more than ever, have a tremendous opportunity to remind each other of the beauty of life and living and being."

And as we all know, each and every one of us contains those seeds. We are all capable of tending our gifts and flourishing.

Amplify this 8 billion times to all of the people who live on this planet. What can happen when we cultivate the arts and culture within our communities?

7

Creating
Community

The purpose of art is to lay bare the questions
that have been hidden by the answers.

—JAMES BALDWIN, WRITER

When the coronavirus pandemic abruptly hit the Pause button on our ability to gather in person in 2020, we both began to reevaluate what it means to come together. We thought about what community and connections are, what they mean, and why they matter. Over the last decade, both of us have witnessed, and experienced, a steady and consistent shift toward transactional relationships, where people are relating to one another more for production and output than for greater understanding and meaning. We all seem to be moving away from the kinds of transformational interactions that sustain and embolden us. We've felt it in our own lives, and have seen it in the world at large, making strong community bonds more essential than ever.

Since the beginning of human existence, the ways in which we have gathered have changed, but the reasons we come together have not. We are ultra-social creatures who biologically evolved to belong to something greater than ourselves. We need one another, and without strong and lasting connections to family, friends, colleagues, and neighbors, without the relationships we create over a lifetime, we cannot survive, let alone thrive.

Supporting this core human imperative to live in community is our unique ability to creatively share our thoughts, ideas, and emotions. The success of our species comes down to this: Art creates culture. Culture creates community. And community creates humanity.

More than 250 million years of evolution have favored our social development. To understand how creative human expression has fueled the creation of community, we began a series of conversations with evolutionary biologist Edward O. Wilson before his death in 2021. Ed was respected around the world for his groundbreaking research and insights about the natural world. He studied the foundations of human existence for decades, writing about it in books such as *Consilience* and *The Origins of Creativity,* and talking about it in scores of films, television shows, and radio programs. Together, we talked about how the arts and aesthetic experiences have been essential to human development, a topic Ed thought about extensively.

You couldn't talk to Ed for more than five minutes without getting hooked by his insatiable wonder and curiosity. There were no formalities; he just jumped into the heart of the topic as if he had already been in the middle of a thought. Ed delighted in a good conversation, and ours often meandered from art-making to biodiversity and his belief that we might discover alien cultures.

Ed began our discussion with the first of four compelling insights. "Humanity began with firelight," he told us. "Our lives as we know them come courtesy of lightning."

Arcs of electricity six times hotter than the surface of the sun sparked trees and brush to flames on the African savanna where early *Homo erectus* and *Homo sapiens* captured this magic and carried it with them from place to place. Our prehistoric ancestors learned to harness wild-

fires into controlled campfires, bringing them back to shelters and camps. This was, of course, a pivotal moment in early human progress because it allowed us to cook meat. The addition of hunting to our gathering brought seismic change. Eating meat not only transformed our bodies—reshaping everything from our molars to our digestive tracts—it also required complex communication and cooperation. During the day, language developed to address the basic daily needs of the group, from the logistics of tracking animals to caring for children and preparing food.

At night, though, something remarkable happened. Fires were built, wood crackled into flame, and woodsmoke, heady and fragrant, filled the air. A honeyed glow warmed faces and illuminated the dark for the first time, offering warmth and protection from predators. So began the lasting human desire to make a circle, stare into the flickering fire, and commune.

The pragmatism of the day made way for the mystery and evocative nature of night, as fire fostered new forms of coming together. We created stories. We sang. We danced. We developed myths and metaphors that passed on the moral and ethical values of the group. We celebrated and we mourned. We began to sing and move together, and these moments of shared emotion and sound forged bonds, collective transcendence, and communal joy.

Here, around the fire, creative human expressions developed as an important layer of meaning-making and belonging. It is in this very place that the activities we now call "the arts" began to take shape as an evolutionary priority to keep us alive. Art-making laid the basic foundation for culture and community among our earliest ancestors. By stimulating the neurobiological reward system, these early gatherings helped to seed the social value of community. Researchers now know that participating in, and fostering, social connections in this way is akin to exercise for the brain: It improves cognitive function, lowers stress, and diminishes depression. And, through mirror neurons, it allowed our species to build empathy and understanding with others. Witnessing and beholding art taught us about ourselves and the world.

Ed had seen this early birth of arts and culture validated not only in his own research but in fossil discoveries and archaeological finds, as well as in surviving communities that continue to live closer to the ways of early civilization. For instance, caves used as prehistoric dwellings in what is now Gibraltar and Israel contain evidence of two kinds of hearths. One, often at the entrance, was a kitchen. The busy center of daily activity. A second, farther back and in a separate space similar to a living room with a natural vent in the rocks, was where people gathered to socialize around a fire.

This led to another revelation about evolution that Ed shared: "Along with ants, bees, wasps, and termites, we humans are one of only nineteen species on the entire planet that are *eusocial*. In other words, we work together to ensure our collective future. Group selection over individual survival developed with the core human traits we have honed to this day including sympathy, empathy, and teamwork," Ed said. "Altruism was essential to build and support community as a portion of the group members made sacrifices for the good of the group as a whole."

While it might not always seem the case, humans throughout history have more often chosen community and altruism over isolation and selfishness because irresolvable rivalry, from an evolutionary perspective, is deadly.

Successful cooperation for our ancestors required new ways to signal intent as well as complex thoughts and emotions to others. We developed even more advanced techniques to communicate and express individual and group identities. We dug natural clay from the earth and turned it into ocher, or we crushed rocks to dust for pigments, and painted our bodies. We collected colorful feathers for decoration and ceremonial purposes. We started to ascribe symbolism and meaning to nature, expressing the real world through our made-up imaginings. Strong social skills became a hereditary trait favored in genetics, and aesthetic distinction became the path for social identity.

This, in turn, fostered the development of our complex emotional brains, which was Ed's third insight. "It's thrilling to see how skilled our ancestors became at conveying sophisticated feelings and eliciting specific emotional responses from one another," he said.

Take for example, storytelling. Stories, born in the imagination of the teller, are capable of transporting the listener to another place and time. They provide critical information and meaning. We literally *feel* a story as our brains release a cascade of chemicals that encode them in our hippocampus. We now understand that the stronger the emotional content, the stronger the memory is of a story. The ability to completely fabricate stories out of the human mind in order to convey important feelings, ideas, emotions, and shared knowledge is but one of the capacities we developed in order to make sense of the world in a shared and aesthetic way.

Storytelling triggers strong neural reactions in our brain that make us connect to the ideas being communicated, and to the person speaking. In 2010, researchers at Princeton University watched what happened in the brains of storytellers and listeners using fMRI imagery. They specifically looked at spatiotemporal activity: where and when activity occurred in the brain. They created a map of that activity for the person who was speaking. They then overlaid that map onto the brain activity of the person listening. And guess what? They found that the speaker's brain activity coupled with that of the listener's.

This is known as neural coupling or, sometimes, mirroring, because our brains literally mirror the activity of the storyteller. The stronger that neural coupling, the stronger the story comprehension and the understanding, the researchers concluded. The more salient the story, the more our brain activity aligns with that of the storyteller. Saliency in narratives can come as the result of myriad factors, including all of those neurochemical emotional reactions we discussed in the learning and flourishing chapters. Curiosity, awe, surprise, humor, novelty. But even when we know how a story ends, there can still be saliency: Our brain encodes memories as causal narrative—if A happens, B follows— and the ability of a good story to pull up relevant memory can also make the tale feel more salient. The brain itself is a natural storyteller. It is constantly trying to put a narrative to the stimuli that bombard it.

Our brains grew tremendously as a result. There was a massive increase in brain size, primarily in the frontal lobe. Our pre-human ancestors had a cranial capacity close to that of a chimpanzee, but quickly, from an evolutionary timeline anyway, *Homo sapiens* more

than tripled brain mass. We invented new ways to express complex emotions and shared experiences, and our brains transformed in response by creating new ways to make art.

We evolved to be able to transform our complex emotional states and thoughts into communicable art forms that helped bridge the distance between individual self and others. As Lisa Feldman Barrett, a neuroscientist and psychologist at Northwestern University, so succinctly puts it: "Humans are the only animals on this planet who can simply make things up, agree on them as a group, and they become real."

The phenomenal evolutionary value of this, Ed explained in his final insight, was that "we are now capable of creating a new future through imagination and creative thinking." And that is exactly what we have been doing for millions of years.

Art as Evolution

Once humanity began to settle in regions around the world, as our ancestors created permanent encampments, Indigenous cultures began to emerge with the knowledge gained from our prehistoric family.

Art was a form of communication, and we began to perfect it as a way of expressing feelings, beliefs, and observations. "The need to make and create is fundamental to being human," Ed told us during one of our talks. "The next stage of development expanded our need to paint, to chisel, make tools, and solve complex problems through creativity, innovation, and trial and error."

Using the local resources of their environments, these emerging distinctive communities developed recipes and cooked. They drew and sculpted. They created clothing, body art, personal adornments, and tattoos. They refined the making of pottery, jewelry, and fiber arts, and began, even, to play with complex structures from different points of view and vantages. Aboriginal artists, for instance, created landscape maps with an aerial view.

The advent of language and writing—at first with symbols on the caves—greatly expanded the ability humans had to create. This enabled us to pass along generational knowledge and we took a great leap over other animals who had to learn survival from the other animals around them. This also gave humans the time necessary to be creative, contributing to the increase in our brain size because the more behaviors we adapted, the more brain cells were needed.

Indigenous cultures iterated creative practices and new modes of making things to convey societal values and beliefs, and interestingly, while their creations varied based on where they were made in the world, they all contained similar underlying intentions to connect, communicate, and bond. Today, there are more than 5,000 distinctive Indigenous groups in 90 countries, with around 475 million people, or about 5 percent of the global population. Each and every community is unique, and yet there are similarities in how they historically, and contemporaneously, use art and aesthetics to forge community.

To get a sense of how the arts were used to build culture in some of the earliest communities, we're going to introduce you to cultural leaders from two Indigenous groups that exist across the globe from each other.

We begin in the American Southwest, in the home of husband and wife Phillip and Judy Tuwaletstiwa.

Phillip is a member of the Hopi tribe. Judy is the visual artist you met in Chapter 3. We met up with the Tuwaletstiwas at their home in Galisteo, New Mexico, which sits in a valley basin with a ridgeline of red earth encircling it. On this day, we could smell the sage-tinged air as we watched the sun play tricks of light across the broad sky.

Judy welcomes us with her signature warm and inviting smile. Phillip has shown up in a T-shirt that says DON'T WORRY BE HOPI, and blue jeans, which we later learn is his standard outfit. Now in their early eighties and married for more than thirty years, they can start and finish each other's sentences with ease.

In their home, we are drawn to their stunning Hopi kachina doll collection that hangs on the white clay walls. Hopi men carve these dolls from cottonwood roots. Kachina dolls represent Hopi supernatu-

rals, or spirits, called Kachinas. Kachinas are part of Hopi ceremonies that date back hundreds of years, ceremonies that have grown from the Southwestern American landscape. The room suddenly feels like there are more than four of us present.

"Art, life, and identity were, and still are, inseparable in Hopi culture," Judy begins. The Hopi continue to create, celebrate, and perform ritual in much the same way that their ancestors did centuries ago.

"These creative expressions reinforce the ideals of the society, and if you're behaving properly, you're walking the Hopi path," Phillip adds.

Ivy has known Phillip and Judy for more than twenty years. She met them at the Galisteo community center's annual chili cook-off. Ivy had purchased a home in Galisteo in 2004 and wanted to meet her neighbors. Drawn to this town of fewer than three hundred people, Ivy often jokes that she goes there to *mainline nature*.

The three of them immediately connected over Phillip's chili. "For Hopi, cooking is, in itself, an art," he told us during our visit. No wonder, then, Phillip won the chili cook-off that day. His chili was a mixture of broth, tomatoes, onions, chiles, and a few spices. "No beans," he says emphatically.

"At Hopi, however, a multitude of dishes are based on corn. Let me tell you about corn. Corn is life," Phillip continues. Many ceremonies focus on corn, an essential diet staple for this desert culture. The Hopi learned to cultivate food in arid conditions, passing down the ritual of seed saving and planting through generations. "You make a deep hole in Mother Earth with a planting stick. You place a few teeny kernels of corn in the hole and cover them with the sand. The seeds sprout and grow. As they come up, they become the corn children. You must nurture them. Corn is a metaphor for life: You shelter the little corn plants. Sometimes, you build small windbreaks around them. You water them. You protect them from predators such as crows and rabbits."

The Hopi have more than twenty different names for the life stages of a corn plant, from womb to death. Hopi is amazing in how it uses this one ingredient, in so many different dishes, transforming it. Many rituals and ceremonies were built around corn and moisture: song, dance, prayer, and story that embody the Hopi spirit and celebrate the

natural world. Everyone, from children to elders, has a role to play, and everyone participates. For the Hopi, "art is a very democratic process," Phillip says.

Hopi creative expressions take many forms, including weaving, pottery, jewelry, and carvings. Regardless of the finished piece, universal symbols represent their culture through a kind of visual shorthand imbued with specific meaning.

One, among many, beautiful examples are the kachina dolls. "The art is abstract, it's concrete, it's metaphoric, and it's full of icons and symbolism," Judy says as she holds up two very distinctive kachina dolls. The first, called the racer, is black with two red stripes across its small circle-shaped eyes and mouth. The slightly rounded corners of its rectangular head are mounted on a minimal black body with hands at the navel. The second is called Crow Mother, the mother of the Kachinas. She wears an intricate dress with high moccasins and a blanket shawl and has wings attached to her head. Judy and Phillip explain the role and nature of each of these dolls, and the ceremonies that communicate these stories.

During these ceremonies, the rhythm, songs, and movement of individuals meld into a whole of the group. A narrative of mystery, danger, fear, joy, pride, and pleasure are told over and over again. And through these ancient experiences a shared understanding emerges on the path of human existence.

Judy reminds us that native cultures are not tourist attractions with costumes and props. "Hopi is an ancient community in a modern world," she says. It is through the daily rituals and profound ceremonial cycle that the Hopi traditions continue to be shared from one generation to the next, and the lessons of living reinforced.

Studies on the neurobiology of pleasure and happiness have identified the biological correlation between human gatherings such as these and the joy that shared movement and sounds produce in our bodies and brains. Dopamine, oxytocin, serotonin, and endorphins are released anytime there is a pleasurable moment, as well as when we anticipate and remember these moments. Music and dance increase levels of all of these neurotransmitters.

Through their corn and Kachina rituals and ceremonies, the Hopi instinctively activated these strong bonding chemicals to create a unified people. These community activities involving music, dance, and performance activate care and connection in our brain, where studies have shown how a deep state of altruism, joy, awe, and delight comes along with the release of dopamine, serotonin, and oxytocin.

On the other side of the globe from Judy and Phillip is Jerome Kavanagh. Jerome is a composer and artist from Aotearoa (New Zealand) and a practitioner of Māori Taonga Puoro, or Māori musical instruments. Jerome comes from the North Island, where his tribal ancestors inhabited both coastal and inland areas.

Jerome wears ancestral markings known as Tā moko all over his body. Tā moko reflects an individual's whakapapa (ancestry) and personal history. Each mark is a distinctive symbol of Jerome's family lineage, his role, and his relationship to his people. His body is a living artform honoring his place in Te Ao Māori—the Māori world acknowledges the interconnectedness and interrelationship of all living and nonliving things.

"These symbols are everywhere in Te Ao Māori," Jerome tells us. "We have a concept called wānanga that is about creating time and space to come together. When in wānanga, these stories and rituals are shared, practiced, carried on, and built into the fabric of our culture."

He explains that the Māori word for stories is *pūrākau*, which means talking tree, "so straightaway this tells you so much about our connection to nature, which is the ultimate reality," he says. "Everything in the Māori culture and arts is about the natural world and balance. There's a recognition that everything's connected and everything's important—right down to that little blade of grass, a grain of sand, a drop of water. It's all important. One of my elders would always say, 'Don't talk about your river. Go and talk *with* your river.'"

Māori art serves a valuable function in daily life.

Taonga Puoro instruments were, and still are, used for healing, sending messages, marking the stages of life, and for other ceremonies. They are made out of natural materials that reflect the sounds of nature including the wind, sea, and birds.

The Māori term for creating art is *Mahi Toi* and is different from the

Western concept of art. It is a continuation of ancestral practices connected to the cultural response with nature.

"What we do is more about respect. Our culture, our art, it is about how we serve our people," Jerome says.

One day when we spoke, Jerome had just finished carving a Pūtōrino, a kind of wooden flute made from native Kauri wood. He spent hours making the cultural instrument for the parents of a newborn, as a way to welcome their child into the world.

"You can play this instrument in three different ways, and in the stories of this instrument there are themes of the connection and intelligence of nature and community. These stories are passed down from our ancestors to help us navigate life in the modern time," Jerome shares. "Our cultural practices keep us connected, and it takes the Western concept of individualism out of it. The idea is that if we each bring something to the table, it's going to be easier for everyone."

Our conversations often come back to science, as well as art, and Jerome told us how at times he has read about a new scientific discovery in the news, and affirmed that "Māori already had that knowledge, but it's recorded in a different way. It's in story form. It's in an art form. When this happens, the community has a little bit of a joke about it. Jerome says, "Wow, we already knew that. We were taught that stuff when we were little kids. And only now, they're making a scientific discovery?"

Even as the forms we use to communicate evolve, these primary artistic skills used to communicate values persist. Rooted in our biological imperative for community, the two of us see fundamental values woven together to build connection through creative expression, the arts, aesthetic experiences, and culture. And when we put these same values into action, in even the smallest ways, we thrive.

One is holding a respect and a reverence for the natural world, which is what Ed calls biophilia. It is our human need to connect to nature and other biodiverse species. Nature is at the core of existence in Indigenous culture, too, and ceremonies and rituals were created and timed to honor natural cycles. It inspires the creation of art.

Another important tenet is making art an everyday practice. While the word "art" didn't exist in early cultures, acts of creative expression

were totally inseparable from daily living. They were integrated into the everyday, and the urge to practice creative acts was universal. Creative activities were democratized in that everyone participated, regardless of expertise, age, or gender. There was no delineation between the maker and the beholder. Diversity and complementary strengths were celebrated. There existed the ability to bring many voices, ideas, and skills to the creation of community needs, identity, and growth.

This use of art in the everyday helps to foster shared vision. Belief systems and community principles are expressed and reinforced using the resources available. For Indigenous cultures, this meant pottery, drawing, weaving, agriculture, home-building, and making—as well as ritualistic acts such as song, dance, and mythmaking. Today there are a vast array of materials and technologies to create meaning. A beautiful contemporary example is the creation of urban wall murals. We've included a piece by Portuguese street artist Huariu called *African Beauty* at the opening of this chapter. Huariu shared with us that it "was painted in a poor neighborhood, mostly a Black community, and the goal was to highlight and portray the beauty of the people who live there. It was a very heartwarming experience."

Often, a larger meaning is woven in. Call it what you will—religion, spirituality, or the divine. Art lays the foundation to create transcendent moments, forging emotional bonds present in the life of community. Our culture shapes our perceptions of self. Symbolism, icons, and metaphors amplify meaning, and are often passed down from generation to generation. These cultural artifacts serve to embody the values and beliefs that keep a community strong and that help to ensure its survival. And perhaps most important, the practice and repetition of creative expression in the form of songs, stories, fables, myths, dance, and other rituals reinforce beliefs, identity, and cohesion.

Connecting to Culture Again

The Hopi and Māori are strong and vibrant Indigenous communities. But like so many communities around the world, they face significant

obstacles and oppression. Maria Rosario Jackson notes that particularly for historically marginalized communities—who have been forced to assimilate, who have had their culture disparaged and erased—there has been harm done to what she calls the "root culture." Maria is a scholar, researcher, and professor on leave from Arizona State University while serving as chair of the National Endowment for the Arts. She has focused her career on comprehensive community revitalization, systems change, and arts and culture in communities from diverse perspectives, including higher education, think tanks, philanthropy, government, and a range of nonprofit organizations.

What we need, she says, are places where people can repair and make whole again their cultural roots, as well as create new traditions. A place where they can figure out how they want to show up both individually and collectively, and also have the chance to imagine their future.

Maria began her career three decades ago working on solutions to what she calls "wicked problems"—complex and multifaceted issues, including racism and social inequity. When she began championing arts and culture through this work, well-meaning colleagues couldn't understand why a person dedicated to social justice and change would focus her energy on the arts. "They thought I had lost my way. They would say to me, 'You care about low-income neighborhoods, poverty, inequity, racist policies and practices . . . why are you doing this arts-and-culture stuff?'"

But Maria understood that when people are oppressed, the first thing to be taken is their literature, their language, their art. "That ability to delve into the past, present, and future individually and collectively and without external judgment is so important," she says. Better understanding and nurturing opportunities for creative expression and building special places that integrate public health, community development, and arts and culture that can support the rebirth and evolution of identity have been an important part of Maria's work.

Just like Ed, Phillip, and Judy, she understands that the arts are a human imperative for making sense of the world. "But," she says, "if you don't have a place to generate something, to make something, to make sense of the world, to figure out how you want to show up and

reckon, together, with challenges, then authentic participation is compromised or not possible in those places where diversity and inclusion are touted as virtues." So many communities have been displaced, and their ability to build culture has been compromised.

Maria has come to call places capable of restoring, replenishing, and reinvigorating our full creative selves and communities "cultural kitchens." We love Maria's metaphor of a kitchen. Kitchens in homes are traditionally communal places. They can be private, where people have intimate conversations. They can be the place where you invite the outside in and feed them at your table. "Cultural kitchens are places where people come to be generative, to interrogate individual and collective intention and public good," she tells us. "The work that happens there is about repair, nourishment, and evolution, about making and sharing. Art, culture, creativity, and heritage are essential parts of the mix." As is the case at home, how others are invited in is up to the host. The key is that people get to decide their own path.

"Cultural kitchens can take many forms, but they all ask well, who am I, who are we in this evolving context, what do I/we bring? What does it mean to be bringing my/our voice or contributions forward?

"We too often think of art or creative expressions only as widgets to be consumed," she says, "or something that is produced for consumption. And then that consumption is what typically gets counted. That's only one piece of a much bigger picture that has to do with making, doing, teaching, critiquing, and becoming whole. Cultural kitchens are where that full spectrum of participation is often present."

A place that embodies Maria's cultural-kitchen concept is Sweet Water, a garden and community center located on several city blocks on the southeast side of Chicago. Emmanuel Pratt, a recipient of the MacArthur "Genius" Grant Fellowship, began what he calls "regenerative neighborhood development" in 2014, after completing two degrees in both urban planning and architecture from Cornell and Columbia universities. Emmanuel found his way to Chicago after graduate school, where he formulated the blueprint for a grassroots, resident-driven, nature-infused oasis with neighbors and artists.

Here, covering over two acres of urban land, woodchip-covered

pathways wind through hundreds of neatly arranged raised beds filled with kale, Swiss chard, tomatoes, and squash. Bees move among tall rows of sunflowers. Species of birds once absent from this neighborhood have returned in flocks to nest in newly planted fruit trees.

"This place harnesses all your sensory perceptions. It is the definition of a healing garden," Emmanuel says. The aesthetics of the garden, the colors and the shapes, speak to biophilia and a respect and reverence for the natural world. "Just digging in dirt makes a person happier," he says.

In fact, scientists have discovered that stirring up microbes found in the soil can indeed improve brain function and boost mood. Gardening is a pragmatic act, but also a form of creative expression that is capable of increasing levels of serotonin, the hormone that stabilizes mood and produces feelings of well-being. Gardening is one of those glorious hybrid forms of aesthetic expression that is beneficial to both the creator and the beholder.

In 2020, a study by environmental engineers at Princeton University followed 370 urban gardeners to measure their emotional well-being (EWB) using a universal scale. This scale tracked, among other things, happiness and meaningfulness, as well as the frequency of experiencing these peak positive emotions. They found that gardening at home supports a strong EWB score. This was found to be particularly the case for those living in low-income areas.

The neighborhood of Englewood was once dubbed "the murder capital of Chicago." Nearly half its occupants live below the poverty line; it is plagued by boarded-up houses and vacant lots. It was a place that lost its social connections after years of disenfranchisement and brutal hardship, after redlining and racial covenants. It is a place that gets written off, like too many in our world, as "blighted." This is the well-worn narrative of community degeneration that gets told time and again.

"You know, the definition for blight actually comes from agriculture?" Emmanuel says as he takes us on a virtual tour through Sweet Water.

Blight, he points out, is the death and decay of a crop so that it no

longer sustains life. "And when 'blight' becomes spatialized, it has a rough aesthetic. It is the aesthetic of oppression, of vacant houses and vacant lots, of weeds and desolation. All of this has eaten away at community. But now communities are saying enough is enough. We wanted to build a space where people could show up and be human in the city again. We are now in a process of emergence—that is not predictable, it is understanding of place from blight to light. I think the twenty-first-century city planner really needs to understand and appreciate it," he says.

Too often, though, the regeneration of a neighborhood like this one is farmed out to outside developers rather than presented as an opportunity for the community itself. This "degeneration/regeneration conflict," as Emmanuel has come to call it, creates "an ecology of absence."

Sweet Water began transforming this absence by rezoning an abandoned two-acre lot for commercial farming in a residential neighborhood. "If you think that's easy, let me tell you about the paperwork," says Emmanuel with a laugh.

Next, they took over a foreclosed house across the street and turned it into a canning business for the garden. A vibrant mural went on the exterior and attracted neighbors. "We started aggregating people in this house, and it became a vehicle for a community school to form in an otherwise depreciated property."

In one classroom, students from the neighborhood lead courses on aquaponics and agriculture. In another, a chef harvests food grown outside to teach cooking classes. "When the squash blossoms are blooming, you should see the beautiful homemade dishes made right here," he says.

They call this the Think-Do House. Here they imagine things. They make them up. Then they agree on them as a group, and those ideas become real. It is the very manifestation of what Lisa Feldman Barrett identified as our "human aesthetic ingenuity." They imagine. Then they create.

"We call ourselves solutionaries," Emmanuel says. "We are surrounded by problems but we find the solutions. Think it. Imagine it. Do it. Make it real. Sell it. That's our way."

Sweet Water uses the arts, architecture, design, and agriculture, along with aquaponics, carpentry, and urban planning to forge community.

The chips that line the walkways through the garden are leftovers from the on-site woodshop, where young people from the neighborhood learn how to build. They take shipping pallets and the wood leftover from packaging the expensive glass for high-rise developments downtown, and they transform them into garden beds, growing boxes, and greenhouses, as well as outdoor swings and benches.

This place also honors the art of the everyday, understanding how the smells of a good family style meal and the beauty of a simple gathering can be a generative and aesthetic act. "The social significance of a shared meal is so underrated," Emmanuel says.

Studies show that "breaking bread" literally has an effect on our emotions and behavior. Eating is both a practical need and a cultural one. The aesthetics of food, the beauty of the presentation, how it registers on our senses, is an aesthetic experience that is being studied. The insular cortex, the primary area for our sense of taste, also contributes to our visceral and emotional experiences. When we eat food together it tastes more flavorful. Yale psychologist Irving Janis has also observed that eating together alters how we communicate. We are generally more cooperative, work better as a team, and build closer relationships.

At Sweet Water there is also a shared vision, created in unison among the neighbors. There is a diversity of voices and people working together with complementary strengths to build. Symbolism and metaphor are everywhere, including the garden thriving in replacement of urban blight. Beliefs and skills are reiterated not only in the classes offered but in the messaging here. The tagline for Sweet Water is "There Grows the Neighborhood."

And then there's that larger connection to our internal life. "With these aesthetic changes, the conversations begin to change," Emmanuel says. "It's about interior transformation, not just in the land and the household but also personally, emotionally, spiritually. The aesthetic begins to shape our internal selves."

A community defines for itself what is needed. It's an internal voice

that is honored and listened to. Emmanuel and the people who make up Sweet Water intrinsically understand this fact: Community comes from within. The mistake we consistently make as a society is to *tell* people who they are. But as the urban activist Jane Jacobs wrote, "Every community has the seeds for its own regeneration."

Jill Sonke is the research director of the University of Florida Center for Arts in Medicine, and she has been creating arts, health, and public-health programs for years. Jill was a principal dancer and a soloist with companies like the Lori Belilove & The Isadora Duncan Dance Company in New York before, in 1994, becoming the dancer-in-residence at the UF Health Shands Arts in Medicine Program. She brought dance and other creative arts into the hospital there, and two years later, she helped to co-found the Center for Arts in Medicine.

In 2020, Jill launched The EpiArts Lab, a NEA research lab at UF, co-directed with Daisy Fancourt from University College London, where researchers conduct epidemiological analyses of large cohort studies to understand the effects of arts and cultural engagement on population health outcomes in the United States. They've been studying how creative activities such as listening to and making music, creative writing, storytelling, theatre, dance, gardening, cooking, and museum visits alter both individual and community health outcomes.

Their data demonstrates that the arts have a direct impact on health and well-being. "When people are having self-transcendent moments through the arts, they're expanding their conceptual boundaries and seeing the world differently," Jill says. "They're seeing themselves differently. Those moments are particularly memorable. We remember our aesthetic experiences, they stand out, and they have lingering effects in our senses and they help with our self-efficacy."

This growing knowledge around arts, health, and communities is spawning a global movement called social prescribing, which we mentioned earlier in the book.

An example in the United States is the CultureRx Initiative in Massachusetts that began to link doctors, social workers, therapists, and community leaders to bring arts prescribing to statewide residents. The program, launched in 2020, offers many healthcare providers across the state opportunities to refer their patients or clients to arts and cul-

ture experiences as a support for their health. "Research shows that access to culture can engage vulnerable populations; it can encourage physical activity, reduce stress and isolation, and help with the substance recovery process; and it can be a major factor in addressing social determinants such as poverty, racism, and environmental degradation—all at a much lower cost than conventional health care practices," the program leaders explain.

Tasha Golden, who holds a doctorate in public health science and is a research director at the IAM Lab, evaluated the CultureRx initiative to determine what is working, what could be improved, and how the program could be scaled or replicated. Tasha says, "What I'm seeing in this program is a model for enhancing existing models of community care in the U.S. Currently, most community-care networks include basic services but currently lack support for well-being and social connection. In addition, arts-based organizations are often well positioned to connect their participants to health and social services. So there is value not only in opening up the opportunity for referrals from care providers to community arts but truly integrating arts and culture into the fabric of community care. By doing so, we could improve access to care and strengthen the health of our communities."

Loneliness and Connection

When Vivek Murthy became the nineteenth surgeon general of the United States in 2014, he decided to take a tour of the country to better understand the health realities facing Americans. A physician, Murthy expected to see the physical ailments that were on the rise, from cardiac disease and diabetes to epidemic levels of obesity. And he did. Yet underlying all of these very real physical issues was a surprising psychological one: loneliness.

As Murthy sat in homes and backyards and church basements, he listened to people describe feeling a lack of belonging. He soon realized that "we need to more deeply appreciate the relationship between loneliness, social connection, and physical and emotional health," as

he wrote in his book *Together*. "Most of us are interacting with lonely people all the time, even if we don't realize it," Murthy says. Loneliness has since been called the hiding-in-plain-sight mental health crisis of our era.

While being alone sometimes can be positive and restorative, human beings are not built to be alone all the time, or to feel disconnected from one another. We are social creatures who need the support of fellow human beings to thrive. Everyone feels lonely sometimes, because this painful and universal emotion evolved to remind us human animals that social relationships and community keep us alive and help alleviate outside threats. But our brains also evolved to expect proximity to others. Prolonged loneliness has profound effects on how we interpret the world.

When we're lonely, we perceive everyday demands as more overwhelming. But when we hold the hand of someone we trust and love, our brain sees threats as less menacing. Touch is a vital sense. Skin-to-skin contact, feeling safe and connected to someone else, decreases blood flow in the brain to the place where a threat cues a stress response. In an MIT study of loneliness, people who were alone for ten hours craved contact the way they craved food.

In his book, Murthy identified three different dimensions of social life where humans need to feel connection. "Intimate, or emotional, loneliness is the longing for a close confidante or intimate partner— someone with whom you share a mutual bond of affection and trust," he wrote. "Relational, or social, loneliness is the yearning for quality friendships and social companionship and support. Collective loneliness is the hunger for a network or community of people who share your sense of purpose and interests. The lack of relationships in any of these dimensions can make us lonely, which helps to explain why we may have a supportive marriage yet still feel lonely for friends and community."

More than half of us feel lonely frequently. And more than a third of us feel lonely right now. When we are lonely, "we feel disconnected, irrelevant, and incomplete," says Jeremy Nobel, who founded the Foundation for Art & Healing.

In 2016, Jeremy created Project UnLonely to look at how the bur-

den of loneliness might be alleviated through the arts. In their Campus UnLonely program, they help eighteen-to-twenty-four-year-olds in that fragile transition into adulthood. With Community UnLonely, they help those who may feel ostracized from the general population to find their support networks. Through Workplace UnLonely, they help businesses to identify when their workers are isolated.

As we age, loneliness can be prevalent in the elderly, so Aging Un-Lonely offers programs to help mitigate this isolation. Just as Murthy noted, you can have fulfillment in other places in your life but still feel lonely at work or in community. The foundation sponsors a range of art experiences for finding connections, including knitting and sewing circles, dance parties, and storytelling, offering individual meaning-making experiences as well as shared time together. Participants report that they feel seen and heard, and have vastly improved mood.

Next, Jeremy created the UnLonely Film Festival, which presents short films aimed at offering viewers an opportunity to "learn, laugh, cry, smile, and, most importantly, connect." In one recent film submission, a young Black man was ostracized because of a pervasive stutter. He felt isolated, until he stumbled upon a small subculture of performance yo-yoing. Throwing, they call it, and it's pure magic to watch. This is not your usual yo-yoing. Here, music, movement, dance, and feats of skill combine into a truly beautiful art form. It's like the Cirque du Soleil of yo-yo. Jeremy adds, "When he found his art form, it gave him purpose. His yo-yo proficiency and contest victories also provided an enhanced sense of self-worth, a sense that he had accomplished something important, that he mattered. And he was able to identify his feelings of loneliness, express himself in a creative way, and in doing so, find acceptance and validation in his cohort of fellow throwers."

Moving in Sync with Our Social Brain

The ability to be in community is so essential to our survival and our well-being that UCLA social psychologist and neuroscientist Matthew Lieberman, author of the book *Social: Why Our Brains Are Wired to*

Connect, has been studying why that is. Like Ed Vessel, Matt has been researching our default mode network, particularly how it relates to our social awareness. When our brain stops being engaged in an active task, like solving a math problem or following driving directions, it immediately reverts back to a resting state. And when you rest, even for a brief second or two, it is the DMN that comes online. Of its many purposes, Matt told *The Atlantic*, "the default network directs us to think about other people's minds—their thoughts, feelings, and goals," particularly, as how it relates to our relationship to the world. Where do we fit in?

Our social awareness quiets down when we're involved in analytical thinking—that function is centered in the prefrontal cortex—but when we're done, it's what Matt has dubbed our "social brain" that comes back online by default. Whenever your brain gets a chance to rest, the DMN is the one that pops up.

"Evolution made a bet that the best thing for your brain to do in any spare moment is to get ready to see the world socially," he told *The Atlantic*. What's more, when we are in this social frame of mind, we are more prone to share our unique thoughts and ideas with others through language and creative expressions. Both as the person experiencing or making art, we have a unique capacity to identify complex patterns, qualities, feelings, and emotions in order to make meaning possible.

In one study, which Matt conducted with his wife, the social psychologist Naomi I. Eisenberger, the researchers placed individuals in an fMRI machine and asked them to play a game called Cyberball. Unbeknownst to the participants, this game was designed to specifically make them feel left out. The subjects believed they were tossing a virtual ball in a game with others, when in fact, they were playing against a computer algorithm designed to leave them out. The human player is led to believe that the others involved in the game aren't throwing them the ball. What the brain scans revealed is that the feelings elicited when they were left out of the game prompted pain responses as agonizing as a physical injury. "Rationally we can say being excluded doesn't matter, but rejection of any form still appears to reg-

ister automatically in the brain, and the mechanism appears to be similar to the experience of physical pain," Matt said when that study was published.

More recently, neuroscientists have been looking at what they call our social brain connectome, or the way in which our social skills exist because of interactions within different regions of the brain. They developed a neural architecture model of the social brain network.

In 2022, a team of researchers from Canada, the U.K., and the Netherlands looked specifically at how art ignites this social brain. Their findings are presented in a paper titled "More Than Meets the Eye: Art Engages the Social Brain," published in the journal *Frontiers in Neuroscience,* and they argue that there is a "neural grounding in the social brain" that "raises important practical implications" about the way the arts work on us neurologically. Their review study builds off the work of Daniel Alcalá-López and his team, who, in earlier studies, determined the scope of our social brain connectome by using data from nearly 4,000 separate fMRI and PET studies, as well as data from 22,712 healthy adults.

Just as many parts of the brain light up when we are learning and using social skills, the arts engage multiple parts of the brain as well. The researchers found that "art essentially engages the social brain," and they demonstrate this by showing how "art processing maps onto the social brain connectome—the most comprehensive diagram of the neural dynamics that regulate human social cognition to date."

Art, the researchers write, "is inherently a social construct and for this reason, art engagement recruits the same brain networks as complex social behavior." Therefore, they add, "we propose . . . that the meaning and experience of an artwork is always created in a social context. Art allows us to reflect on the world around us, but the effects of a particular artwork cannot be assumed to be universal: this will be highly dependent on the viewer's personal knowledge and experiences and their social and cultural environment." Further, they conclude, "art potentially constitutes a novel and powerful tool to understand, diagnose and treat disorders of the socio-emotional brain."

Musician and artist David Byrne's life journey has been one of be-

coming more social through creative expression. While many people think of David as the leader of the amazingly innovative band Talking Heads, David doesn't see himself as a rock star. He is primarily interested in what it means to creatively connect and build community with curiosity and by using art, music, and collaboration.

In 2018 he created the Arbutus Foundation, a meeting place where artists, scientists, journalists, educators, technologists, and more gather to develop, produce, and inspire projects that reach audiences worldwide.

"Years ago, I realized how socially uncomfortable I've been, that I was someone who had a really hard time communicating socially," David tells us. "And then I realized that music became a way of expression, a social expression. I found it very difficult to communicate with people one-on-one in a normal social setting, but I could write songs, and perform, and get up onstage, and do pretty wacky things, and be what would appear to be pretty extroverted. And then stepping off the stage, I just go right back into a more introverted person. But I'd had a moment of putting out to the world, or to a small audience, this idea of 'This is who I am, this is what I'm interested in, this is what I think about. And here I am.'"

Soon, David recognized that something else was going on in performances such as this, something in the magic of the group dynamics. "I was feeling a sense of community with the people I performed with. I was more relaxed. I was coming outside of myself, my little shell, by working with them. And the music began to reflect that, the music and the performing became more of a group communal experience. I'm fairly socially comfortable now, and that might've happened anyway, but it seems to me that I went to performing and making music as a way of being in community."

David's body of work is so broad and diverse, but the through-line is always bringing people together in movement, art, and singing in order to build connection. He has used his art to understand himself and his relationship to people and where he fits into the world, and this ability to be connected to others is what it's all about for him.

Increasingly, he has incorporated scientific research into his work.

American Utopia, David's award-winning Broadway show, opens with him holding a brain as he talks about the neural connections that get eliminated in our heads. He is fascinated by how the brain works and how it influences our behavior through art and culture.

When Susan saw David's play in a small theater in New York in 2019, she was struck by the layered aesthetic details. Listening carefully, she realized there were birds singing in the theater before the show began. Then, the juxtaposition of the human-built environment on the stage, and the movement of the performers entering and natural sounds lit up her brain. Toward the end of the show, David said something like, *Okay, okay, everyone can dance now.* The familiar Talking Heads songs "Burning Down the House" and "Road to Nowhere" played as David and his co-performers sang and danced. The audience went wild as they were all dancing in step.

David says, "When you move with people, especially when you start to move in sync, or if you sing in sync with other people, you form this kind of bond that doesn't exist between you as individuals. Think about marching or military bands or square dancing—there is immediate kinship and strong connection."

He's referring to the way in which bodies moving in sync build stronger social ties and create a greater sense of belonging. Research is showing that when we are in sync with one another our generosity, trust, and tolerance increase. Simultaneous and coordinated movement delivers an "extra dose of affinity," according to Laura Cirelli, a psychologist and synchrony researcher at the University of Toronto, and the reasons for that are just now becoming understood. In a *Scientific American* article Cirelli is quoted as explaining how the phenomenon's "powerful effects on us result from a combination of neurohormonal, cognitive and perceptual factors," she says. "It's a complicated interplay." There is also evidence, she says, "that we have a propensity for synchrony that may have been selected during the course of human evolution, in part because it allows us to bond with large numbers of people at once, offering a survival advantage."

That's exactly what happened to Susan after leaving the theater. She felt like she had just been at a concert with five hundred of her closest

friends. She felt renewed as well, happy and joyful. That's what happens when storytelling, singing, and dancing create strong bonds within groups. It changes us, biologically and emotionally.

When COVID-19 shuttered everyone inside, David decided to create the Social Distance Dance Club. Toward the end of the quarantine, he and his collaborators invited people into the Armory in New York for a night of DJ-led music where each person had their own spotlight, a safe distance from the others. David called out dance moves, "and while we all kind of have our own inner groove, or the way our body responds, at the same time, we automatically adapt and mirror what other people are doing around us," he says.

David noticed that even within the individual dances, the people in the room were forming a little community simultaneously. "You have this bond that happens between you and other people who are participating, and it can be really simple, but it's transcendent in that people start to see themselves as a social organism," David says. "You get outside of yourself and your own daily worries, you get outside of yourself as an individual, and you bond with other people. Maybe just for an evening, maybe only through the fact that you liked the same kind of music or something. We're communing with other people and making a large tribe for one evening."

Prior to the event, David sent a video to participants in the dance club with a set of very simple moves for the final song. "I wanted to see if we could manifest that feeling of moving together in sync in time. I mean, we're dancing all the time, moving through life, and then when we move together in sync, it's super powerful. It's not something that can be done virtually." By the end, people were crying, laughing. They were jubilant and connected, even despite their social distance.

What's so remarkable about creative experiences like these is that individuals from very different backgrounds are united through song and movement. The experience of being together and of joining a larger whole is completely transcendent.

"And there's something you get back that's more than what you're giving in these moments," David explains. "You see it in the gospel church, you see it in lots of other places where it's really ecstatic. Peo-

ple go back to their daily individual lives afterwards, but they've had a taste of something else, something beyond themselves as individuals."

The act of moving bridges the gap between self and others to create a temporary but strong bond. That feeling of belonging carries with us as we walk away, a kind of high that comes from a release of endorphins, hormones involved in other pleasurable activities.

David believes there are these sparks that we can all create, these moments that invite our creative selves to engage with others and foster a positive and healthy community. And he keeps igniting them.

With the spark of a flame we began our long journey as a species on this vast planet. We figured out, against all odds, how to express ourselves in unlimited, beautiful, mysterious, sometimes funny, humbling, and sublime ways to cultivate the energy that connects us together as socially responsible people.

The work of creating strong communities is continuing to happen at all levels of society, in every corner of the world. It continues in indigenous cultures. It is permeating homes, schools, workplaces, neighborhoods—anywhere and everywhere we come together. The Internet and social media have emerged as our global virtual campfire and have the capacity to exponentially foster and support healthy community growth if harnessed in the right way.

The journal *Nature* dedicated an entire issue in 2018 to the science of human cooperation and concluded that the strongest barrier to our getting along "is simple lack of communication." As *Homo sapiens* learned, as Indigenous cultures know, and as many of us are discovering, creative expressions and the arts are paramount to the effective exchange of ideas, and to our very survival.

Creative expression, the arts, and aesthetics serve a core purpose: To birth new thoughts and ideas. To mirror back to one another what is important and what is needed. To weave together common threads of humanity. The arts empower us to reimagine, re-envision, and reconnect in order to create a better future together.

The Art of the Future

The mind, once stretched by a new idea,
never returns to its original dimensions.

—RALPH WALDO EMERSON, ESSAYIST

A round the time that the two of us began exploring the idea for this book, a team of Chinese geologists was discovering what is believed to be the oldest known piece of art in the world.

David Zhang of Guangzhou University led a group high into the Tibetan Tableau of Southwestern China, an area known as "the roof of the world" for its elevation 4,000 meters above sea level. There, they found a piece of limestone that had fossilized a playful composition of hand and foot impressions. The pattern was "deliberate" and "creative," according to a paper that Zhang and fellow researchers published in the journal *Science Bulletin* in 2021, and the piece "highlights the central role" that artistic exploration and play

has held for our species. Uranium series dating determined that this artwork could be 226,000 years old. With our hands and our feet as our first artistic tools, we've been leaving behind our imaginative impressions since Earth's last ice age.

The arts evolved over millennia to become central to our human experience, and throughout history they have sparked revolution and cultural change. The arts, by their very nature, reflect and inform the time in which they are created; they take the pulse of their time, but the artists have also been essential for forecasting the future, and serving as an early-warning system for society. The Greek chorus of classic antiquity was a creative theatrical invention that became the moral voice of civilization. The arts have spurred societal shifts: The Renaissance propelled humanity out of the Middle Ages with evocative music and visual storytelling, and the citizen artists of 1980s Germany turned the Berlin Wall into a bold tableau of political protest, to name just a couple of examples.

What the arts do to our brains and bodies allows us to give voice to important messages, reveal our emotions, drive innovation, spark creativity, raise ethical and moral issues, and shepherd in new eras of humanity. Paola Antonelli, a senior curator at New York's Museum of Modern Art, once aptly noted that art and design offer "a renaissance attitude that combines technology, cognitive science, human need, and beauty to produce something that the world didn't know it was missing."

Or as Christopher Bailey, the WHO's lead for arts and health initiatives, told us, "The arts make visible what we are feeling but may not have been able to name just yet, enabling us to see that we are not alone."

The influence of the arts on humanity is irrefutable. So, too, is the scientific evidence that we are biologically wired for it.

Throughout this book, we've shared some of the mechanisms, neurotransmitters, neural circuits, and networks that are activated in you by arts and aesthetics. We've shown you how the arts can be used to ease physical and mental distress, to learn more deeply, to galvanize community, and to help you flourish. The arts have been ushering in profound individual and societal change over millennia because they

quite literally change our biology, psychology, and behavior in undeniable and profound ways.

Even as we continue to rely on our primary tactile human tools to communicate the complex language of humanity, we have also unleashed, with every generation, new techniques for creative expressions. We have the technological prowess to build virtual and augmented worlds. We have the ability and the knowledge to focus light and sound in ways never used before, to name a few. And through advances in research and technology, we are able to better quantify how our bodies change in real time thanks to arts and aesthetics.

The arts, coupled with the insights of the sciences that we've explored here, are once again primed to usher in a new era of humanity. The future of neuroarts promises what may well be our next revolution: one where we embrace the artist that exists in each of us and recognize that we possess the innate skills to transform our biology, our families, our work, and our communities by integrating arts practices in intentional and sustainable ways.

New research, discoveries, and applications continue to mount. The sheer magnitude of this work is exceptional, and it promises to continue to accelerate. In the near future, as ever-more-sophisticated neuroaesthetic research becomes capable of measuring the effect of the arts on neural networks and those 600-plus mechanisms already identified, we will know more about how the arts affect us and how they can further benefit every aspect of our lives.

Just as the work of scientists like Zhang is revealing the long arc of human art-making in the past, the neuroaesthetic research and invention of the present is seeding our future. What will the world look like in the coming years as the neuroarts propel us forward?

Sensory Expansion and Exploration

You are, as we've discussed in this book, exquisitely designed to bring the world in through sensory stimuli and the chemical concoction of neurohormones created through feelings and emotions. These combine

to create the saliency that builds strong synaptic connections in your brain.

Taste, touch, smell, vision, and hearing are only the tip of the proverbial iceberg. Research in neuroaesthetics and other fields has sparked a debate about just how many senses we truly have. Some suggest that number could be as great as fifty-three, and include complex dynamic networks such as thermoception, or how we sense heat; equilibrioception, our perception of balance; and proprioception, our awareness of how our bodies move through space. We are still very much discovering the universe that is the human body. The emerging complexity science that many researchers discussed will help illuminate the way. We will, undoubtedly, also continue to substantiate why and how the arts and aesthetic experiences, with their capacity to simultaneously engage multiple biological systems and brain regions, are so potent.

Technological advances are already allowing researchers to capture biological data, and there are a few devices in development that will soon offer the ability to better tap into our diverse sensory responses and chemical states. Beyond the basic biomarkers already captured through existing wearable tech, engineers are perfecting wearable skin sensors capable of analyzing our hormones, proteins, and chemical states in real time, offering early warning signs of conditions like prolonged stress. Others are at work developing smart threads, or clothing that moves with you throughout the day and becomes a data stream via circuitry that's woven in and invisible to the naked eye.

As technology continues to evolve, it will become more precise and in sync with our bodies, enabling us to have more information that we can choose to use or not. "Think of it as a personal radar system that gives you more agency and can enhance your capacity to live a healthier life," Joanne DeLuca told us. Joanne is a sought-after cultural analyst and futures strategist who co-founded the consultancy Sputnik with Janine Lopiano. For more than twenty-five years, they have been providing foresight to international companies about what the future holds.

Based on their latest research, Joanne and Janine believe that our sensory literacy will expand. The neuroarts are connecting the dots to show us more of our mind-brain-body relationship, and as the field

advances, it promises to help inform our lifestyle choices. In the same way that you exercise knowing a run or a walk lowers cortisol and raises serotonin, and in the same way that you have the evidence that twenty minutes on the arts provides immediate stress-relieving benefits, you will have more research showing how specific arts activities yield tangible results.

Creating art will be even more essential and pervasive. In fact, arts activities are already on the rise around the globe. A study published in the journal *Frontiers in Psychology* in 2021 underscores years of anecdotal observations from news outlets like the *Washington Post* and *The Guardian* about how, in challenging times such as the COVID-19 pandemic, people turn to the arts. The researchers looked at data from more than 19,000 people living in the U.K. who reported that "arts activities were used to help people manage their emotions." We are seeing an uptick of people around the world who are knitting, gardening, painting, writing, playing music, and inviting more art and aesthetics into their lives.

"We predict sensory literacy will be taught across the life-span in a number of ways," Joanne told us. "Early childhood development will be one of the first to deploy this knowledge for prevention and protection. We will see the emergence of sensory-based curriculums using the latest scientific information. Sensory training will expand in high schools and colleges and the workplace and we will see the growth of sensory skills in healthcare and rehabilitation."

As we have shared, there is a growing desire to become more than productive workers, and to instead live in the full thrall of our sensory world. The shift toward sensory literacy will result in our collective awareness of the mind-brain-body connection, resulting in advances for our health and wellness.

The New Sensorium: Engaging with Mixed Realities

One way our sensory literacy will increase is through the advancement and integration of virtual and augmented realities. In the same way

that the video game SnowWorld eases pain in burn victims, or virtual reality transports University of Arizona biology students to immersive habitats, our physical "real" world will merge more with virtual ones with increasing seamlessness and fluidity. Mixed reality will become more commonplace. You are already beginning to see this in simple ways, such as the many filters that can change your appearance on your phone or social media, or that put you in another virtual location instantly.

Examples of the merging of worlds are developing rapidly for a range of outcomes. At the Johns Hopkins University School of Medicine's Neurology Department, John Krakauer and Omar Ahmad have collaborated to develop a form of immersive experience called I Am Dolphin, a video game with a unique form of controllable animation to help people recover from strokes and other neurological conditions, as well as stress and burnout. Individuals who play I Am Dolphin control the intentions and movements of Bandit, a simulated dolphin with emergent dynamics, and by doing so explore and discover latent cognitive and movement capacities. MedRhythms, a digital therapeutic device that uses the neurological capacities of music to help people with multiple sclerosis, Parkinson's, and those who are at risk for falling, walk better. Sensors placed on shoes offer real-time feedback as an algorithm adjusts the rhythm of music for the wearer, supporting better movement. In 2020, the FDA approved MedRhythms with its breakthrough device designation for treating chronic-stroke walking deficits.

VR and AR technology enables immersive storytellers to bring us, the viewer, into their storytelling. Sundance Film Festival has started screening live-action VR films, such as 2022's *The State of Global Peace,* in which you are a delegate delivering a speech to the UN General Assembly when the security system is hacked and you are face-to-face with the hacker.

Researchers have discovered through experiments with animal models that virtual reality strengthens theta waves in the hippocampus. Theta oscillations are associated with cognition, like learning, memory, and spatial navigation, and after one experiment at UCLA in

2021, neurophysician Mayank Mehta told *Science Focus* magazine, "We were blown away when we saw this huge effect of VR experience on theta rhythm enhancement" in rats. This new technology, he said, "has tremendous potential. We have entered a new territory." Imagine more VR tailored for specific therapies for conditions like ADHD and Alzheimer's, but also for enhancing learning.

These immersive and enriched environments engage our senses and create strong emotional reactions that heighten learning and memory. As Marian Diamond's work showed, and additional studies have continued to prove, we learn faster, and better retain information, in sensory-rich environments.

In 2015, the Tate Britain partnered with artists to create a first-of-its-kind exhibition called the Tate Sensorium, which brought the museum alive through vision, sound, touch, smell, and taste. While looking at a 1945 portrait painted by Francis Bacon, visitors were invited to eat chocolate blended with specific tastes of charcoal, sea salt, and smoky Lapsang souchong tea. For the painting *The Full Stop* by artist John Latham, the acrylic-on-canvas piece from 1961 was paired with a soundscape as well as a midair haptic device that creates a kinesthetic sensation of movement using sound, vibration, and light. Viewers were given headphones playing specific tones to accompany the painting, while the midair haptic feedback device created a rainlike effect in the audio and visual field. The result was a full-bodied experience of Latham's painting.

The more we engage our senses—when technology and art are used together—it can give us new experiences, opening possibilities for discovery. This is an emerging art form with the promise of enriching our lives for years to come. Leading the way are artists like Refik Anadol. Refik is a mixed-media artist who creates monumental, dreamlike environments using AI and algorithms. Refik is deeply curious about the aesthetics of machine learning, and through his room-sized installations, he merges the cold, hard numbers of code and data into an evocative and sensuous visual language. The artist coined the terms "AI data painting" and "AI data sculpture" during his residency at Google's Artists and Machine Intelligence program in 2016 to describe site-

specific, three-dimensional, and dynamic sculptures at the intersection of architecture, media art, light studies, and AI-based data analysis.

"We believe that immersive and multisensory spatial experiences, when combined with meaningful and cutting-edge data visualization techniques, can create a healing power," Refik explained in a *Design Boom* article in 2022. "There are countless medical studies in progress about the use of gaming technologies and multimedia for pain management as well. There is infinite creative potential in machine algorithms that can take various shapes for the advancement of humanity. We have been researching well-being aspects of our works in collaboration with UCLA neuroscientists since 2020. We also collaborate with scientists at Harvard and UCLA to create tools for them for better data visualization that will aid their research in the long run."

For his 2018 installation *Melting Memories*, Refik used tools like EEG machines from the Neuroscape Laboratory at the University of California, San Francisco, to gather data on the neural mechanisms of cognitive control. He then built a multidimensional artwork fed by changes in human brain-wave activity, as gathered by the lab. Standing in front of the wall-sized display, the viewer watches a white, sandlike world morph and dance into virtual landscapes and swirling masses. Colors representing different data sets then burst forth in blues and pinks and purples, and these crest and crash together like ocean waves. At times these colors seem to explode, like a cosmic image of a supernova. It's poignant in a way that rendered the two of us speechless when we first witnessed it. Refik's work, like the data it is culled from, seems to work on you at a cellular level.

Refik's innovative work is featured on the cover of this book, in the opening image for this conclusion, and in image H in the color insert. The cover image is an AI data sculpture from *Sense of Space: Human Connectome,* Refik Anadol's exhibit on connectivity and structure in relation to living organisms' invisible architectural forms at the 2021 International Venice Architecture Biennale. Through collaboration between Dr. Taylor Kuhn, coordinator of the Human Connectome Project (HCP) at UCLA, Refik Anadol Studio processed approximately 70 terabytes of multimodal MRI data, including structural, diffusion

(DTI), and functional (fMRI) scans of people ranging from newborns to nonagenarians and beyond, to train machine-learning algorithms that discover patterns and imagine the development of brain circuitry. With this groundbreaking approach, his studio was able to generate a fully immersive, augmented 3-D brain structure model.

Computing functions such as the haptic devices used at the Tate and the tech used by Refik represent our art-meets-data future, where the best of technology and the best of the artistic mind merge to create lush, provocative imagery.

Soon, you will likely be able to interact in high-fidelity holographic 3-D models. Rather than removing us from the sensory, these digital enhancements have the potential to make us even more embodied. "These new aesthetic experiences that we create, that we embrace, will actually make us feel more human through multisensory triggers," Janine told us. "Art as technology can transfer how our sensory experiences will manifest inside the metaverse. The arts will not only be something we view. The arts will be us. We will become part of the arts. Our sensory experience, how we feel in space, will become a physical exploration through the arts."

The interdisciplinary arts collective teamLab created an audience-driven experience in Tokyo called teamLab Borderless that brings the natural world to life. See image E in the color insert. The collective incorporates light, sound, and visual effects that feel as though you are part of the art, and that seem to transcend our normal perceptions of time and place. As you meander through the space, you are able to manipulate the surroundings through touch, and to watch as digital flowers bloom, and die, and bloom again. We often think of ourselves as individuals separate from our surroundings, from nature, but this stunning interactive museum dissolves the boundary between art and the viewer, allowing you to feel your surroundings in a visceral way. Composed of artists, programmers, engineers, CG animators, mathematicians, and architects, teamLab represents the exciting, transdisciplinary collaborations of the future.

Artists are also taking public art to a new level through the use of light, which uses almost any surface to project interactive images and

displays. Cities around the world are seeing projection mapping crop up on sculptures, skyscrapers, museums, and municipal buildings. Everyday spaces are being transformed, shifting how communities interact with familiar environments to create surprise and delight.

Mixed media, too, is expanding beyond traditional entertainment into training, education, and healthcare. In 2022, an AI-powered immersive experience called *Paradise* debuted at South by Southwest. The program was developed to provide couples with in-home support for building more empathetic relationships and for addressing partner violence. Creator Gabo Arora is an award-winning filmmaker and the founding director of the Immersive Storytelling and Emerging Technology Lab within the Johns Hopkins University Krieger School's Master of Arts in Film and Media Studies program. He partnered with Darkfield Radio, a British creator of audio programs, and with Nancy Glass at the Johns Hopkins University School of Nursing and the Bloomberg School of Public Health. What they developed incorporates the latest research on domestic violence strategies and solutions into a thirty-minute immersive aural theatre program that uses gamelike AI interactivity and surround sound.

Gabo explained that while he has a background in film, "when I discovered immersive technology, I found it offered the emotional resonance that traditional media just doesn't have. And there is now research that confirms this," he adds. Immersive programs like his "change hearts and minds in ways no other media can. *Paradise* is asking more of AI technology and narrative storytelling. It is asking how this art form can help to make us better, in terms of mental health and trauma. Work like this is making us ask what new technology can do for us, rather than being in fear that it will control us."

The Rise of Personalization and Agency

Science has shown that no two people respond to the arts and aesthetics in the exact same way. This scientific data is laying the foundation

for individualized practices, experiences, and interventions in every sector, from education and healthcare to public health and community development.

We are already seeing an increase in social prescribing and personalized medicine as creative arts therapists, physicians and psychologists, social and homecare workers suggest arts activities as ways to prevent illness, relieve symptoms, and maintain well-being. Over the next few years more findings about our unique biology are coming, and this research will be used to inform, personalize, and enhance every aspect of our lives.

We will see a rise in personalized microdosing of aesthetics. We are already seeing signs of this in healthcare, where specific scents are used to relieve stress, light sources are calibrated to relieve a headache, and personalized playlists are offered to reduce anxiety. There are hospital rooms planned right now that will have the digital augmentation capacities to offer preferential color, music, scent, temperature, and textures to enable healing to happen better and faster. And classrooms could take this mixed reality to help children with learning differences engage through dynamic personalized simulations.

Musicians and performers are translating the physical, mental, and emotional benefits of their professional arts practice for the rest of us, creating a new type of community and personal health service. One such artist is world-renowned soprano Renée Fleming. Millions of people around the world have watched and re-watched her arts and health programs. She believes that in the future, personalized arts-based treatment, prevention, and wellness programs will be an integrated part of our healthcare system as insurers become convinced by the mounting evidence that these programs truly work.

Renée's advocacy and philanthropy in the arts grew out of her personal experience with the physical pain that manifested from performance pressure. Over the last ten years, she has nurtured the growth of the arts and health movement around the world, bringing together diverse stakeholders. She has spearheaded the NIH/NEA Sound Health collaboration as an advisor-at-large, and she serves as the co-chair of the NeuroArts Blueprint that Susan co-directs.

Now, in addition to her global performance touring, Renée offers "Music and Mind" presentations for her audiences. In these events, she highlights researchers, physicians, creative arts therapists, and others working at the intersection of music, neuroscience, and healthcare. During the COVID-19 pandemic, Renée took this work virtual, launching a 19-episode series called *Music and Mind Live.*

Renée has also been actively developing a series of personalized arts and health programs and partnerships, including Healing Breath, created in collaboration with the Kennedy Center, Google Arts & Culture, and Mount Sinai Beth Israel hospital. She invited more than a dozen music therapists, actors, and singers from a range of diverse genres to share breathing exercises with the general public and promote pulmonary health. Kristin Chenoweth, Vanessa Williams, Angélique Kidjo, Audra McDonald, Kelli O'Hara, Denyce Graves, Lawrence Brownlee, and others joined to share their vocal training tips and resources.

"As singers and actors, most of us have our trusted breathing exercises that we have used for years to build our voices," Renée said to us. "I wanted to share this work to assist people around the world struggling with long COVID, COPD, and other debilitating lung issues."

And it might sound like science fiction, but another example of where personalized aesthetics are headed in the not too distant future comes from Jeff Thompson, the founder and director of the Center for Neuroacoustic Research in Carlsbad, California, who uses sound vibration as a health and well-being intervention. He envisions a time where, instead of waking up every morning and taking vitamins, there will be a unique sound composition calibrated to your body's exact vibrational needs that will regulate metabolism and help prevent chronic diseases.

Building a Sustainable Field

There are millions of people around the world already tapping into the arts and aesthetics for health and wellness. In order for the field of

neuroarts to reach its full potential and become accessible to everyone, it will need to be sustained and supported. This means that there must be an increase in interdisciplinary research, in training and education for diverse practitioners, in new public and private policies, and in funding. There also needs to be accurate and ongoing communication, both within the field and with the general public, on how to talk about this work and to bring the arts and aesthetics into our lives.

The good news is that we're already seeing strong global initiatives emerging around the arts and aesthetics. All disciplines from public health and education to business and technology are integrating the arts into their fields.

In healthcare, the arts are being seen as a vital component for expanding support with patients and providers alike. In the U.K., they are in the midst of a first-of-its-kind study called the Scaling-up Health-Arts Programme: Implementation and Effectiveness Research, or SHAPER. This is the world's largest effort to integrate the arts into mental health treatments within a national healthcare system. This complex and multilayered study is measuring both the clinical effectiveness of the arts programs being offered to patients—including a singing program for mothers with postpartum depression—and how successfully these programs have been embedded within the public health service.

Architecture and design is another area where neuroarts are being applied to inform commercial, municipal, and residential projects. Today, top design studios and architecture practices are using neuroarts-informed design, while neuroarchitecture courses and certifications are increasingly being offered in schools.

Institutions that support the arts are also evolving their missions, expanding who they reach and what they offer. Museums no longer see themselves as only repositories for artifacts, but also as interactive spaces where visitors can engage with arts and aesthetics to benefit their health and well-being. This includes new ways in which museums take their programs out into communities. In 2021, for instance, New York's Rubin Museum of Art opened an interactive sensory-stimulating exhibition called the Mandala Lab as a permanent space for visitors. The space was curated using Buddhist principles that support self-

awareness and empathy. In the scent room, you are invited to inhale from a library of different smells. A meditative breathing alcove features a sculpture by Palden Weinreb that pulses with light on pace with regulated breathing. In the gong space, you can take a mallet to one of eight gongs to make resonant vibrations. Jorrit Britschgi, the executive director of the museum, told *Architectural Digest* that he hopes the installation can "serve as one of the city's first cultural healing spaces and be a source of insight and well-being." The Rubin plans to take this exhibit to other communities in the coming years.

Vitally important to the growth of this field are the thousands of organizations building evidence-based practices and solidifying an expanded role of the arts and aesthetics—from local, state, and federal governments to professional associations, advocacy groups, cultural and community arts organizations, and colleges and universities.

A major step in taking the neuroarts mainstream happened in 2021 with the release of the Neuroarts Blueprint, a five-year initiative that was co-directed by Susan through the IAM Lab, and by Ruth Katz, vice president and executive director of the Health, Medicine & Society Program at the Aspen Institute. The goal was to make the arts a part of mainstream medicine and public health. Along with a twenty-five-person global advisory board, which was co-chaired by Renée Fleming and neuroscientist Eric Nestler from the Icahn School of Medicine at Mount Sinai (and on which Ivy serves), the Blueprint mapped ways in which the field can strengthen research, honor and support the arts practices that promote health and well-being, expand educational and career pathways in the field, advocate for sustainable funding and effective policy, and build capacity, leadership, and communications strategies to propel the field forward.

"There is huge momentum behind building the field around the world," Ruth told us. "Achieving well-being is both an art and a science, and neuroarts bridges that gap."

This vision of the future holds great promise. But you don't need to wait. As you've seen throughout the book, arts practices and aesthetic experiences are available to you anytime, anywhere. Lidewij Edelkoort is one of the world's most famous trend forecasters. She studies the

evolution of socio-cultural trends, and she reminded us how aesthetics and the arts are already becoming more integrated into our lives. "It's the precious little things that matter most as aesthetics become more intimate, more personal," she says. "It's the way you put things together. The way, for instance, people go to the floral shop now and they buy individual flowers and they make their own creation." Simple arts and aesthetics practices are immediate, affordable, and accessible.

Like the kaleidoscope metaphor in the introduction, by slightly moving the aperture of your awareness, you can create entirely new experiences that move you to a more aesthetic mindset. One where curiosity, open-ended exploration, sensory awareness, and creative expression become a cornerstone of your life.

Your Aesthetic Life

So what does it really mean to live with an aesthetic mindset? What does it look like to apply what the scientists, artists, and practitioners in this book have shown us?

Imagine just one day in your life where the science and practices outlined in this book come to fruition, where arts and aesthetics are seamlessly integrated.

Your new morning routine might include simple sensory choices to begin your day. Smell informs as much as 75 percent of our emotions, and you've selected favorite scents to wake you up. A vase of flowers by the bed, potted herbs on the kitchen counter, an aromatic tea or coffee blend tailored to your preferences. You've turned on lights that are using bulbs in the 6,500 kelvin blue-white color temperature to simulate sunlight and help signal to your circadian rhythms that it's time to wake up.

In the shower, you sing a tune that you can't get out of your head, and this activates multiple brain areas, all of which are connected by complex neural networks. Even just humming becomes an act of pleasure, activating the vagus nerve and engaging the parasympathetic sys-

tem to help you feel good. Your brain is humming, too, now, and you begin to feel good as endorphins are released. And as the warm water quenches your trillions of skin cells, a sense of calm washes over you, activating your nervous system, improving balance, and putting you in an alert, cognitively ready state of mind for your day.

You are the curator of your life, and you've created an enriched environment in your home that reflects your aesthetics. You prioritize your intuitive taste over what popular culture says you should like, because you understand the unique confluence of your own aesthetic triad. You also appreciate how your default mode network has made meaning out of your lived experiences. There's art that you've made, or art that you've collected, that challenges your thinking and enriches you.

You have a daily art practice that is as vital to you as exercise and meditation routines. Art, you now understand, isn't only a hobby, it's a conversation with yourself, a way to connect your mind, body, and spirit and to support your health and wellness. Some days, it's just twenty minutes of sketching or doodling to reduce cortisol after a challenging or stressful experience. Other times, it's something tactile, like sculpting with clay, knitting, or gardening, where your mind wanders and you are in a flow state. The sensation of working the clay, the yarn, the soil, in your hands stimulates skin and nerve endings and ignites the body's internal sensory receptors. Through sensorimotor pathways, you feel instantly attentive, awake, and receptive. Artmaking here is not about the end product. It is a process, an active way of being and knowing.

As your day progresses, should a headache hit, a dose of dance and movement helps; when anxiety rises, tuning forks in C and G create a sound wave that soothes the fight-flight-freeze response and elicits relaxation.

On this day, you make time to be in nature. The sunrise, a red cardinal alighting on a branch, wind in your hair, the yellow freshness of daffodils, all inspire a brief pause to appreciate the awe of the natural world. Being reconnected to nature's rhythms supports and sustains us, and you are now more aware that these simple everyday aesthetic

moments activate neurochemicals already in your brain, like dopamine and serotonin. The beauty of the natural world is motivating and mending you in small ways.

When you bring your aesthetic mindset into the workplace, you recognize that efficiency isn't the only goal—it's about belonging, collaboration, creativity, communications, attention, creative problem-solving, and so much more. Space changes the way we think and feel. Here, creating an enriched environment forms the conditions to achieve greater success and satisfaction.

In the evening, you make plans to see live music, catch a dance or theatre performance, or visit a local arts venue with friends. It's great to be together, experiencing and enjoying a range of art forms, but that's not all. You are gaining empathy and perspective, being immersed in new feelings and ideas, enhancing the conditions for flourishing.

Within your family you bring more attention to these relationships. You encourage your children or grandchildren, your nieces or nephews, to experiment with their own hands-on arts and aesthetic experiences. This builds vital executive-function skills at an early age, allowing them to explore and express their emotions, to build identity and agency because their brains are developing neural pathways at lightning speed.

When caring for others, you've got additional tools to ensure that you look after yourself as well, creating habits to renew your physical and mental health. And if you take care of others, your arts and aesthetic toolkit is robust, from creating playlists of songs that help recall memories for people with dementia, where their long-term memories are remarkably preserved; painting and collaging to slow cognitive decline as part of creative aging; dancing together to reduce symptoms in neurodegenerative disorders like Parkinson's; and drawing to share thoughts and ideas when words fail us, reopening the Broca's area of the brain.

Instead of emotionally shutting down when difficult feelings, challenging situations, or traumatic events happen, you remember that twists and turns come to all of us, and the arts and aesthetics are here to help you through. You use writing as an expressive tool when you

feel vulnerable or uncertain, and painting and coloring offer a pathway to emotions that literally ignite neuroplasticity.

At the end of the day, there is the intentional art of making a meal. There is more music that soothes the mind, whether you are creating it or listening to it. You might watch a sunset or a moonrise. When you are ready for bed you dress yourself in fabrics that feel good on your skin, while the sounds of nature lull you to sleep. The lamps by the bed glow a warm 3,000 kelvin to evoke the end of the day and the room temperature is lowered, helping to release melatonin and support your circadian rhythm.

The arts have the ability to transform you like nothing else. They can help move you from sickness to health, stress to calm, or sadness to joy, and they enable you to flourish and thrive. They can lead you to profound altered states, changing your very physiology.

The arts have always offered the highest form of hope, and science is now providing new knowledge that each of us can immediately use.

Just as your brain waves oscillate with the electric energy of rhythms, just as sound and color vibrate through you, the personal choices of your aesthetic life feed and support your unique self.

Are you ready?

The world, and its beauty, are there waiting for you.

Acknowledgments

Over the course of the last four years our journey to write a book that could speak to so many of the issues we face through the lens of the arts and aesthetics has taken us around the world, gathering stories, gaining insights, and loving every single encounter. Creating this book has been an honor and an absolute pleasure. Collaborating with each other has been a rare and precious gift, and we recognize the magic of it. We've read each other's minds and finished each other's sentences. We've laughed a lot.

We are both enormously grateful to so many people who have encouraged, advised, and sustained us. First, our husbands, Arthur Drooker and Rick Huganir. They have rolled up their sleeves editing, fact-checking, and encouraging us. There are no words to express our love and appreciation for their inspiration and support.

Our agent, Bonnie Solow, guided us through the process with grace and steely determination to write the absolute best proposal and then the very best book. Her vision of what this book could be became our north star. Elizabeth Evitts Dickinson assisted us in writing the book. She is an accomplished author in her own right and agreed to work with us because she believed what we were embarking on was important. Her brilliance in helping to weave personal stories with complex science made the text sing. Laura Murcek has been our go-to sherpa. From stellar strategic marketing advice to organizing thousands of research studies and references, we couldn't have navigated so many details without her. And Julie Tate, who methodically fact-checked our book.

Ben Greenberg, our editor at Random House, understood the potential of *Your Brain on Art,* and he challenged us to add layers to every story, believing that readers would want to learn more and apply

the arts to their daily lives. He worked with us to sculpt the manuscript, making sure every word mattered.

The two of us believed that the book should "walk the talk" and be aesthetically beautiful. Heartfelt gratitude to all the amazing Random House team members who have traveled with us. There are more than twenty pieces of art throughout the book illuminating stories and offering additional ways of knowing. We love sharing these works. A special thanks to Refik Anadol for allowing us to use his art on the cover and to neuroscientist and artist Greg Dunn, who collaborated with us on the brain map.

On an epic journey like this one, it is easy to go astray. Everything is interesting and worthy. We were blessed to have Joanne Gordon, a writer who has elevated the voices of many thought leaders, gently and enthusiastically keeping us on track. Andrea Camp read the manuscript from her perspective as a policy advisor and communications guru, helping to ensure that we landed our messages with an eye to action and agency. And Linda Gorman, Johns Hopkins University neuroscientist and educator, who stepped up as our final scientific advisor, made sure we got the science right.

Chuck Savitt, founder and former publisher of Island Press, saw the complexity and importance of showing the science of the arts in context with the future of humanity and made an introduction to evolutionary biologist E. O. Wilson. Ed passed away during the writing of this book, and we are eternally grateful we were able to share with you his revolutionary ideas on the vital necessity of the arts for humankind's success.

There were so many people we conferred with to shape the book. Their generosity of spirit and wisdom is woven throughout these pages. A special thanks to philanthropist and entrepreneur Jeff Walker, who graciously shared his knowledge about how to build a new field. Nina Wise helped us understand improv as a tool for exploring what we are feeling. Edie Weiner, CEO of the Future Hunters, opened our minds to the power of science fiction, positive storytelling, and archetypal superheroes as arts that enable us to see a brighter future. Sarah Lewis, associate professor of history of art and architecture and African and

African American studies at Harvard University, shared her brilliant articulation of the "aesthetic force" and the power of the arts to change the world. Seth Godin, author and speaker, offered us sound advice about the role of curiosity and creativity. We thank neuroscientist Joe LeDoux for explaining our social brains. And D. Paul Schafer, founder and director of the World Culture Project, who has been an inspiration and guiding light, for sharing the essential need for rich culture and diversity.

To all of those whose stories we have shared, we thank you for your time and the opportunity to bring your work and passions to others with the purpose of illustrating how the arts transform us. There are so many more people and stories whose extraordinary work we would have loved to share. From researchers and practitioners to artists and advocates around the world, there is just so much more to say. We look forward to bringing you additional stories through our website.

To the many friends and colleagues who have listened to us talk about the book, believed in us, and empowered us to do this work, thank you for all of your ideas, thoughts, and advice. This book represents the power of the collective, and it is better for each of you breathing a bit of life into it.

Ivy is grateful to have worked with talented designers, creatives, artists, and colleagues at a variety of companies over the years, especially her current awesome team at Google with whom she practices the aesthetic mindset every day. Susan's professional life has been filled with creativity and collaboration over the last forty years. Since 2004, she has loved building programs at Johns Hopkins University, especially with her brilliant and passionate team at the International Arts + Mind Lab, Center for Applied Neuroaesthetics. Marilyn Pedersen inspired Susan to do something meaningful at Hopkins early on, believing the arts and aesthetics make all the difference in our lives. Marilyn Albert has been a cherished advisor and friend through the twists and turns of academia. Kathryn Goldman has fearlessly journeyed with Susan on many adventures and is always there, no matter what.

These acknowledgments could not be complete without recognizing where we have come from and who has helped to shape us. It was Ivy's

father who fostered an insatiable curiosity that has permeated her life. Li Edelkoort of Trend Union inspired her to see wonder and beauty in everything. Her mom and brother have always been there to share special moments and memories. Brittany, Ivy's daughter, warms her heart when she tells her mom how proud she is of her. And now with grandson Blaine, the future of the arts is being realized every day.

Susan is grateful for "the sisters": Donna, Sandra, Karen, and Lisa for their joyful and fierce support. Growing up, she was immersed in the love of making, inherited from her mother, Patsy, and grandmother, Granny. They lived life through their hands—knitting, sewing, cooking, gardening, writing, and so much more. From day one her sister, artist and author Sandra Magsamen, has been her greatest collaborator and critic—like only a twin sister could. Susan is blessed for being the mom of Sam and Ben, from whom she has learned much about the true nature of creative expression and aesthetic mindset. Together with a big and growing blended family including Nikki, Henry, Adam, Katie, and Tina, Susan is inspired by the nourishing intellect, imagination, and kindness of this beautiful bunch. And she can't forget her dogs, Logan and Ryder, who kept her company through many interviews and edits.

For the two of us, this book has been a labor of love, and we have felt carried by so many amazing people doing extraordinary work. Thank you all.

Notes

Unless otherwise cited, quotes come from interviews conducted with the authors.

Chapter 1: The Anatomy of the Arts

6 *Different tempos, languages, and sound levels:* Emily Saarman, "Feeling the Beat: Symposium Explores the Therapeutic Effects of Rhythmic Music," *Stanford News,* May 31, 2006.

6 *they saw that alpha waves:* "Releasing Stress Through the Power of Music," University of Nevada, Reno, https://www.unr.edu/counseling/virtual-relaxation -room/releasing-stress-through-the-power-of-music.

6 *It's here that we perceive:* Zaira Cattaneo et al., "The Role of the Lateral Occipital Cortex in Aesthetic Appreciation of Representational and Abstract Paintings: A TMS Study," *Brain and Cognition* 95 (April 2015): 44–53, doi:10.1016/j .bandc.2015.01.008.

7 *Touch receptors in your skin:* Sandra Blumenrath, "The Neuroscience of Touch and Pain," BrainFacts, February 3, 2020, https://www.brainfacts.org/thinking -sensing-and-behaving/touch/2020/the-neuroscience-of-touch-and-pain-013020.

7 *Information about touch and texture:* Matt Wood, "How the Brain Responds to Texture," *ScienceDaily,* February 8, 2019, https://www.sciencedaily.com/releases /2019/02/190208124705.htm.

7 *Touch is one of the more powerful:* Natalie Angier, "Primal, Acute and Easily Duped: Our Sense of Touch," *New York Times,* November 9, 2008.

7 *Recent studies have found:* Steven C. Pan, "A Touch to Remember," *Scientific American,* January 8, 2019.

7 *reactions at staggering speeds:* Luis Villazon, "What Is the Time Resolution of Our Senses?" *Science Focus,* https://www.sciencefocus.com/the-human-body /what-is-the-time-resolution-of-our-senses/.

13 *There are several regions:* Lucina Q. Uddin, *Salience Network of the Human Brain* (London: Academic Press, 2017).

14 *Diamond later wrote:* William Grimes, "Marian C. Diamond, 90, Student of the Brain, Is Dead," *New York Times,* August 16, 2017.

14 *remembered how one neuroscientist:* Ibid.

22 *Neuroscientists have been able to:* Robert Sanders, "Recording a Thought's Fleeting Trip Through the Brain," *Berkeley News,* January 17, 2018.

23 *"Why would my body equate ease":* Rab Messina, "Google's Milan Show Was Emotionally Painful—and That's Exactly What I Liked About It," *Frame,* April 10, 2019.

Chapter 2: Cultivating Well-Being

32 *Feel-good neurochemicals including dopamine:* Heidi Moawad, "The Brain and Nostalgia," *NeurologyLive,* October 13, 2016, https://www.neurologylive.com /view/brain-and-nostalgia.

34 *"mental health crisis of great proportion":* "Stress in America 2020: A National Mental Health Crisis," American Psychological Association, https://www.apa .org/news/press/releases/stress/2020/report-october.

35 *A 2020 report from AARP:* "Caregiving in the U.S.," AARP and National Alliance for Caring, May 2020, https://www.caregiving.org/wp-content/uploads /2021/01/full-report-caregiving-in-the-united-states-01-21.pdf.

35 *According to the WHO:* "Integrated Care for Older People (ICOPE)," World Health Organization, https://apps.who.int/iris/rest/bitstreams/1352688/retrieve.

37 *One study in Finland looked at VAT:* Elsa A. Campbell, "Vibroacoustic Treatment and Self-Care for Managing the Chronic Pain Experience," JYU Dissertation, University of Jyvaskla, June 2019, https://jyx.jyu.fi/handle /123456789/64286#.

37 *Nitric oxide enhances cell vitality:* Elliott Salamon, et al., "Sound therapy induced relaxation: down regulating stress processes and pathologies," *Medical Science Monitor,* May 22, 2003, http://www.MedSciMonit.com/pub/vol_9/no_5/3514.pdf.

38 *In one small study of the effects:* Tamara L. Goldsby et al., "Effects of Singing Bowl Sound Meditation on Mood, Tension, and Well-Being: An Observational Study," *Journal of Evidence-Based Complementary & Alternative Medicine* 22, no. 3 (July 2017): 401–6, https://doi.org/10.1177/2156587216668109.

40 *the neuroscience of color:* Keith W. Jacobs and Frank E. Hustmyer, Jr., "Effects of Four Psychological Primary Colors on GSR, Heart Rate, and Respiration Rate," *Perceptual and Motor Skills* 38, no. 3 (June 1974): 763–66, https://doi.org/10 .2466/pms.1974.38.3.763.

41 *In a fascinating study:* Hsin-Ni Ho et al., "Combining Colour and Temperature: A Blue Object Is More Likely to Be Judged as Warm Than a Red Object," *Scientific Reports* (July 2014), https://doi.org/10.1038/srep05527.

41 *More than 12 million coloring books:* Nikki VanRy, "What Happened to Adult Coloring Books? Charting the Boom and Bust," BookRiot, November 6, 2019, https://bookriot.com/adult-coloring-books-trend/.

41 *the simple act of coloring:* Malcolm Koo et al., "Coloring Activities for Anxiety Reduction and Mood Improvement in Taiwanese Community-Dwelling Older Adults: A Randomized Controlled Study," *Evidence-Based Complementary and Alternative Medicine* 6 (January 2020), https://doi.org/10.1155/2020/6964737.

42 *New Zealand psychologist Tamlin Conner:* Tamlin Conner et al., "Everyday Creative Activity as a Path to Flourishing," *Journal of Positive Psychology* 13, no. 2 (November 2016): 181–89, https://doi.org/10.1080/17439760.2016.1257049.

42 *anxiety was measured in participants:* Nicole Turturro and Jennifer E. Drake, "Does Coloring Reduce Anxiety? Comparing the Psychological and Psychophysiological Benefits of Coloring Versus Drawing," *Empirical Studies of the Arts* 40, no. 1 (May 2020): 3–20, https://journals.sagepub.com/doi/abs/10.1177 /0276237420923290.

42 *These results make sense:* Takashi Ikeda et al., "Color Harmony Represented by

Activity in the Medial Orbitofrontal Cortex and Amygdala," *Frontiers in Human Neuroscience* 9 (July 2015): 1–7, https://doi.org/10.3389/fnhum.2015.00382.

42 *scientists have turned to magnetoencephalography devices:* Sara Harrison, "A New Study About Color Tried to Decode 'The Brain's Pantone,'" *Wired,* November 24, 2020.

42 *shown varying hues of blue, brown, and yellow:* Isabelle A. Rosenthal et al., "Color Space Geometry Uncovered with Magnetoencephalography," *Current Biology* 31 (February 2021): 515–26, https://doi.org/10.1016/j.cub.2020.10.062.

43 *A study published in the journal:* Nancy A. Curry and Tim Kasser, "Can Coloring Mandalas Reduce Anxiety?" *Art Therapy: Journal of the American Art Therapy Association* 22, no. 2 (April 2011): 81–85, https://doi.org/10.1080/07421656.2005.10129441.

43 *mindfulness-based art therapy:* Megan E. Beerse et al., "Biobehavioral Utility of Mindfulness-Based Art Therapy: Neurobiological Underpinnings and Mental Health Impacts," *Experimental Biology and Medicine* 245, no. 2 (October 2019): 122–30, https://doi.org/10.1177/1535370219883634.

47 *twenty minutes in nature:* Tania Fitzgeorge-Balfour, "Stressed? Take a 20-Minute Nature Pill," *Frontiers Science News,* April 9, 2019, https://www.sciencedaily.com/releases/2019/04/190404074915.htm.

47 *As Andrew Huberman, a neuroscientist at Stanford:* Jessica Wapner, "Vision and Breathing May Be the Secrets to Surviving 2020," *Scientific American,* November 16, 2020.

47 *The famed architect Frank Lloyd Wright once said:* Lee F. Mindel, "Lee F. Mindel Compares the Oculi at the Vatican and the Guggenheim Museum," *Architectural Digest,* February 28, 2013.

48 *neuroaesthetic studies on curves:* Gerardo Gómez-Puerto et al., "Preference for Curvature: A Historical and Conceptual Framework," *Frontiers in Human Neuroscience* 9 (January 2016), https://doi.org/10.3389/fnhum.2015.00712.

49 *Too many of us, though, especially children:* Richard Louv, *Last Child in the Woods: Saving Our Children from Nature-Deficit Disorder* (New York: Algonquin Books, 2005), 2.

49 *"When one ponders humans":* Margaret M. Hansen et al., "Shinrin-Yoku (Forest Bathing) and Nature Therapy: A State-of-the-Art Review," *International Journal of Environmental Research and Public Health* 14, no. 8 (July 2017): 851, https://doi.org/10.3390/ijerph14080851.

53 *Greeks, who "prescribed" poetry:* Stephen Rojcewicz, "Poetry Therapy in Ancient Greek Literature," *Journal of Poetry Therapy* 17, no. 4 (December 2004): 209–13, https://doi.org/10.1080/0889367042000325076.

53 *groups of researchers across the globe:* Eugen Wassiliwizky et al., "The Emotional Power of Poetry: Neural Circuitry, Psychophysiology and Compositional Principles," *Social Cognitive and Affective Neuroscience* 12, no. 8 (April 2017): 1229–49, https://doi.org/10.1093/scan/nsx069.

54 *The new research was suggesting:* Arthur M. Jacobs, "Neurocognitive Poetics: Methods and Models for Investigating the Neuronal and Cognitive-Affective Bases of Literature Reception," *Frontiers in Human Neuroscience* 9, no. 186 (April 2015), https://doi.org/10.3389/fnhum.2015.00186.

54 *By providing quantitative data from psychophysiology:* Eugen Wassiliwizky et

al., "The Emotional Power of Poetry: Neural Circuitry, Psychophysiology and Compositional Principles," *Social Cognitive and Affective Neuroscience* 12, no. 8 (April 2017): 1229–1249, https://doi.org/10.1093/scan/nsx069.

54 *Our brains are hardwired:* Patrick J. Kiger, "The Human Brain Is Hardwired for Poetry," How Stuff Works, https://science.howstuffworks.com/life/inside-the -mind/human-brain/how-poetry-affects-human-brain.htm.

Chapter 3: Restoring Mental Health

62 *the simple act of doodling:* Cathy Hutchison, "To Doodle or Not Doodle? Science Says Doodlers' Brains Are Smarter and Sharper," *Medium,* June 10, 2018, https://cathyhutchison.medium.com/to-doodle-or-not-to-doodle-science-says -doodlers-brains-are-smarter-and-sharper-40ee9f27d5aa.

63 *neural effects of visual art:* Anne Bolwerk et al., "How Art Changes Your Brain: Differential Effects of Visual Art Production and Cognitive Art Evaluation on Functional Brain Connectivity," *PLOS One* 9 (July 2014), https://doi.org/10 .1371/journal.pone.0101035.

64 *Toxic stress and chronic trauma:* Marie E. Gill, "Integration of Adverse Childhood Experiences Across Nursing Curriculum," *Journal of Professional Nursing* 35 (March–April 2019): 105–111, https://doi.org/10.1016/j.profnurs .2018.07.003.

65 *"The trauma that started 'out there'":* Bessel A. van der Kolk, *The Body Keeps the Score* (New York: Penguin, 2014), 68.

72 *rhythmic, repetitive movements with the hands:* Sasha Gonzales, "What Knitting, Painting and Pottery Do to Your Brain, and Why They Can Make You Happier and Reduce Stress," *South China Morning Post,* July 29, 2018.

72 *Sculpting with clay:* Kerry A. Kruk et al., "Comparison of Brain Activity During Drawing and Clay Sculpting: A Preliminary qEEG Study," *Journal of the American Art Therapy Association* 31, no. 2 (June 2014): 52–60, https://doi.org/10.1080 /07421656.2014.903826.

74 *According to peer-reviewed studies of this work:* James Gordon et al., "Transforming Trauma with Lifestyle Medicine," *American Journal of Lifestyle Medicine* 15, no. 5 (2021): 538–40, https://doi.org/10.1177/15598276211008123.

75 *"Concealing or holding back":* James W. Pennebaker, "Expressive Writing in Psychological Science," *Perspectives on Psychological Science* 13, no. 2 (October 2017): 226–29, https://doi.org/10.1177/1745691617707315.

76 *the effects of expressive writing on the brain:* Brynne C. DiMenichi et al., "Effects of Expressive Writing on Neural Processing During Learning," *Frontiers in Human Neuroscience* 13 (November 2019), https://doi.org/10.3389/fnhum .2019.00389.

76 *As the writer Mary Karr wrote:* Mary Karr, *The Art of Memoir* (New York: HarperCollins, 2015).

77 *Melissa remembers hearing him at night:* Melissa S. Walker, "Art Can Heal PTSD's Invisible Wounds," TED Talk, https://www.ted.com/talks/melissa _walker_art_can_heal_ptsd_s_invisible_wounds?language=en.

77 *In his lab, Bessel van der Kolk:* Bessel A. van der Kolk, *The Body Keeps the Score* (New York: Penguin, 2014), 42.

79 *One veteran who came through the studio:* Andrea Stone, "How Art Heals the Wounds of War," *National Geographic,* February 13, 2015.

79 *Over ten years and thousands of masks:* Melissa S. Walker et al., "Active-Duty Military Service Members' Visual Representations of PTSD and TBI in Masks," *International Journal of Qualitative Studies on Health and Well-Being* 12, no. 1 (November 2017), https://doi.org/10.1080/17482631.2016.1267317.

83 *A group of sensory nerves:* Kim Armstrong, "Interoception: How We Understand Our Body's Inner Sensations," Association for Psychological Science, September 25, 2019, https://www.psychologicalscience.org/observer/interoception-how-we -understand-our-bodys-inner-sensations.

83 *"Their experience is best understood":* Nisha Sajnani et al., "Aesthetic Presence: The Role of the Arts in the Education of Creative Arts Therapists in the Class-room and Online," *The Arts in Psychotherapy* 69 (July 2020), https://doi .org/10.1016/j.aip.2020.101668.

84 *Dancing has been shown to:* Angela Betsaida B. Laguipo, "Is Dancing Good for the Brain?" *Medical Life Sciences,* June 2019, https://www.news-medical.net /health/Is-Dancing-Good-for-the-Brain.aspx.

84 *dance increases neural activity:* Scott Edwards, "Dancing and the Brain," *On the Brain: Harvard Medical School,* Winter 2015.

84 *a conduit for emotional wellness:* Julia F. Christensen et al., "Dance Expertise Modulates Behavioral and Psychophysiological Responses to Affective Body Movement," *Journal of Experimental Psychology* 42, no. 8 (August 2016): 1139–47, https://doi.org/10.1037/xhp0000176.

85 *"teaches us to become aware":* Kai Lehikoinen and Isto Turpeinen, "Fear, Coping and Peer Support in Male Dance Students' Reflections," *Masculinity, Intersec-tionality and Identity* (February 2022): 207–26, https://doi.org/10.1007/978-3 -030-90000-7_10.

92 *when a stigmatizer learns:* Amy Loughman and Nick Haslam, "Neuroscientific Explanations and the Stigma of Mental Disorder: A Meta-Analytic Study," *Cog-nitive Research: Principles and Implications* 3, no. 1 (November 2018): 1–12, https://doi.org/10.1186/s41235-018-0136-1.

92 *a person is set apart from others:* Amy Loughman and Nick Haslam, "Neurosci-entific Explanations and the Stigma of Mental Disorder: A Meta-Analytic Study," *Cognitive Research: Principles and Implications* 3, no. 1 (November 2018): 1–12, https://doi.org/10.1186/s41235-018-0136-1.

93 *This is compounded by inequity:* Michael A. Hoge et al., "Mental Health and Addiction Workforce Development: Federal Leadership Is Needed to Address the Growing Crisis," *Health Affairs* 32, no. 11 (November 2013): 2005–12, https:// doi.org/10.1377/hlthaff.2013.0541.

94 *The arts specifically combat stigma:* Giuseppe Blasi et al., "Brain Regions Under-lying Response Inhibition and Interference Monitoring and Suppression," *Euro-pean Journal of Neuroscience* 23, no. 6 (March 2006): 1658–64, https://doi .org/10.1111/j.1460-9568.2006.04680.x.

94 *A 2021 meta-analysis:* Shivani Mathur Gaiha et al., "Effectiveness of Arts Inter-ventions to Reduce Mental-Health-Related Stigma Among Youth: A Systematic Review and Meta-Analysis," *BMC Psychiatry* 21, no. 1 (July 2021), https://doi .org/10.1186/s12888-021-03350-8.

94 *arts enhance brain function:* Melissa Campbell et al., "Art Therapy and Cognitive Processing Therapy for Combat-Related PTSD: A Randomized Controlled Trial," *Journal of the American Art Therapy Association* 33, no. 4 (October 2016): 169–77, https://doi.org/10.1080/07421656.2016.1226643.

Chapter 4: Healing the Body

99 *"You change the frequency":* Hanae Armitage, "Scientific Innovations Harness Noise and Acoustics for Healing," *Stanford Medicine: Listening,* Spring 2018, https://stanmed.stanford.edu/listening/innovations-helping-harness-sound-acoustics-healing.html.

99 *Jenny explained in his book:* Hans Jenny, *Cymatics: A Study of Wave Phenomena and Vibration* (MACROmedia Publishing, 2001; Extensively Revised Edition, 2024).

100 *"People have often viewed":* Daisy Fancourt et al., "How Leisure Activities Affect Health: A Narrative Review and Multi-Level Theoretical Framework of Mechanisms of Action," *Lancet Psychiatry* 8, no. 4 (April 2021): 329–39, https://doi.org/10.1016/S2215-0366(20)30384-9.

101 *chronic pain is a reality:* "Chronic Pain," *The Lancet: Executive Summary,* May 27, 2021, https://www.thelancet.com/series/chronic-pain.

101 *Pain is the number one reason:* "Chronic Pain: The Impact on the 50 Million Americans Who Have It," Healthline, https://www.healthline.com/health-news/chronic-pain-the-impact-on-the-50-million-americans-who-have-it, accessed July 1, 2022.

102 *too many of us are in some form of discomfort:* Steve Ford, "Understanding the Effect of Pain and How the Human Body Responds," *Nursing Times,* February 28, 2018.

103 *"it's often much more difficult":* Tara Parker-Pope, "Pain as an Art Form," *New York Times,* April 22, 2008.

105 *"Per-protocol analysis":* Indra Majore-Dusele, "The Development of Mindful-Based Dance Movement Therapy Intervention for Chronic Pain: A Pilot Study with Chronic Headache Patients," *Frontiers in Psychology* 12 (April 2021), https://doi.org/10.3389/fpsyg.2021.587923.

105 *Other arts interventions:* "Art Therapy for Migraine Relief—Does It Work?," MigraineBuddy, September 30, 2020, https://migrainebuddy.com/art-therapy-migraine-relief-does-it-work.

105 *having a personal playlist:* Alexandra Linnemann et al., "The Effects of Music Listening on Pain and Stress in the Daily Life of Patients with Fibromyalgia Syndrome," *Frontiers in Human Neuroscience* 9 (July 2015), https://doi.org/10.3389/fnhum.2015.00434.

105 *During wound care:* Hunter G. Hoffman et al., "Virtual Reality Distraction to Help Control Acute Pain During Medical Procedures," *Virtual Reality Technologies for Health and Clinical Applications* (August 2019): 195–208, https://doi.org/10.1007/978-1-4939-9482-3_8.

106 *"VR creates a positive":* Emily Honzel et al., "Virtual Reality, Music and Pain: Developing the Premise for an Interdisciplinary Approach to Pain Management," *The Journal of the International Association of Pain* 160, no. 9 (September 2019): 1909–19, https://doi:10.1097/j.pain.0000000000001539.

107 *"have a profound effect":* Daisy Fancourt, "Beyond Measure? Daisy Fancourt in Conversation with Darren Henley," YouTube, November 28, 2020, https://www .youtube.com/watch?v=pO80PTHK3pk.

109 *One reason that the arts are so effective:* Daisy Fancourt et al., "Cultural Engagement and Cognitive Reserve: Museum Attendance and Dementia Incidence over a 10-Year Period," *The British Journal of Psychiatry* 213, no. 5 (July 2018): 661–63, https://doi:10.1192/bjp.2018.129.

110 *nearly 80 percent of hospital administrations say:* Judy Rollins et al., "State of the Field Report: Arts in Healthcare/2009," National Endowment for the Arts, 2009, https://www.americansforthearts.org/sites/default/files/ArtsInHealthcare_0 .pdf.

112 *used to treat both pain and emotional distress:* Jenny Baxley Lee et al., "Arts Engagement Facilitated by Artists with Individuals with Life-Limiting Illness: A Systematic Integrative Review of the Literature," *Palliative Medicine* 35, no. 10 (December 2021): 1815–31, https://doi.org/10.1177/02692163211045895.

116 *What happens in the brain as we move:* Steven Brown et al., "The Neural Basis of Human Dance," *Cerebral Cortex* 16, no. 8 (October 2005): 1157–67, https:// doi.org/10.1093/cercor/bhj057.

116 *One of our favorite Rumi sayings:* Sarah Davies, "Dance, When You're Broken Open," *Medium,* February 20, 2020, https://medium.com/@heart_19487/dance -when-youre-broken-open-439b6aeaae5b.

118 *A three-year longitudinal study:* Karolina A. Bearss and Joseph F. X. DeSouza, "Parkinson's Disease Motor System Progression Slowed with Multisensory Dance Learning over 3 Years: A Preliminary Longitudinal Investigation," *Brain Sciences* 11, no. 7 (May 2021), https://doi.org/10.3390/brainsci11070895.

119 *dance supports the PD brain:* Alli Hoff Kosik, "Here's Why Dancing Is Good for Your Brain," *Brit + Co,* May 1, 2019, https://www.brit.co/why-dancing-is-good -for-your-brain.

119 *helps develop new neural connections:* Scott Edwards, "Dancing and the Brain," *On the Brain,* Harvard Medical School, Winter 2015, https://hms.harvard.edu /news-events/publications-archive/brain/dancing-brain.

122 *music played at a certain frequency:* Kaho Akimoto et al., "Effect of 528 Hz Music on the Endocrine System and Autonomic Nervous System," *Health* 10, no. 9 (September 2018): 1159–70, https://doi:10.4236/health.2018.109088.

123 *recognizes autobiographical music:* Robert Jagiello, "Rapid Brain Responses to Familiar vs. Unfamiliar Music—an EEG and Pupillometry Study," *Nature* 9, no. 1 (October 2019), https://doi:10.1038/s41598-019-51759-9.

125 *a broader systemic breakdown:* Li-Huei Tsai, "How Science, Technology, and Industry Can Work Together to Cure Alzheimer's," *Boston Globe,* November 29, 2021.

128 *combined visual and auditory treatment:* Massachusetts Institute of Technology, "Brain Wave Stimulation May Improve Alzheimer's Symptoms: Noninvasive Treatment Improves Memory and Reduces Amyloid Plaques in Mice," ScienceDaily, March 14, 2019, https://www.sciencedaily.com/releases/2019/03/190314111004 .htm.

132 *195 Cleveland Clinic patients:* Tamara A. Shella, "Art Therapy Improves Mood, and Reduces Pain and Anxiety When Offered at Bedside During Acute Hospital

Treatment," *The Arts in Psychotherapy* 57 (February 2018): 59–64, https://doi .org/10.1016/j.aip.2017.10.003.

132 *Access to natural light:* Annie Waldman, "Big Pharma Quietly Enlists Leading Professors to Justify $1,000-Per-Day Drugs," ProPublica, February 23, 2017, https://www.propublica.org/article/big-pharma-quietly-enlists-leading-professors -to-justify-1000-per-day-drugs.

133 *Martha Graham, the great dancer:* Martha Graham, "I Am a Dancer," *The Routledge Dance Studies Reader*, ed. Alexandra Carter and Janet O'Shea (London: Routledge, 2010).

Chapter 5: Amplifying Learning

139 *"significant increases"* Michelle Marie Hospital et al., "Music Education as a Path to Positive Youth Development: An El Sistema-Inspired Program," *Journal of Youth Development* 13, no. 4 (2018): 149–63, https://doi:10.5195/JYD.2018.572.

139 *"music training accelerates":* John Rampton, "The Benefits of Playing Music Help Your Brain More Than Any Other Activity," *Inc.,* August 21, 2017, https:// www.inc.com/john-rampton/the-benefits-of-playing-music-help-your-brain-more .html.

140 *an effect on the structural plasticity:* Mathilde Groussard et al., "When Music and Long-Term Memory Interact: Effects of Musical Expertise on Functional and Structural Plasticity in the Hippocampus," *PLOS One* 5, no. 10 (October 5, 2010), https://doi:10.1371/journal.pone.0013225.

142 *Menzer found a research study:* Yovanka B. Lobo and Adam Winsler, "The Effects of a Creative Dance and Movement Program on the Competence of Head Start Preschoolers," *Review of Social Development* 15, no. 3 (August 2006): 501–19, https://doi.org/10.1111/j.1467-9507.2006.00353.x.

142 *Other studies of arts in education:* Lillie Therieau, "11 Rock Solid Statistics That Prove How Vital Art Education Is for Kids' Academic and Social Achievement," ipaintmymind.org, March 22, 2021, https://ipaintmymind.org/blog/11-rock-solid -statistics-that-prove-how-vital-art-education-is-for-kids-academic-social-achieve ment/.

143 *the more you build these neural networks:* Gil D. Rabinovici et al., "Executive Dysfunction," *Continuum* 21, no. 3 (June 2015): 646–59, https://doi:10.1212/01 .CON.0000466658.05156.54.

144 *seven-year-olds were split into two groups:* Per Normann Andersen et al., "Art of Learning—an Art-Based Intervention Aimed at Improving Children's Functions," *Frontiers in Psychology* 10 (July 2019), https://doi.org/10.3389/fpsyg .2019.01769.

145 *researchers followed a group of adolescents:* Reed W. Larson and Jane R. Brown, "Emotional Development in Adolescence: What Can Be Learned from a High School Theater Program?" *Human Development and Family Studies* 78, no. 4 (July 2007): 1083–99, https://doi.org/10.1111/j.1467-8624.2007.01054.x.

145 *Acting also triggers mirror neurons:* Andrea Brassard, "Mirror Neurons and the Art of Acting," Thesis, Concordia University, 2008.

147 *listening to and performing music:* Anne Fabiny, "Music Can Boost Memory and Mood," *Harvard Health Publishing*, February 14, 2015, https://www.health .harvard.edu/mind-and-mood/music-can-boost-memory-and-mood.

147 *Two separate studies, one in Japan:* Anne Fabiny, "Music Can Boost Memory and Mood," *Harvard Health Publishing,* February 14, 2015, https://www.health .harvard.edu/mind-and-mood/music-can-boost-memory-and-mood.

149 *Laughter helps your brain:* Sarah Figalora, "Laughing Makes Your Brain Work Better, New Study Finds," ABC News, April 20, 2014, https://abcnews.go.com /Health/laughing-makes-brain-work-study-finds/story?id=2339305.

149 *laughter lights up multiple regions:* Paula Felps, "This Is Your Brain on Humor," LiveHappy, February 24, 2017, https://www.livehappy.com/science/this-is-your -brain-on-humor.

149 *the same kinds of endorphins let loose:* Sarah Henderson, "Laughter and Learning: Humor Boosts Retention," Edutopia, March 31, 2015, https://www.edutopia .org/blog/laughter-learning-humor-boosts-retention-sarah-henderson.

149 *Humor is a learning juggernaut:* Zak Stambor, "How Laughing Leads to Learning," American Psychological Association, June 2006, https://www.apa.org /monitor/jun06/learning.

150 *research on the neuroscience of play:* Dave Neale et al., "Toward a Neuroscientific Understanding of Play: A Dimensional Coding Framework for Analyzing Infant-Adult Play Patterns," *Frontiers in Psychology* 9 (March 2018), https://doi .org/10.3389/fpsyg.2018.00273.

151 *playful environments encourage children:* Helen Shwe Hadani, "Playful Learning Landscapes: Convergence of Education and City Planning," *Education in the Asia-Pacific Region: Issues, Concerns and Prospects* 58 (May 2021): 151–64, https://doi:10.1007/978-981-16-0983-1_11.

153 *"There are people who just suffer":* Alice Ferng, "Brain Power Has Created a Novel Google Glass Autism App," Medgadget, April 25, 2018, https://www .medgadget.com/2018/04/brain-power-google-glass-autism-app.html.

154 *significant gains in those using the device:* Catalin Voss et al., "Effect of Wearable Digital Intervention for Improving Socialization in Children with Autism Spectrum Disorder," *JAMA Pediatrics* 173, no. 5 (March 2019): 446–54, https:// doi:10.1001/jamapediatrics.2019.0285.

154 *366 million adults:* Peige Song et al., "The Prevalence of Adult Attention-Deficit Hyperactivity Disorder: A Global Systematic Review and Meta-Analysis," *Journal of Global Health* 11 (February 2021), https://doi:10.7189/jogh.11.04009.

160 *"Teachers also confessed":* Cecilia O. Ekwueme et al., "The Impact of Hands-On-Approach on Student Academic Performance in Basic Science and Mathematics," *Higher Education Studies* 5, no. 6 (November 2015), http://dx.doi.org /10.5539/hes.v5n6p47.

161 *John Dewey, a psychologist and an educational reformer:* Jo Ann Boydston, ed., *John Dewey: The Later Works, 1925–1953* (Carbondale, IL: Southern Illinois Press, 1988).

Chapter 6: Flourishing

168 *"Conceptions of what constitutes":* Tyler J. VanderWeele, "On the Promotion of Human Flourishing," *Proceedings of the National Academy of Sciences* 114, no. 31 (June 2017): 8148–56, https://doi.org/10.1073/pnas.1702996114.

170 *"increases resilience":* Cortland J. Dahl, "The Plasticity of Well-Being: A Training-Based Framework for the Cultivation of Human Flourishing," *Proceed-*

ings of the National Academy of Sciences 117, no. 51 (December 2020): 32197–206, https://doi.org/10.1073/pnas.201485911.

172 *As a result, humans find:* Todd Kashdan, "Wired to Wonder," *Greater Good Magazine,* September 1, 2009, https://greatergood.berkeley.edu/article/item/wired_to_wonder.

173 *Curiosity is a building block:* Todd B. Kashdan et al., "Curiosity and Exploration: Facilitating Positive Subjective Experiences and Personal Growth Opportunities," *Journal of Personality Assessment* 82, no. 3 (June 2010): 291–305, https://doi.org/10.1207/s15327752jpa8203_05.

173 *highly empathic people are:* Roman Krznaric, "Six Habits of Highly Empathic People," *Greater Good Magazine,* November 27, 2012, https://greatergood.berkeley.edu/article/item/six_habits_of_highly_empathic_people1.

174 *Wonder is a complex feeling:* Catherine L'Ecuyer, "The Wonder Approach to Learning," *Frontiers in Neuroscience* 8 (October 2014), https://doi.org/10.3389/fnhum.2014.00764.

174 *a central location for beauty:* Jason Castro, "How the Brain Responds to Beauty," *Scientific American,* February 2, 2021.

174 *The idea for a school:* Afdhel Aziz, "How the Nomadic School of Wonder Is Creating Transformational Experiences of Purpose and Meaning," *Forbes,* July 22, 2021.

175 *simple act induces relaxation:* Simone Kuhn et al., "In Search of Features That Constitute an 'Enriched Environment' in Humans: Associations Between Geographical Properties and Brain Structure," *Scientific Reports* 7, no. 1 (September 2017), https://doi:10.1038/s41598-017-12046-7.

175 *When we relax:* Berit Brogaard, "How Deep Relaxation Affects Brain Chemistry," *Psychology Today,* March 31, 2015, https://www.psychologytoday.com/us/blog/the-mysteries-love/201503/how-deep-relaxation-affects-brain-chemistry.

176 *participants were placed inside of an fMRI:* Celeste Kidd and Benjamin Y. Hayden, "The Psychology and Neuroscience of Curiosity," *Neuron* 88, no. 3 (November 4, 2015): 449–60, https://doi.org/10.1016/j.neuron.2015.09.010.

181 *"They actually seek risk":* Beau Lotto, "How We Experience Awe—and Why It Matters," TED Talk, October 2019, https://www.ted.com/talks/beau_lotto_and_cirque_du_soleil_how_we_experience_awe_and_why_it_matters.

181 *"Experiencing awe enables someone":* Beau Lotto, "Awestruck! Part One," *Lab of Misfits Podcast,* December 17, 2021.

181 *This is no small matter:* Diana Fosha et al., "Transforming Emotional Suffering into Flourishing: Metatherapeutic Processing of Positive Affect as a Transtheoretical Vehicle for Change," *Counselling Psychology Quarterly* 32, no. 3–4 (2019): 563–93, https://doi.org/10.1080/09515070.2019.1642852.

183 *"three components that were robustly":* Susan Young, "How the Brain Sees Beauty in Buildings," BrainFacts, February 24, 2021, https://www.brainfacts.org/neuroscience-in-society/the-arts-and-the-brain/2021/how-the-brain-sees-beauty-in-buildings-02242.

187 *"Contrary to romantic notions":* Roger Beaty, *The Creative Brain,* podcast, February 3, 2020.

188 *allowing your mind to wander:* Shelly L. Gable, "When the Muses Strike: Creative Ideas of Physicists and Writers Routinely Occur During Mind Wandering,"

Psychological Science 30, no. 3 (January 2019): 396–404, https://doi.org/10
.1177/0956797618820626.

190 *These roles are known in neurology:* Philip Hernandez, "What Meryl Streep Says
About Acting," *Backstage,* September 13, 2016, https://www.backstage.com
/magazine/article/meryl-streep-says-acting-5578/.

190 *embodiment of a character can result:* Steven Brown et al., "The Neuroscience of
Romeo and Juliet: An fMRI Study of Acting," *Royal Society Open Science* 6,
no. 3 (March 2019), https://doi.org/10.1098/rsos.181908.

190 *Allowing yourself to fall into a role:* John DeSilvestri, "Drama Therapy and the
Therapeutic Benefits of Theater," *Scleroderma, Vasculitis & Myositis eNewsletter,*
August 2014, https://www.hss.edu/conditions_drama-therapy-benefits.asp.

191 *"silence the critical voice":* John Lutterbie, "Neuroscience and Creativity in the
Rehearsal Process," in *Performance and Cognition: Theatre Studies and the Cog-
nitive Turn,* eds. Bruce McConachie and F. Elizabeth Hart (New York: Routledge,
2006).

192 *when emotions, symbols, and knowledge are examined:* Rami Gabriel, "Affect,
Belief, and the Arts," *Frontiers in Psychology* 12 (December 2021), https://doi
.org/10.3389/fpsyg.2021.757234.

193 *"The world was increasingly hungry":* Rachel Monroe, "Can an Art Collective
Become the Disney of the Experience Economy?," *New York Times Magazine,*
May 1, 2019.

193 *An early study on novelty:* Nico Bunzeck and Emrah Duzel, "Absolute Coding of
Stimulus Novelty in the Human Substantia Nigra/VTA," *Neuron* 51, no. 3 (Au-
gust 2006): 369–79, https://doi.org/10.1016/j.neuron.2006.06.021.

194 *Surprise is processed:* "The Brain Loves Surprises," ExploringYourMind, https://
exploringyourmind.com/the-brain-loves-surprises/, accessed July 3, 2022.

194 *When the surprise is pleasant:* Ahmed El Hady, "Your Brain on Surprise!,"
Princeton Neuroscience Institute, May 17, 2001, https://pni.princeton.edu/news
/your-brain-surprise.

Chapter 7: Creating Community

204 *While it might not always seem the case:* Lisa Feldman Barrett, "Why Chimpan-
zees Don't Hold Elections: The Power of Social Reality," *Undark,* January 1,
2021, https://undark.org/2021/01/01/book-excerpt-seven-and-a-half-lessons
-about-the-brain/.

205 *in the brains of storytellers and listeners:* Greg J. Stephens et al., "Speaker-
Listener Neural Coupling Underlies Successful Communication," *Proceedings of
the National Academy of Sciences* 107, no. 32 (July 2010): 14425–30, https://doi
.org/10.1073/pnas.1008662107.

205 *Our brain encodes memories:* Manuella Yassa, "Why Our Brains Love Story,"
Center for the Neurobiology of Learning and Memory, December 4, 2018,
https://cnlm.uci.edu/2018/12/04/story/.

206 *"Humans are the only animals"* Gabrielle Ahern, "Book Review: *Why Chimpan-
zees Don't Hold Elections: The Power of Social Reality,*" *Science of Learning,*
January 22, 2021, https://npjscilearncommunity.nature.com/posts/book-review
-why-chimpanzees-don-t-hold-elections-the-power-of-social-reality.

210 *community activities involving music:* Jeanie Lerche Davis, "The Science of Good Deeds," WebMd, https://www.webmd.com/balance/features/science-good -deeds, accessed July 3, 2022.

215 *370 urban gardeners:* Graham Ambrose et al., "Is Gardening Associated with Greater Happiness of Urban Residents? A Multi-Activity, Dynamic Assessment in the Twin-Cities Region, USA," *Landscape and Urban Planning* 198 (June 2020), https://doi.org/10.1016/j.landurbplan.2020.103776.

218 *But as the urban activist:* Jane Jacobs, *The Death and Life of Great American Cities* (New York: Random House, 1961).

219 *As Murthy sat in homes:* Vivek Murthy, *Together: The Healing Power of Human Connection in a Sometimes Lonely World* (New York: Harper, 2020).

220 *When we're lonely:* Ibid.

222 *"the default network directs us":* Emily Esfahani Smith, "Social Connection Makes a Better Brain," *The Atlantic,* October 29, 2013.

222 *"Rationally we can say":* University of California, Los Angeles, "Rejection Really Hurts, UCLA Psychologists Find," ScienceDaily, October 10, 2003, https://www.sciencedaily.com/releases/2003/10/031010074045.htm.

223 *our social brain connectome:* Daniel Alcalá-López et al., "Computing the Social Brain Connectome Across Systems and States," *Cerebral Cortex* 28, no. 7 (July 2018): 2207–32, https://doi.org/10.1093/cercor/bhx121.

223 *Their findings are presented in a paper:* Janneke E. P. van Leeuwen et al., "More Than Meets the Eye: Art Engages the Social Brain," *Frontiers in Neuroscience* 16 (February 2022), https://doi.org/10.3389/fnins.2022.738865.

223 *"neural grounding in the social brain":* Janneke E. P. van Leeuwen et al., "More Than Meets the Eye: Art Engages the Social Brain," *Frontiers in Neuroscience* 16 (February 2022): https://doi.org/10.3389/fnins.2022.738865.

225 *"extra dose of affinity":* Marta Zaraska, "Moving in Sync Creates Surprising Social Bonds Among People," *Scientific American,* October 1, 2020.

227 *The act of moving bridges the gap between self and others:* Zaraska, "Moving in Sync."

Conclusion: The Art of the Future

229 *The pattern was "deliberate":* David D. Zhang et al., "Earliest Parietal Art: Hominin Hand and Foot Traces from the Middle Pleistocene of Tibet," *Science Bulletin* 66, no. 4 (December 2021): 2506–15, https://doi.org/10.1016/j.scib.2021 .09.001.

232 *Beyond the basic biomarkers:* Yuhao Liu et al., "Lab-on-Skin: A Review of Flexible and Stretchable Electronics for Wearable Health Monitoring," *American Chemical Society Nano* 11, no. 10 (October 2017): 9614–35, https://doi.org /10.1021/acsnano.7b04898.

232 *Others are at work developing smart threads:* John Koetsier, "Smart Thread Is the Future of Wearable Tech. Here's One Startup Making It Happen," *Forbes,* July 6, 2021.

233 *arts activities are already on the rise:* Hei Wan Mak et al., "Predictors and Impact of Arts Engagement During the COVID-19 Pandemic: Analyses of Data from 19,384 Adults in the COVID-19 Social Study," *Frontiers in Psychology* 12 (April 2021), https://doi.org/10.3389/fpsyg.2021.626263.

235 *"We were blown away":* Emily Henderson, "Virtual Reality Can Help Boost Brain Rhythms Linked to Learning and Memory," *Science Focus,* June 28, 2021, https://www.news-medical.net/news/20210628/Virtual-reality-can-help-boost -brain-rhythms-linked-to-learning-and-memory.aspx.

242 *Jorrit Britschgi, the executive director of the museum:* Renuka Joshi-Modi, "New York's Rubin Museum of Art Hosts an Unusual Spiritual and Creative Experience," *Architectural Digest,* January 24, 2002.

244 *Your brain is humming:* Sarah Keating, "The World's Most Accessible Stress Reliever," BBC Future, May 18, 2020.

244 *the warm water quenches:* Bruce Becker, "The Brain and Aquatic Therapy," Presentation to American Physical Therapy Association, February 2020, https:// www.hydroworx.com/blog/research-warm-water-therapy-brain/.

Image Credits

Black-and-White Artwork

viii *Spiral Cluster*. Ink on Paper, 2019. Norman Galinsky.

 2 Neuronal Networks in a Dish. Richard L. Huganir.

 26 DNA Voice Signature Images. John Reid, Sound Made Visible.

 60 *Continuing painting 3*. *Painting number 68*. Acrylic paint and mud on canvas, 1987. Judy Tuwaletstiwa.

 96 Sound Heart Cells. *BioMaterial Journal*.

134 Cajal Legacy. Instituto Cajal (CSIC), Madrid.

166 Goldfish poem by IN-Q.

200 *African Beauty*. Fresco. Loures, Portugal. Huariu.

228 *Infinity Room*. Refik Anadol.

Color-Insert Photography

A Jess Bernstein

B Edorado Delille and Google

C Timothy Shenck

D Greg Dunn and Brain Edwards

E teamLab,
 Universe of Water Particles on a Rock
 where People Gather
 © teamLab

F Judy Tuwaleststiwa

G Chris Keeney

H Refik Anadol Studio

I Creative Growth Art Center

Index

Index

Index

Index

SUSAN MAGSAMEN is the founder and executive director of the International Arts + Mind Lab (IAM Lab) at the Center for Applied Neuroaesthetics, a pioneering initiative at Johns Hopkins University School of Medicine.

© BEN KRANTZ

Her work marries brain sciences and the arts, focusing on how our unique response to the arts and aesthetic experiences work at a neurobiological level to amplify human potential.

Magsamen is the creator of the Impact Thinking Model, an evidence-based research approach used to accelerate how the arts and aesthetics are used to address issues in health, well-being, and learning. This framework welcomes the many "ways of knowing" including lived experiences and community voice along with other interdisciplinary research methods.

In addition to her role at IAM Lab, she is an assistant professor of neurology at Johns Hopkins, and she serves as co-director of the NeuroArts Blueprint Project in partnership with the Aspen Institute.

Prior to founding IAM Lab, Magsamen worked in both the private and public sectors, developing social impact programs and products addressing all stages of life—from early childhood to the senior years. She created both the award-winning Curiosityville, an online personalized learning world, which was acquired in 2014 by Houghton Mifflin Harcourt, and Curiosity Kits, a hands-on multisensory company, which was acquired by Torstar in 1995.

An award-winning author, Magsamen has published seven previous books, including *The Classic Treasury of Childhood Wonders, The 10 Best of Everything Families,* and *Family Stories.*

Magsamen is a fellow at the Royal Society of Arts, and a strategic advisor fostering leadership, curiosity, and innovation with global or-

ganizations and initiatives. She is also a member of the Society for Neuroscience, the National Organization for Arts in Health, the Academy of Neuroscience for Architecture, the American Psychological Association, Brain Futures, Playful Learning Landscapes, and Creating Healthy Communities: Arts + Public Health in America, among others.

© BEN KRANTZ

IVY ROSS is the chief design officer of consumer devices at Google.

Since 2017, Ross and her team have introduced a family of consumer hardware products ranging from smartphones to smart speakers earning more then two hundred global design awards.

This collection of products established a design aesthetic for technology products that is tactile, bold, and emotional.

Over her career, Ross has held executive positions—from head of product design and development to CMO and president—at several companies, including Calvin Klein, Swatch, Coach, Mattel, Bausch & Lomb, and Gap.

Ross has been a contributing author of numerous books, including *The Change Champion's Field Guide* and *Best Practices in Leadership Development and Organization Change.*

She has also been profiled in the books *The Ten Faces of Innovation, Rules of Thumb,* and *Unstuck,* among many others.

Ross has appeared as a speaker at *Fortune*'s Most Powerful Women Summit, and has been cited by *Businessweek* as one of the "New Faces of Leadership." In 2019, she was ranked #9 on *Fast Company*'s list of the "100 Most Creative People in Business."

A renowned artist, Ross has innovative metal work in jewelry in the permanent collections of ten international museums, including the

Smithsonian American Art Museum in Washington, D.C. She is a recipient of a prestigious National Endowment for the Arts fellowship, and has also received the Women in Design Award and the Diamond International Award for her creative designs. Ross's passion lies in human potential and relationships. She believes in the combination of art and science to make magic happen and to bring great ideas and brands to life.